ASHE LEANDRO

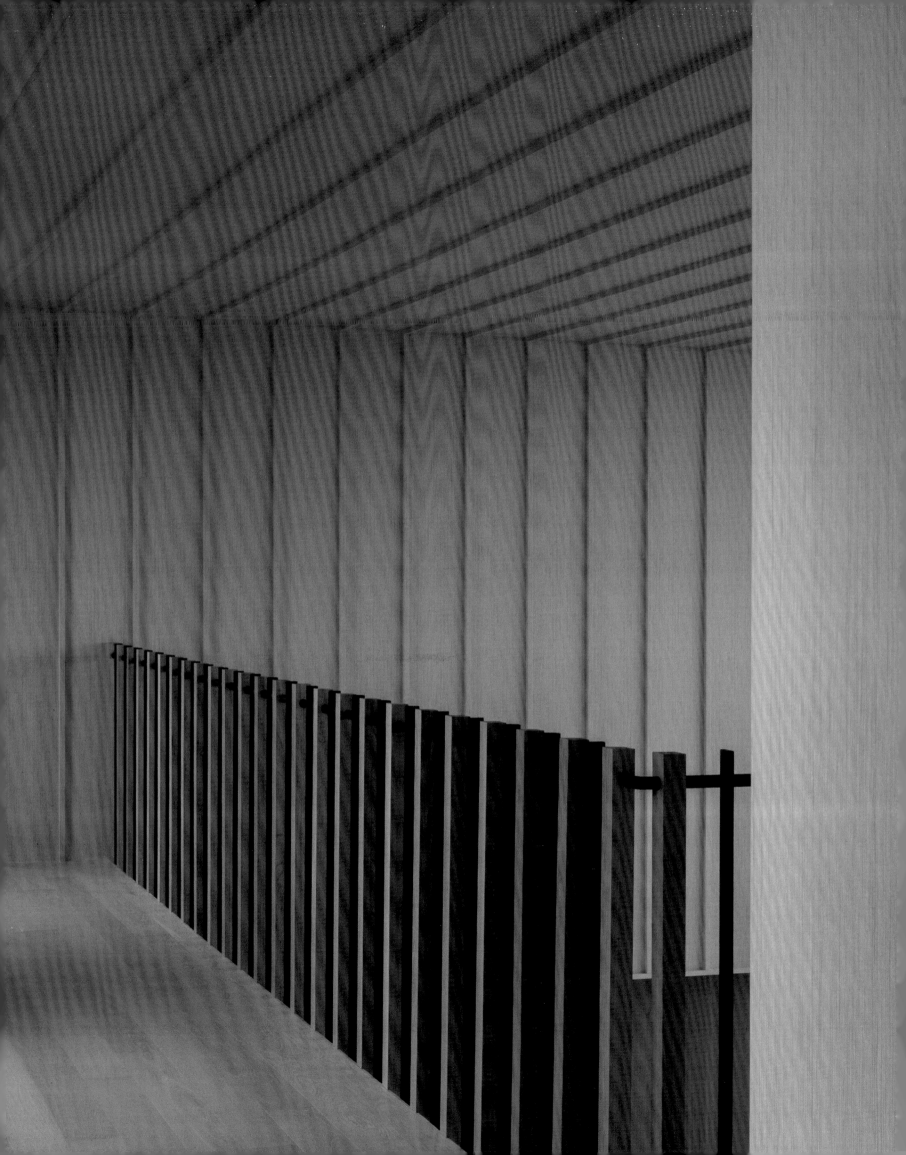

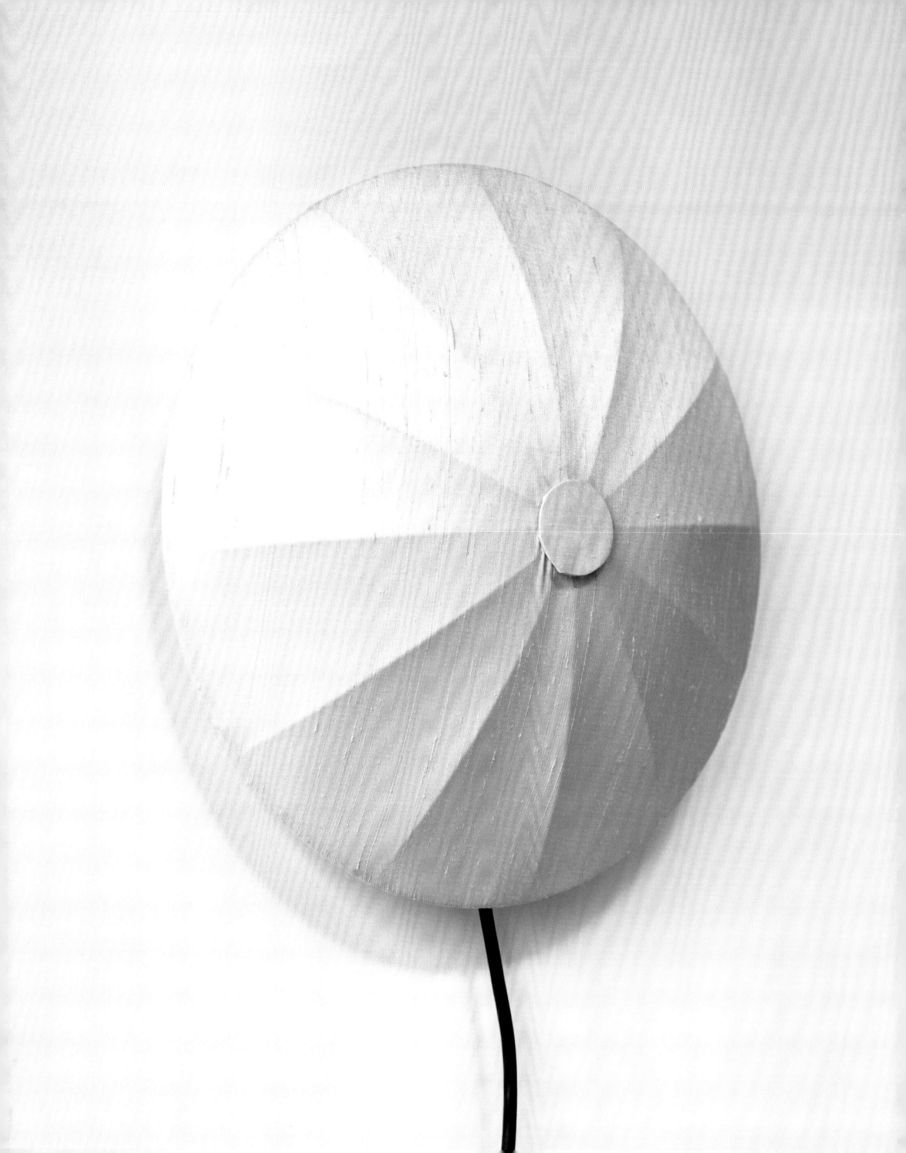

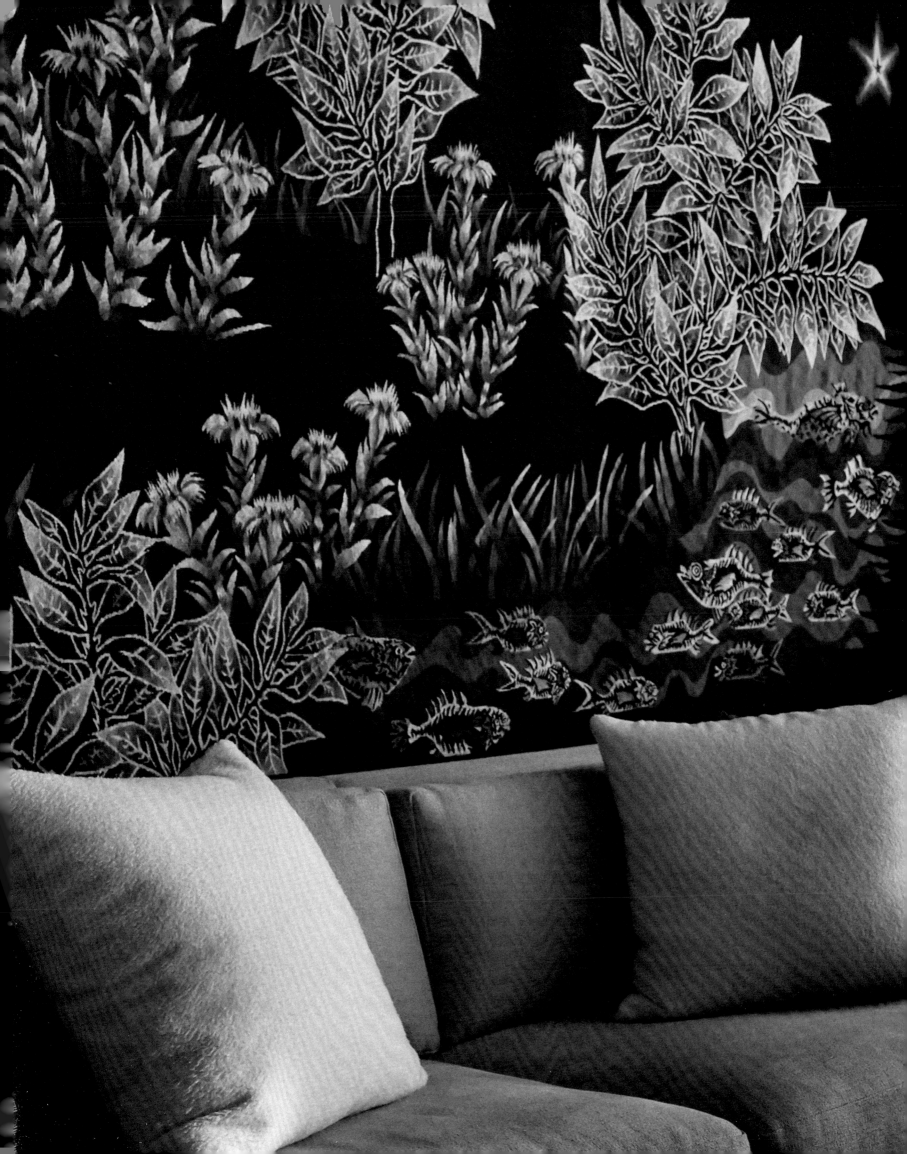

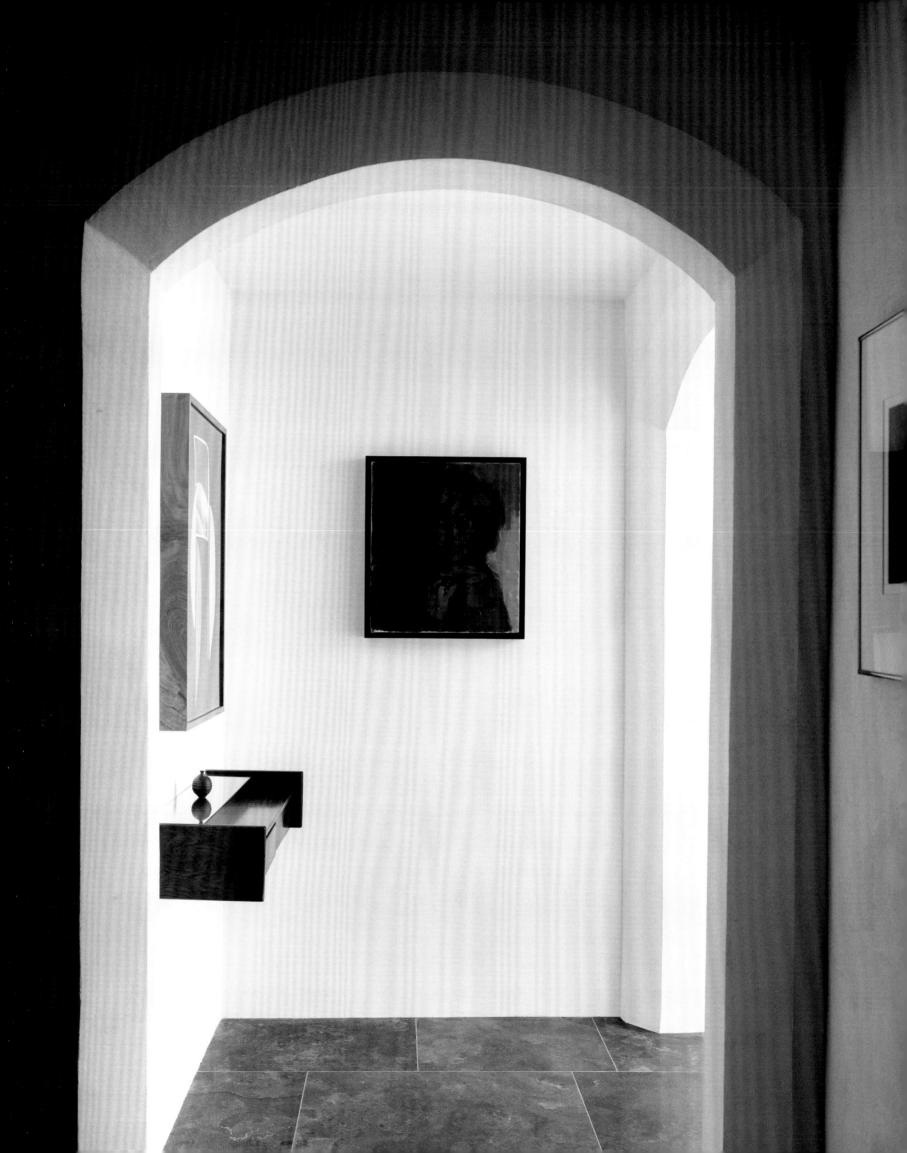

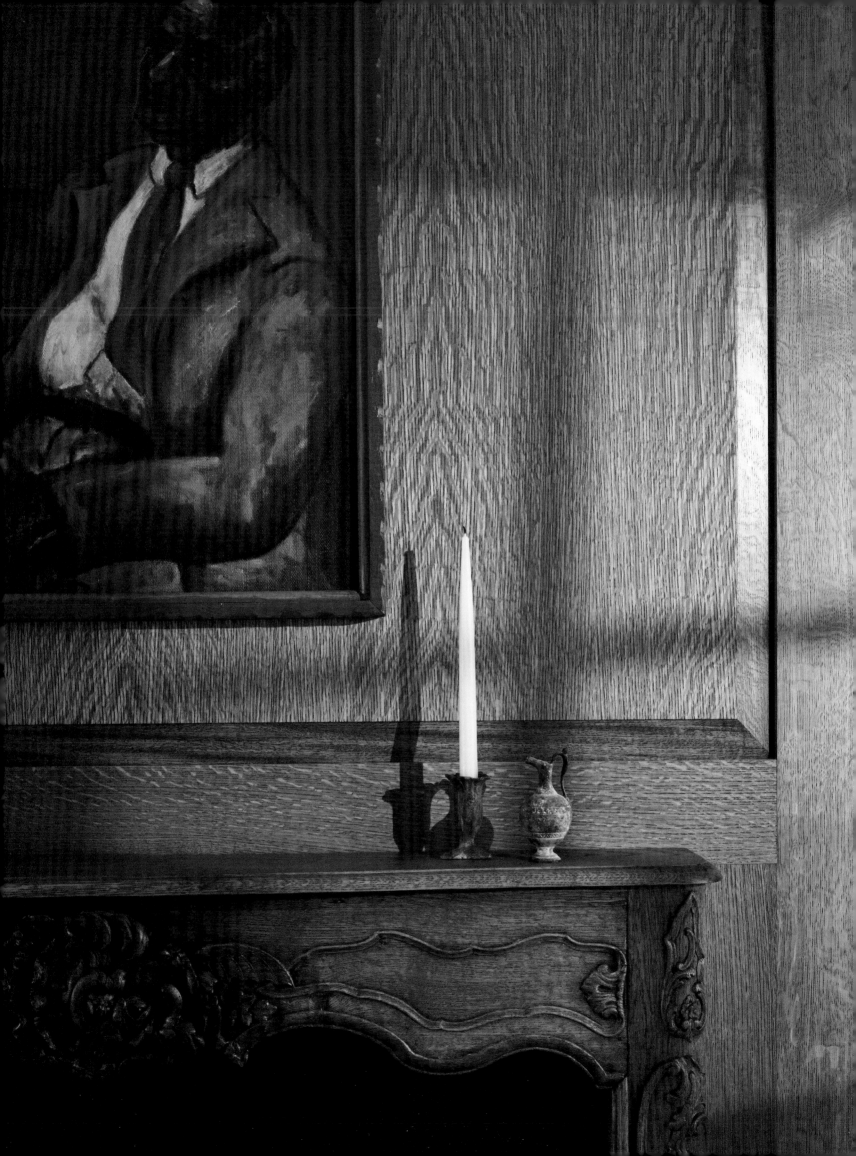

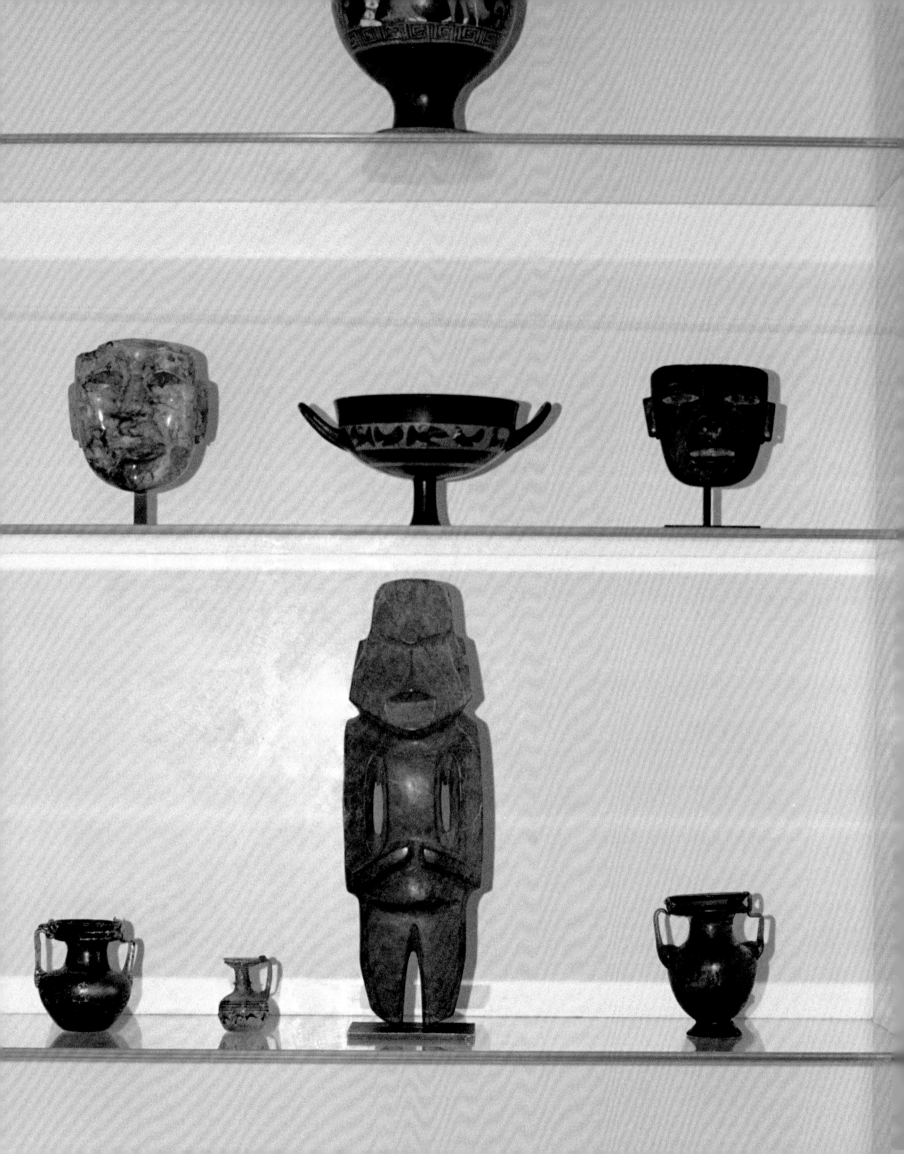

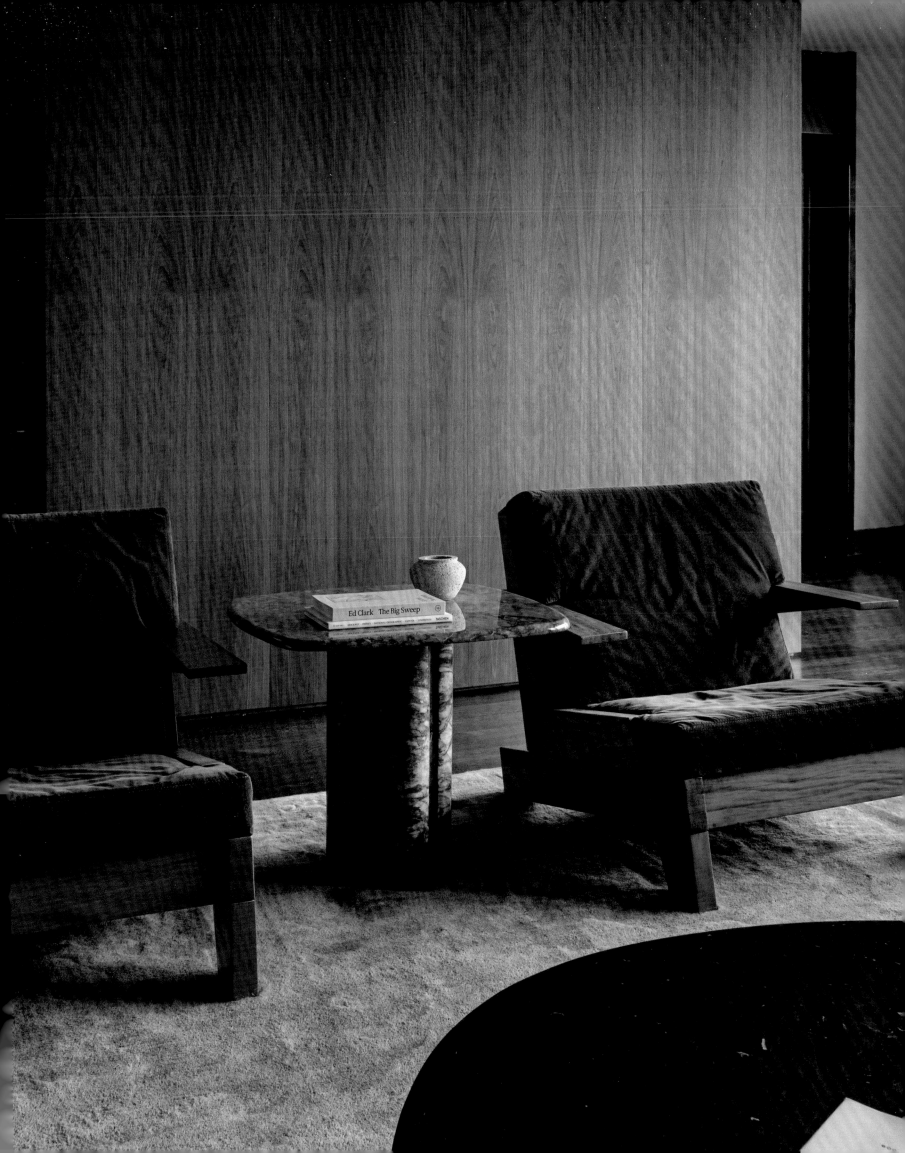

Ed Clark The Big Sweep

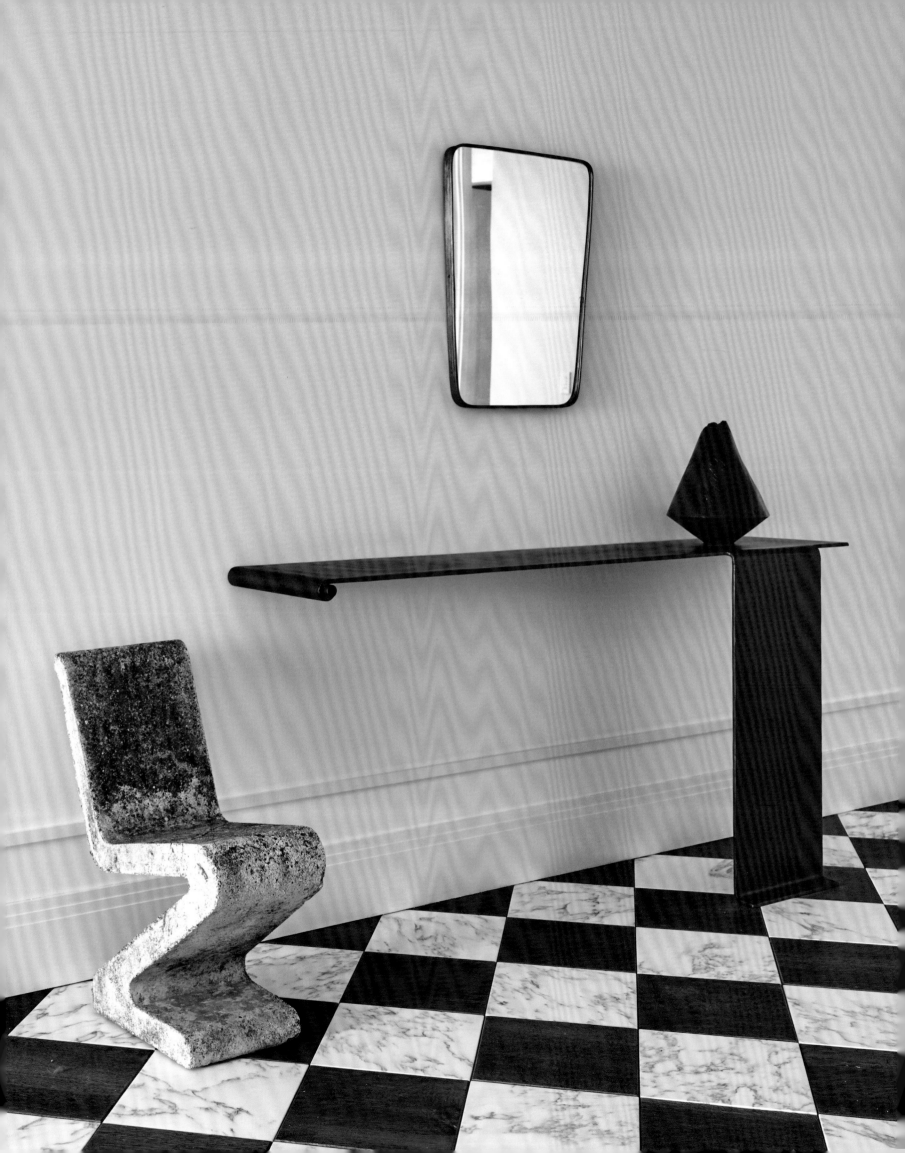

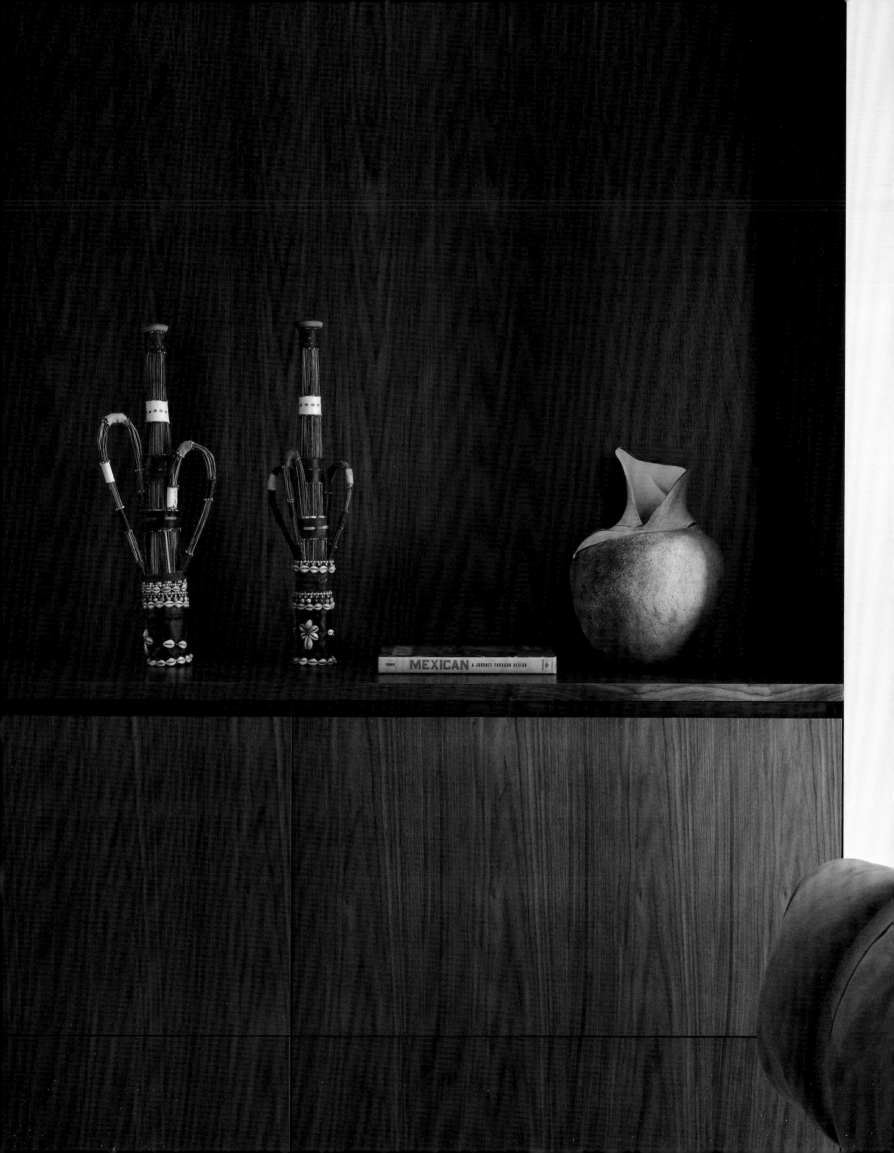

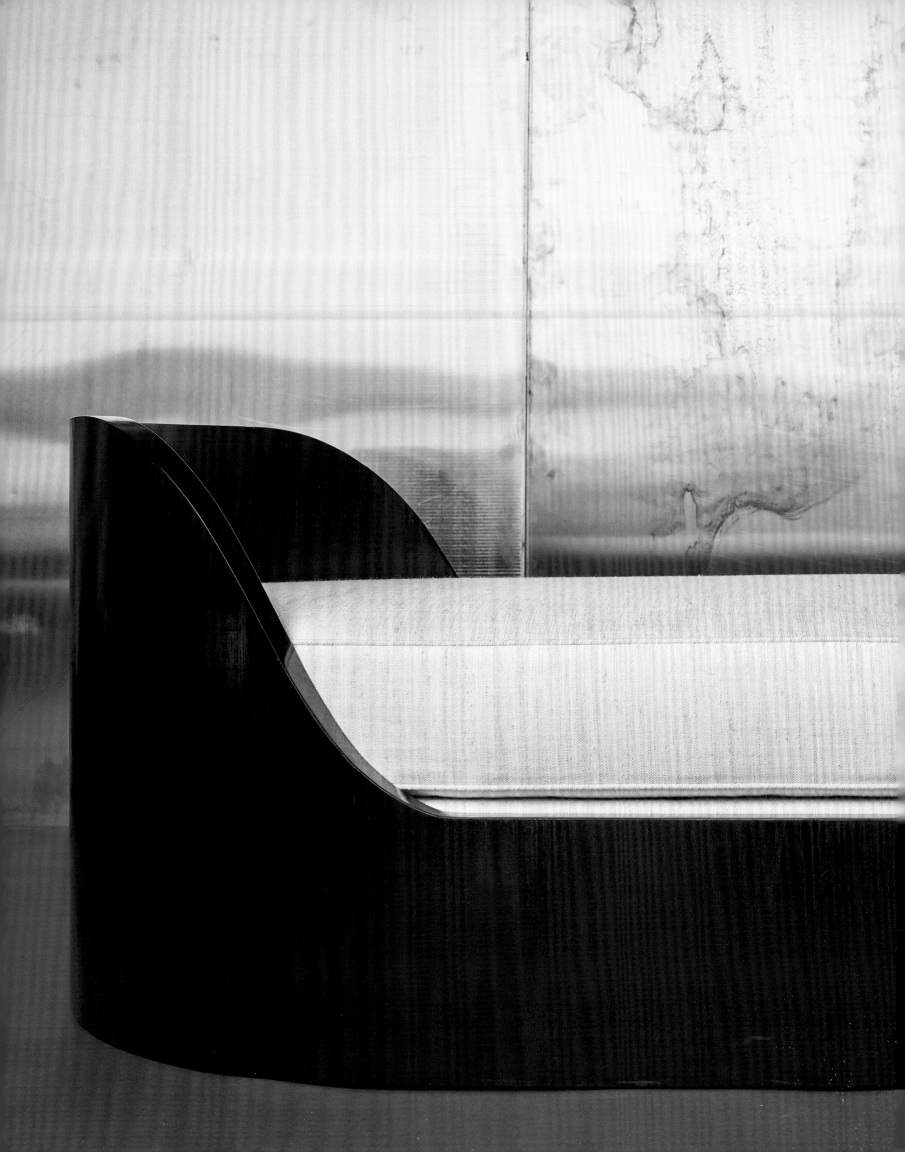

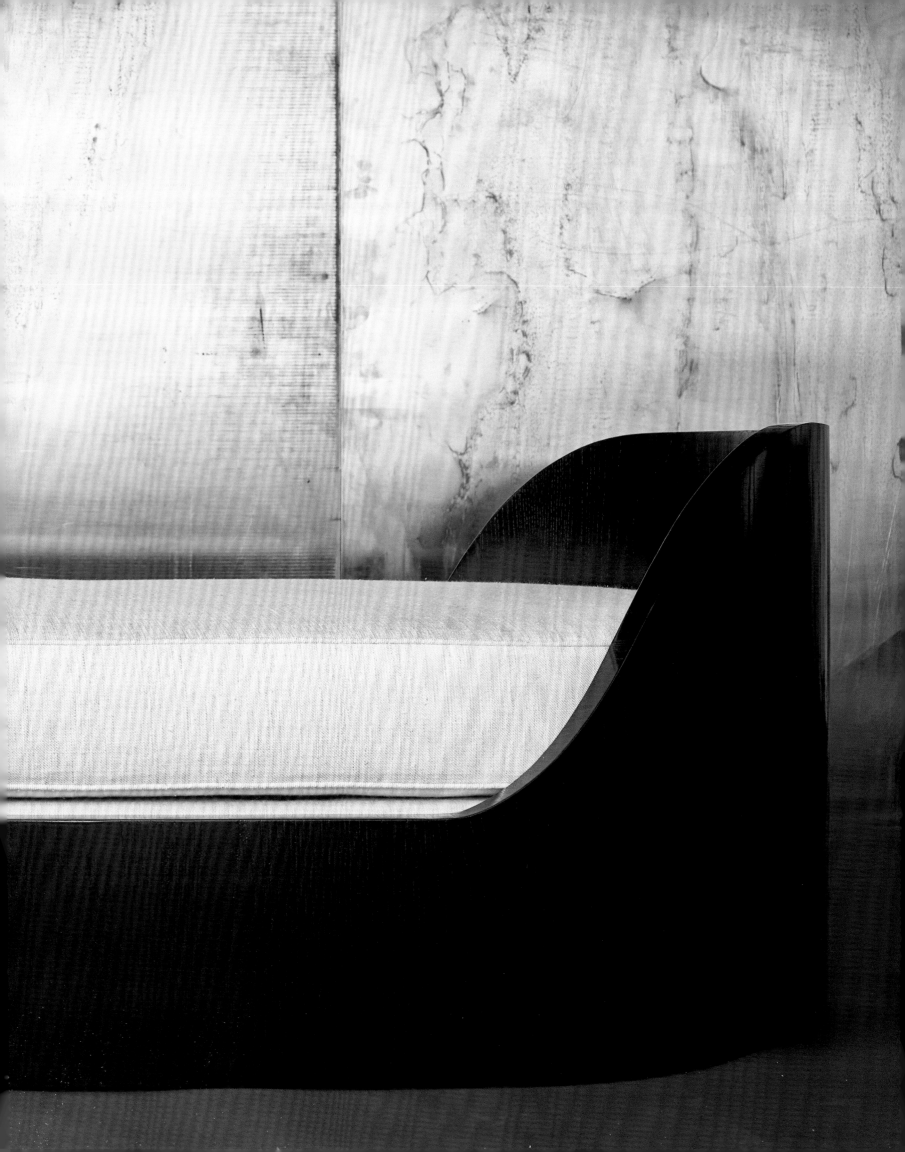

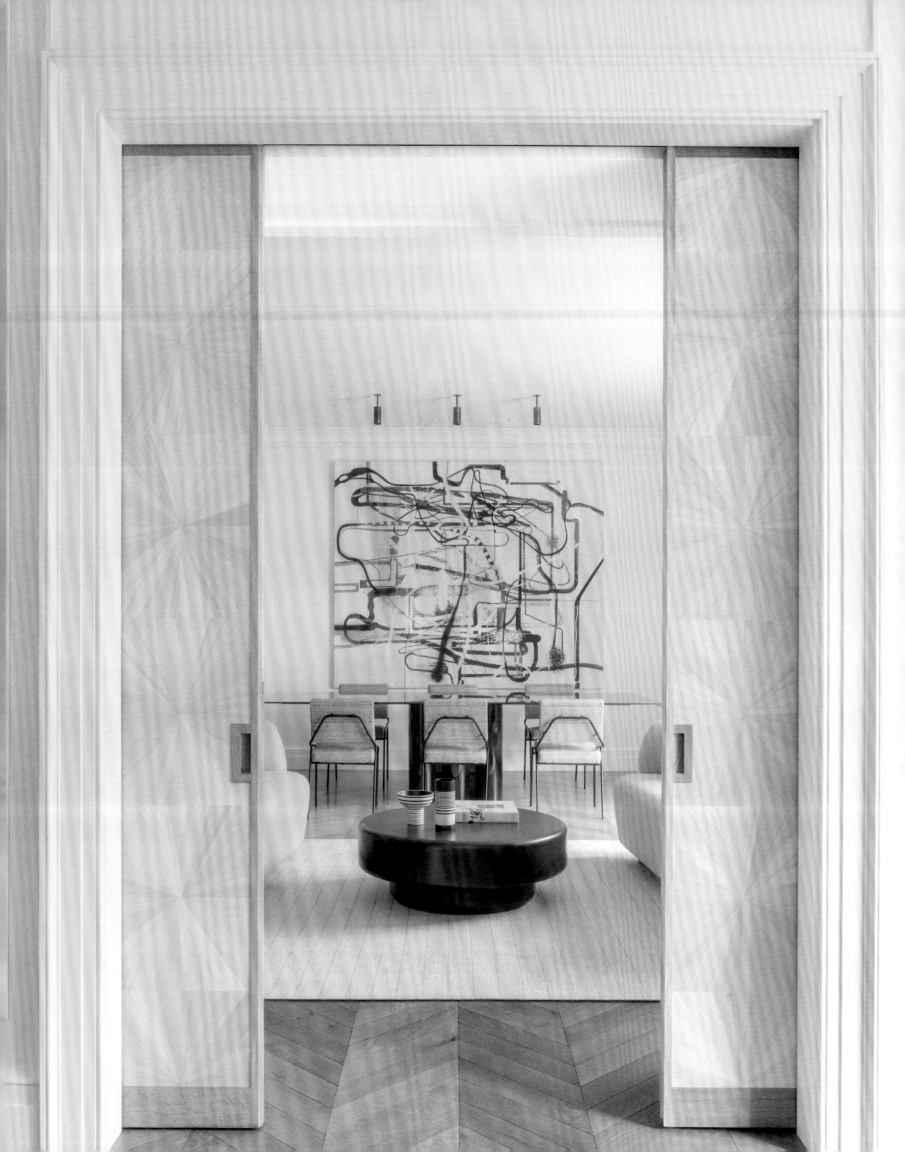

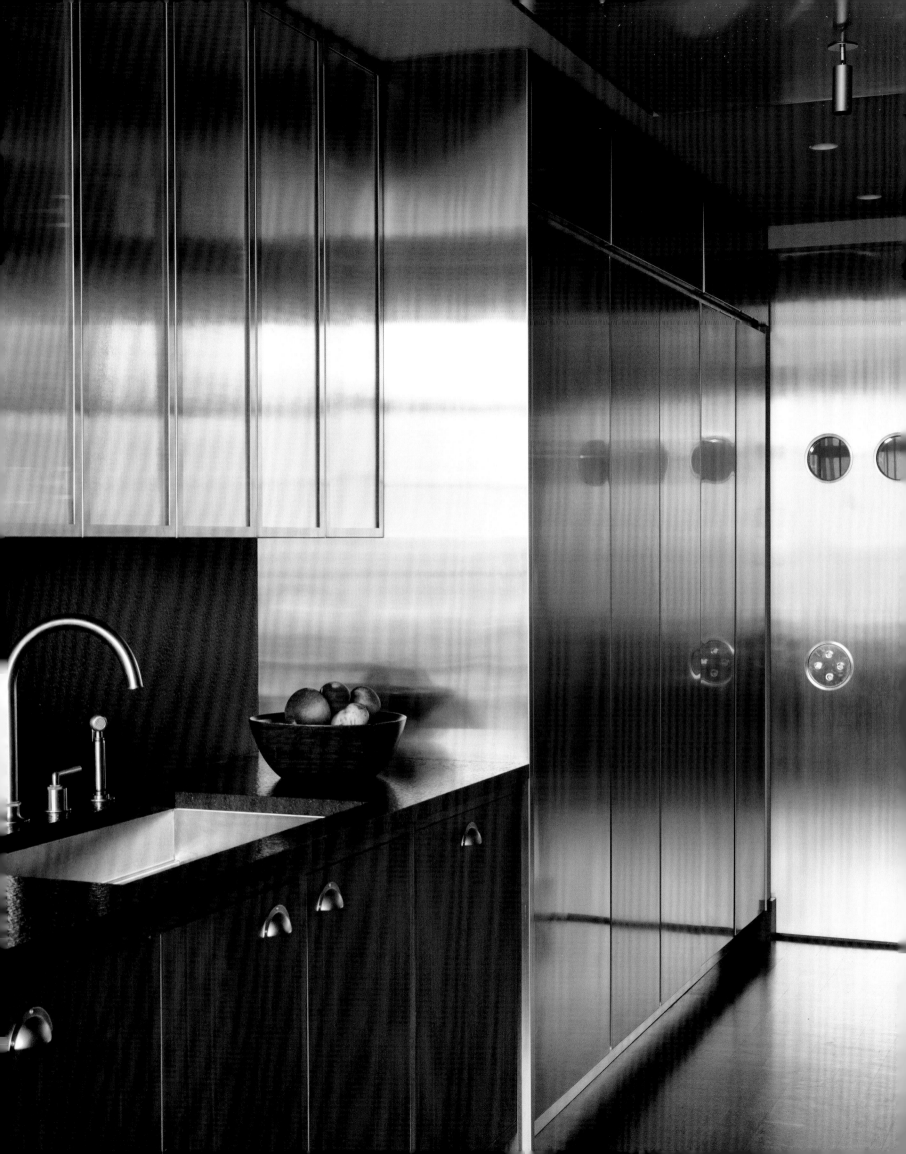

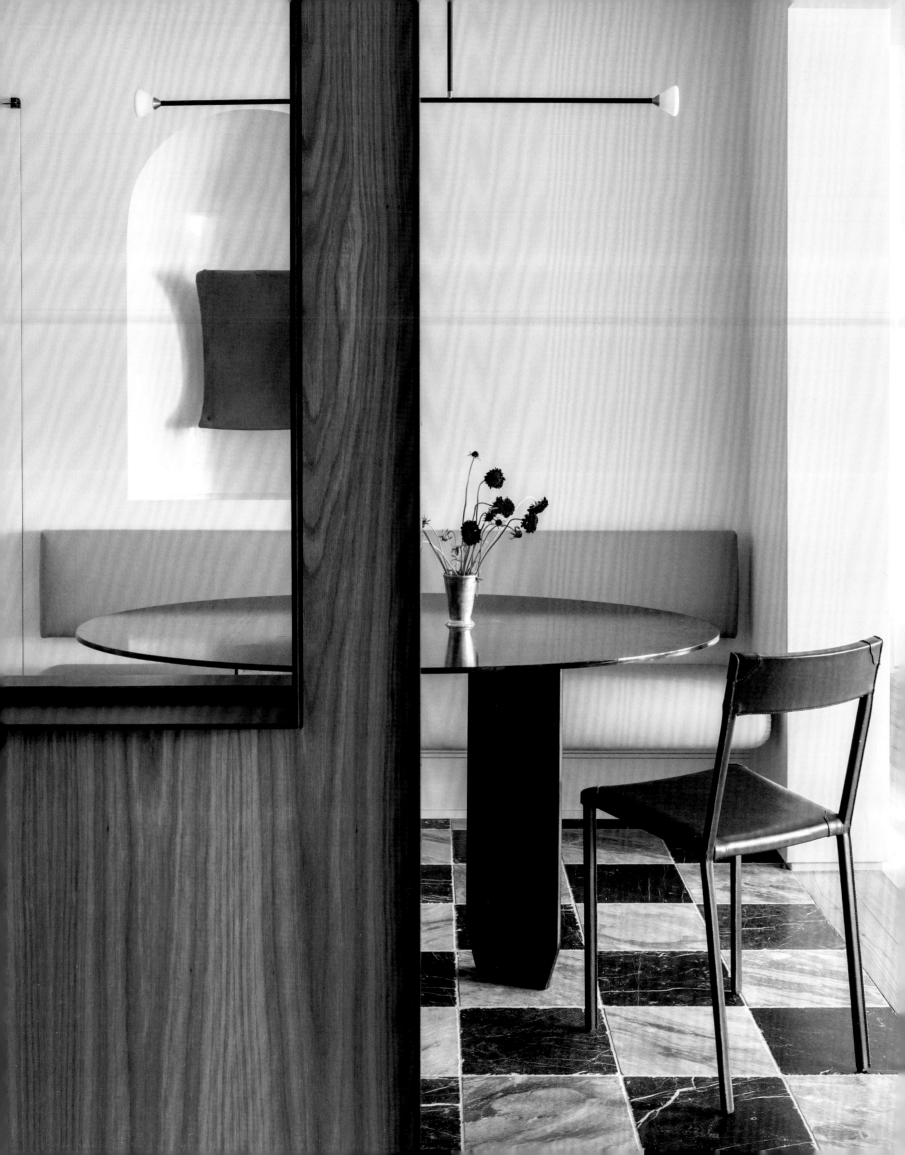

ASHE LEANDRO

ARCHITECTURE + INTERIORS

ARIEL ASHE AND REINALDO LEANDRO

WITH CONTRIBUTIONS BY
SETH MEYERS, FELIX BURRICHTER,
AND RASHID JOHNSON

RIZZOLI
NEW YORK

New York · Paris · London · Milan

CONTENTS

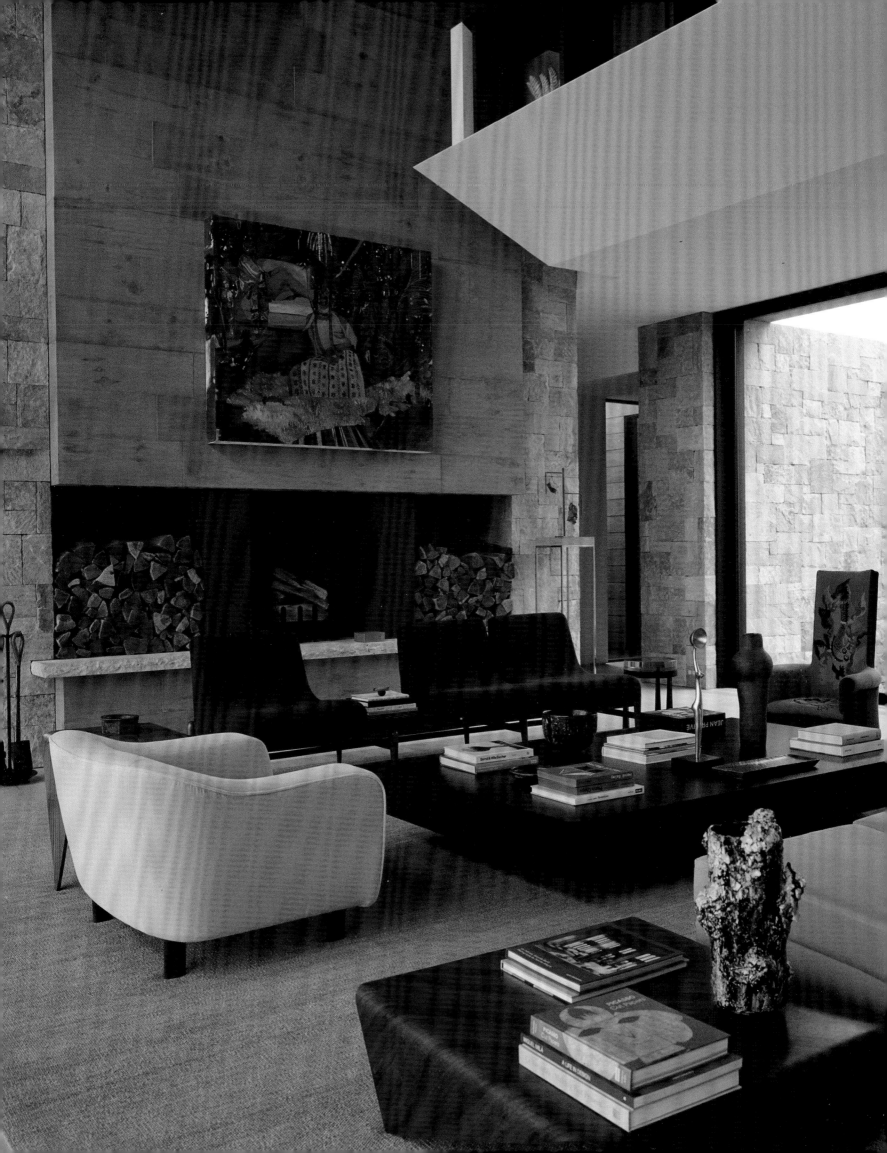

FOREWORD
SETH MEYERS

ASHE LEANDRO

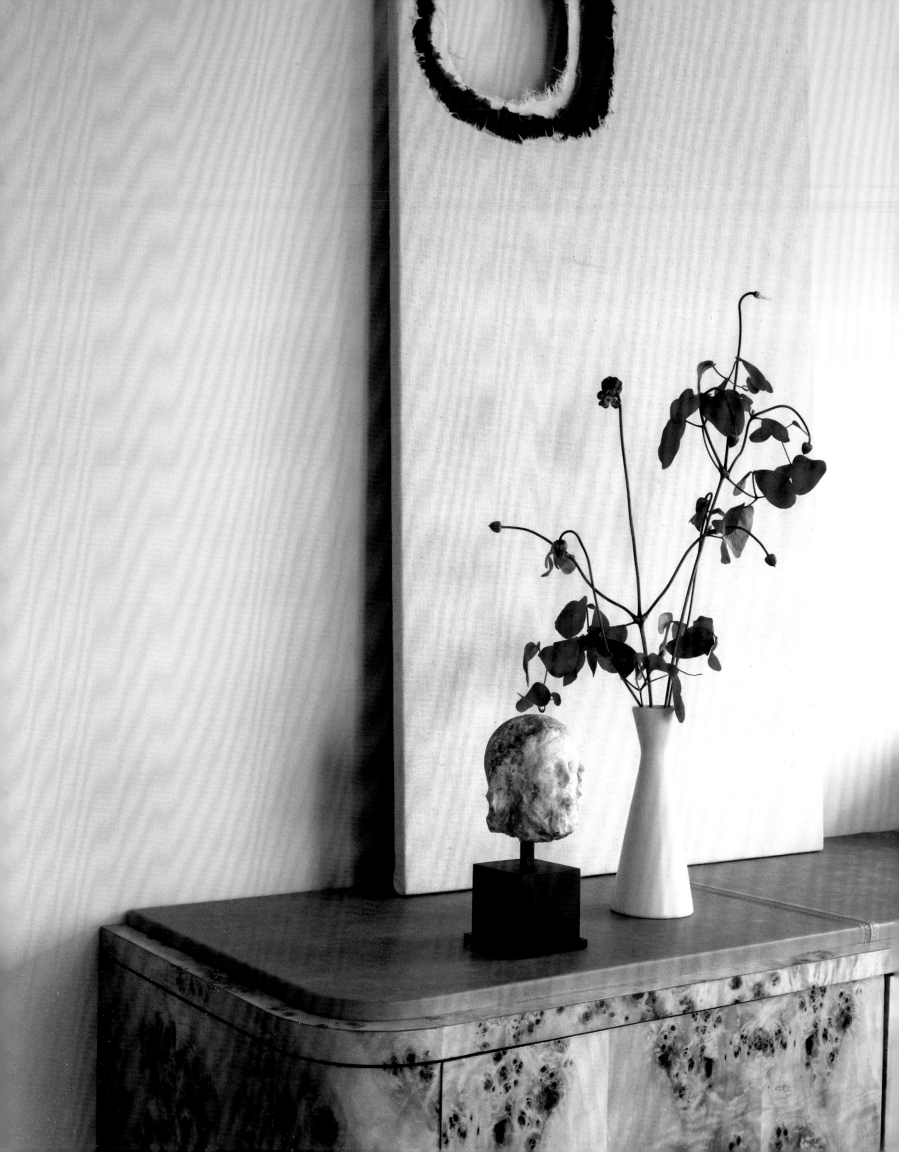

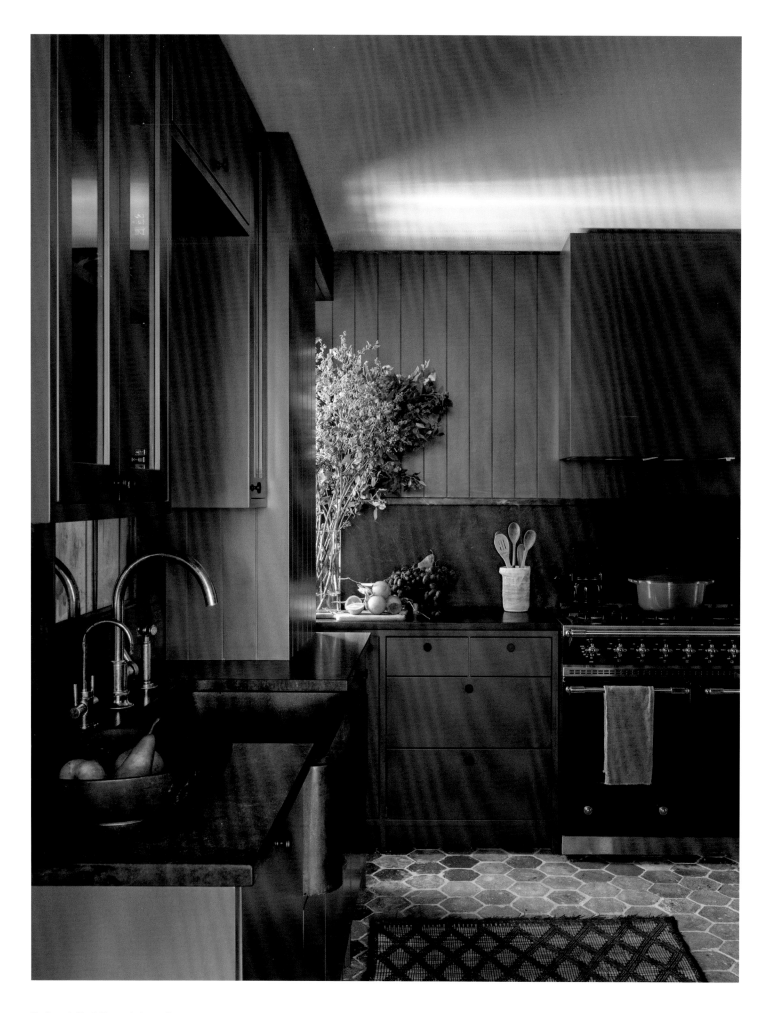

Seth and Alexi Meyers's home in
New York, featured in *Architectural
Digest*, February 2019.

Ariel Ashe is my sister-in-law, and to those who have accused me of marrying my wife only for access to Ashe and Leandro's design skills — you would have done it, too! Don't judge me!

The truth is, I knew Ariel first. She had been an assistant in the set design department at *Saturday Night Live* since the year before I started. We became friends, and early on I leaned on her for help appointing my living quarters. This was incredibly kind of her as my apartment back in those days was, to use an architectural term, a "shitbox." Still, she would patiently guide me when I decided it was time to make purchases such as "chair" and "table." Limited not by her already considerable eye for quality but by my meager budget, she still helped pick pieces that stood out in my otherwise unimpressive one-bedroom. Visitors, upon seeing one of her selections next to the lumpy couch I had purchased at a Crate & Barrel knockoff called "Box & Bucket," would remark, "Is it safe to assume the mid-century coffee table was left by the previous owner or perhaps even stolen?" I would proudly tell them that everything nice was thanks to the eye of one Ariel Ashe. "You should marry her," they would shout. I would explain that it's awkward to marry your designer, but I had plans on doing the next best thing.

In reality, Ariel also set me up with my wife. And that really speaks to the kind of designer she is. Anyone can pick out a nice lamp or piece of art, but to say, "You know what would look great here? A spouse!"

As I graduated from a fourth-floor walk-up to an adult apartment where the radiator didn't leak, I saw the true powers of not just Ariel but her incredible partner, Reinaldo Leandro. Where Ariel has an incredible attention to detail, Rei has an incomparable structural flair. Plus, I like Rei more because when I complain about my wife to him, he doesn't run to tell her right away.

The greatest thing about their pairing is you can tell them what you want in the vaguest possible terms, and they have the power to shape it into something specific that is beyond your wildest dreams. It never looks like something you've seen before, but it looks like something you will see again, because five years later everyone else is trying to copy their moves. And they don't care, because they've moved on to new ideas and new inspirations. They're never complacent, always changing — a step ahead of everyone else.

If you read about designers, you will often see it said that they "crafted" a home. I always found that language to be pretentious. You don't "craft" a home. You build a home. You decorate a home. Let's not make things fancier than they have a right to be. And then Ashe and Leandro did a home for us, and guys, when I walked in, I thought, "This fucking place is *crafted*."

And when my wife saw it, she cried because it was so beautiful. And then she turned to me and said the sweetest thing — "Try not to touch anything."

I hope you enjoy this book as much as I have, and I hope they give me a copy for free (or at least with a healthy discount).

INTRODUCTION
REINALDO LEANDRO

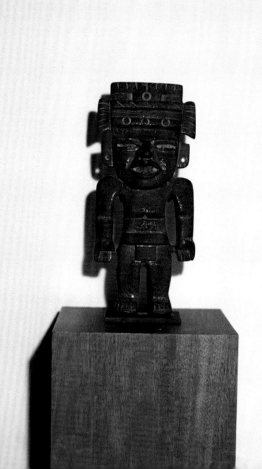

Ariel Ashe and I met in the summer of 2004 in New York. I had just finished my master's of science in Advanced Architectural Design at Columbia University. That summer I started working at Pierce Allen, an architecture and interior design practice led by DD Allen and Michael Pierce.

Ariel had already been working under DD Allen for three years. That was her "master's program" in interior design after graduating from New York University in 2002, where she studied set design at the Tisch School of the Arts. She had started her professional career as a set design assistant at *Saturday Night Live,* where she made many friendships that would play an important part in our future business. But that would be some years later.

In the summer of 2004, we were both in our early twenties, and Ariel was the cool girl in the office where I had just begun working. Naturally, I had to be her friend. A courtship began on my end, which included invitations to the theater, to the movies, and after several failed tries, an accepted dinner date. I remember stuffed piquillo peppers and a lot of red wine. We hit it off and became fast friends. To me, she was refreshing; I called her the all-American Gap Girl, and I meant it as a compliment. This fresh-faced, confident woman in jeans and a T-shirt never really had to try; she just exuded a relaxed and comfortable style. I knew about confident women because I had grown up around three of them. We were living in post-9/11 New York and pre-2008 economic collapse. There was a type of excess that was both exciting and superficial, a *Sex and the City*–type phenomena. The Meatpacking District had just landed as the next "It" neighborhood. That's where the clubs were — APT and Bungalow 8. The West Village was the trendy place to live, the Chelsea gallery district and art world had yet to become the huge money-making industry it currently is, and Fashion Week in Bryant Park still felt aspirational. Being true and real — not trying hard — was refreshing.

Our friendship grew outside of the office long before we had any business plans in mind. I left Pierce Allen after a year. I liked

Spanish Colonial-style angel. Oil on metal. Ariel's house, Martha's Vineyard.

39

what I did, but I felt guilty about having just finished my graduate studies and not using the investment I had made to its full potential. I was spending days choosing door hardware or designing a bathroom tile layout (which I have now come to understand the importance of). And so I went to work at Skidmore, Owings & Merrill (SOM), the world-renowned American architecture firm, whose most famous buildings include Lever House in New York City and a personal favorite, the Beinecke Rare Book and Manuscript Library at Yale University.

For the next four years I worked on projects in the Middle East, including the Four Seasons Hotel and the Arcapita Bank Headquarters in Bahrain. One thing I will always be grateful for during my years at SOM was the experience I received (the firm is great at seeing what you excel at and giving you the opportunity to apply and hone those skills). By the end of my time there, I was a design team leader responsible for the agenda, delegating team roles and overseeing design deliverable schedules — key skills to sharpen for a future business owner. But most importantly I am thankful to SOM for instilling the entrepreneurial bug in me. Did I want a career at a corporate architecture office? Or at any architecture office, for that matter? Was I happy with the scale of projects I was working on? Did I care more about designing a curtain wall than looking for door hardware? I missed the scale and intimacy of the residential project. I missed the fast-paced gratification of it. I missed the clear connection to interior design and decoration. But I was an architect. No self-respecting architect could be dealing with fabrics and curtains.

In another part of town, my friend Ariel had reached her threshold of growth at Pierce Allen and the entrepreneurial bug had also grabbed her. She had grown confident in her taste and skills; she had seen how a boutique interior and architectural office ran, with its clear partner role assignment and team structure. She was also asking herself what kind of life she wanted to build for herself. It turns out that we had much more in common than we originally thought.

Ariel and I are one year apart in age. Ariel was born on the thirtieth day of January. My mother was born on the same day. This fact we discovered very soon after becoming friends.

Ariel grew up in a tight household of five. She was the oldest of two sisters and one kid brother. My family and I were also a close party of five. I am the youngest of three; I have two older sisters. Her household was strongly controlled by the women living with Tom and Tolya, Ariel's father and younger brother. My household was also strongly led by the women, leaving my dad, Rene, usually working to make my mom and sisters happy and me being bossed around by the "Holy Trinity."

Ariel was married on the twenty-seventh of December. My parents were married on the twenty-seventh of December. In our years of friendship, my parents' wedding anniversary was only mentioned and discussed the day Ariel told me the date of her wedding.

Before Ariel's daughter, my goddaughter, was born, Ariel told me that she wanted to name her daughter Agnes Clara. She chose this special name to honor her maternal grandmother and because it is also the name of her favorite artist, Agnes Martin. In our years of friendship, I did not recall mentioning to Ariel that several of my female relatives are named Ines, which is the Spanish equivalent to Agnes — my grandmother, my older sister, and three of my nieces.

I would not describe Ariel and me necessarily as spiritual or new age, but it's funny, these weird coincidences keep coming up in our daily lives. Last week Ariel sent me a report she wrote on Caracas, my hometown, at age ten. Our main connection, that aforementioned entrepreneurial bug, was instilled in both of us respectively by our fathers, Tom and Rene.

Tom and Rene are around a decade apart, Tom being younger than my dad. But they are more or less from the same generation. Growing up in a strong hippie youth culture — the age of

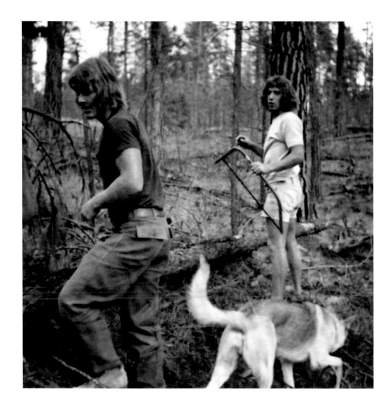

"When I think of home, I think of New Mexico and Georgia O'Keeffe.
She was rigorously committed to living in the service of one's
truest self. She came to this foreign place and made it her own by
taking inspiration from all the emptiness and austerity to find
in that simplicity an incredible amount of beauty and power and
permission to express herself." —*Ariel Ashe*

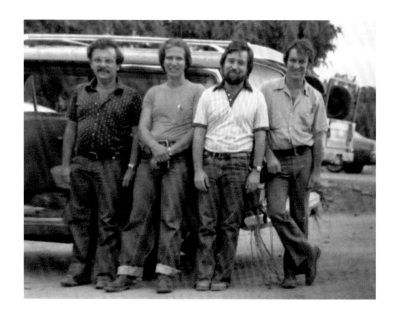

peace and love in reaction to conservatism and the Vietnam War — they both like to use words like *buddy*.

Tom Ashe grew up in Queens and eventually moved to New Mexico, where he married Joanne, and Ariel was born and raised there. It was in Placitas, forty minutes from Santa Fe, where Tom started his business as a property developer, mostly building houses. His first endeavor was the Placitas Door Company — and he quickly moved into home construction in partnership with his best friend. All the residences were imagined and designed by Tom himself in the Santa Fe style as adobe homes with vigas and terra-cotta details. Later the friend moved on, but Tom managed to expand his construction business far beyond what he had envisioned. He played an important role in shaping the town of Placitas itself.

Rene Leandro grew up in the capital of Venezuela, Caracas. He and his wife, my mom, Marina, moved to Houston after they got married. That's where Rene studied industrial engineering. My parents moved back to Caracas where I was born and raised. There, Rene started his own construction business, along with his brother and best friend, building infrastructure for oil companies (roads, housing, and so forth) and later expanding his business as a property developer mainly in Caracas, building office and residential towers.

Not only was the business drive in our blood — to build something for ourselves, something that is ours — but within that blood was the design and construction aspect of it. Both Ariel and I lived in households where we did not have to look hard to find a hard hat to play with or construction plans with the scent of their blue ink, and visiting construction sites was commonplace. Most relevant, we were raised in cities with surprisingly similar architectural histories.

From the sixteenth century onward, New Mexico, including its capital, Santa Fe, was a province of the Viceroyalty of New Spain. With Mexico's independence in 1821, New Mexico would become part of its territory, but that would only last until 1848 when the United States annexed New Mexico. This is obviously

an extremely simplified history, but what is important is the architectural style Ariel grew up with. The Spanish Colonial architecture in New Mexico was mostly imported by Spanish missionaries and differed from rich provinces like Mexico, the center of New Spain. The colonial New Mexican architecture was much more simplified in construction. It responded to the economic status of the region in relationship to Spain and the demands of its environment. The style also took advantage of extant Native American construction techniques and materials. That is to say that a new style was developed, sometimes adorned by ornamentation imported from Spain. Nevertheless, Spanish Colonial architecture does lie at the heart of what is considered Santa Fe style, or Pueblo Revival architecture. This style, of course, is very different from the architecture I grew up with, but it has the same roots — and employs many of the same materials.

Farther south, during the sixteenth century, Venezuela also formed part of the Viceroyalty of New Spain. Later it would be subsumed by the Viceroyalty of New Granada and then by the Captaincy General of Venezuela — all under the rule of Spain. Venezuela would not become independent until 1811, with Caracas as its capital. Among the many influences the Spanish left behind was Spanish Colonial architecture, again not as rich as other more economically important provinces to Spain but a much more developed footprint than other provinces like New Mexico. Of course, the Spanish Colonial architecture was also adapted to what the region demanded in its state of Captaincy and not Viceroyalty, much less ornamentation, and due to its tropical climate, most notably the use of central patios for ventilation and cooling.

The architecture Ariel and I blossomed in had the same roots and has thus become part of Ashe Leandro's DNA: deep thresholds, arches, adobe bricks, terra-cotta floors, wood beams (vigas), stucco walls, and the earthiness and honesty of these materials.

By the twentieth century Santa Fe started to attract a slew of visual artists and writers not only because of its rich cultural

Georgia O'Keeffe's home in Abiquiu, New Mexico, one of Ariel's greatest influences.

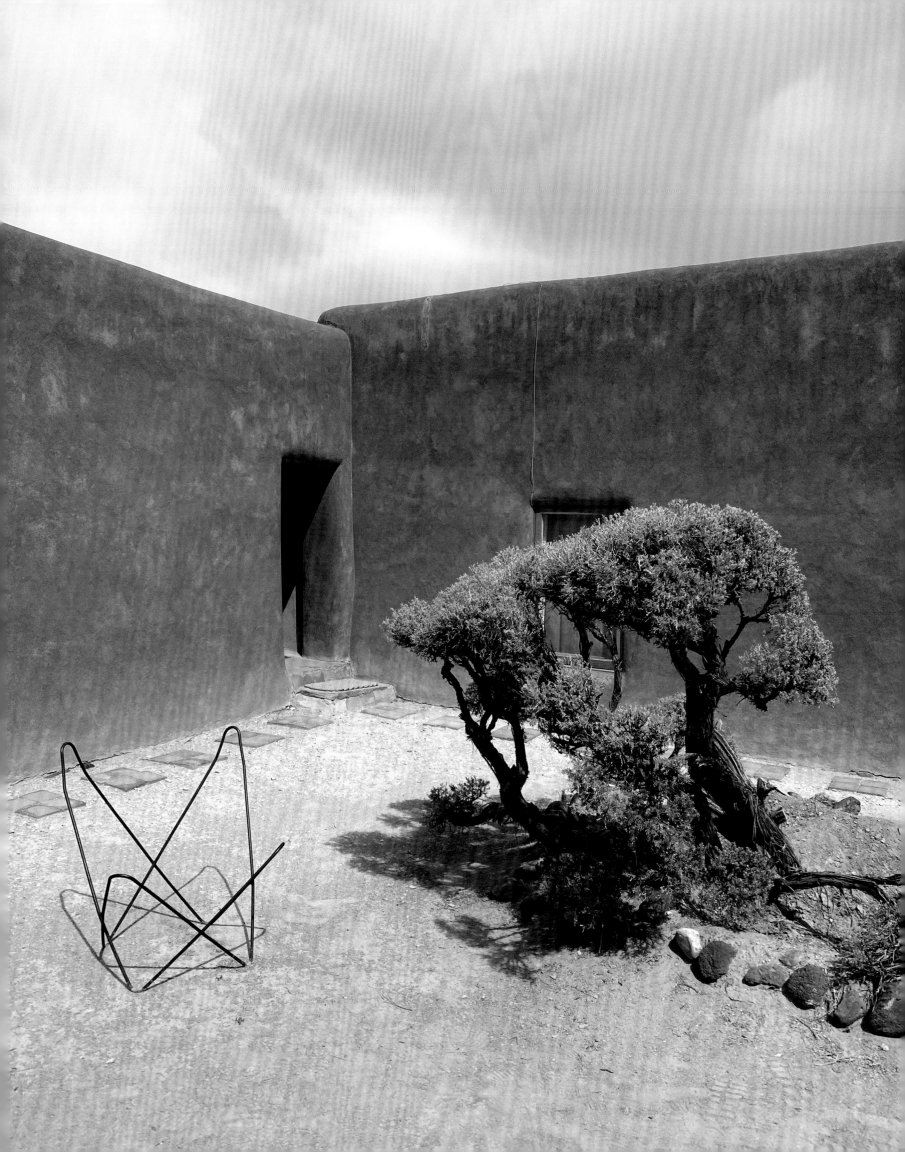

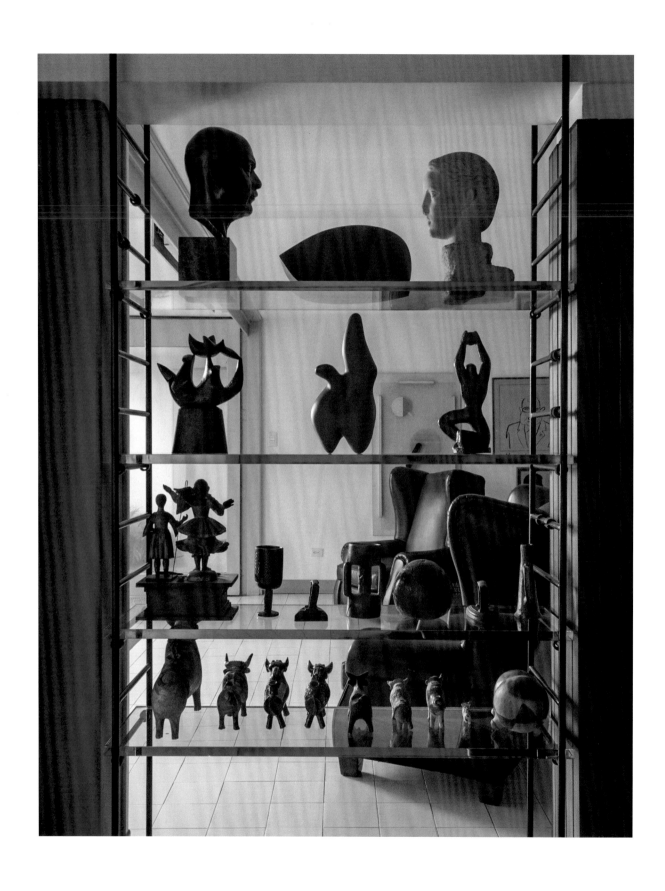

Carlos Raúl Villanueva's home in Caracas.
He is the architect of La Universidad Central de
Venezuela, one of Rei's greatest influences.

heritage but its dry climate and beautiful landscapes. Artist Georgia O'Keeffe moved there in 1943 and stayed until her death. She has always been one of Ariel's icons and a visit to her home and studio in Abiquiu are a required pilgrimage when Ariel goes home.

In the 1990s Ariel and her family started splitting their time between New Mexico and Martha's Vineyard, in Massachusetts, a place that would also feed and expand her creative knowledge. Absorbing New England's coastal architecture would broaden her Americana style. In 1998 she moved to New York to start college.

In the twentieth century, Venezuela had a boom of its own — the discovery of oil, which started in the 1930s and lasted well into the 1980s, making Caracas a central geographic hub and a culturally diverse, wealthy city. Venezuelan architect Carlos Raúl Villanueva, who had studied architecture in Paris in the 1920s and was strongly influenced by his mentor Le Corbusier, brought modernist architecture to the country. Just like Spanish Colonial architecture, modern architecture needed to be adapted to the rigorous tropical climate to become what today is known as Tropical Modernism, which synthesizes the radical ideals of modernism with the more traditional solutions to local conditions of climate and light. In 1997 I started my bachelor's degree in architecture at La Ciudad Universitaria (Central University of Venezuela), today a UNESCO World Heritage Site designed by Villanueva, and along with Brasília, the planned city and capital of Brazil, the only built example of a "modern city." Here, Villanueva envisioned a space where fine art and architecture came together. This has been one of the biggest influences on my work. On any given day walking across the campus, you could admire a Jean Arp sculpture or a Fernand Léger mural, drink coffee among the sculptures of my favorite Venezuelan artist, Jesús Rafael Soto, and receive a diploma under a sea of Calder clouds, the artist having been one of Villanueva's best friends.

Of course, not everything that Ariel and I have in common or that has fed our creativity is so academic. We are also lucky enough to be children of the 1980s and 1990s, products of the

baby boomers who through hard work provided us both with healthy and privileged upbringings. We are both fortunate to have been born as the last of the Gen X generation, which, in our experience, finds it easy to communicate with our hiring pool, millennials, and a generation that still enjoyed life before major advances in computers and telecommunications. Ariel and I don't remember having smartphones until late in college (we had flip phones), or using email or the Internet (instead, we turned to the World Wide Web and encyclopedias). We do remember AIM and our Blackberries. AutoCAD would come almost at the end of our college years. Social media as it is today did not exist. I listened to Madonna and Latin pop (pre-English-speaking Shakira). Ariel listened to country music and the Counting Crows. I have grown to like Garth Brooks; my music has yet to make a strong impression on Ariel. We come together at Everything but the Girl, 10,000 Maniacs, and the Cranberries. In movies and television we fare better: *Reality Bites*, *Singles*, *The Age of Innocence*, *Before Sunrise*, *All About My Mother*, *The English Patient*, *Madonna: Truth or Dare* (actually that is only me), Gap commercials, *Felicity*, *Daria*, *Sex and the City*, and *My So-Called Life* are all favorites.

For those wondering where the spanish-speaking programming is, there was none. Venezuela has never had a prominent movie industry. And although Venezuelan telenovelas have had a big impact on my life, they are more of an influence in my personal life than my professional one.

II. ASHE LEANDRO

We never really had a long conversation about starting a business or a meeting to draw up a financial plan or structure. At least I don't remember it. You would think that launching Ashe Leandro would have been scary for us. True to both our styles, the beginning was very instinctual and casual.

The informal inception of Ashe Leandro dates to 2005, a year into my position at SOM. Ariel and I independently started

Pueblo Revival-style building detail, Santa Fe, New Mexico.

"Since we started Ashe Leandro fifteen years ago, we've always sought to build a body of work that fully represents who we are. To have that documented is really important for both of us." —*Reinaldo Leandro*

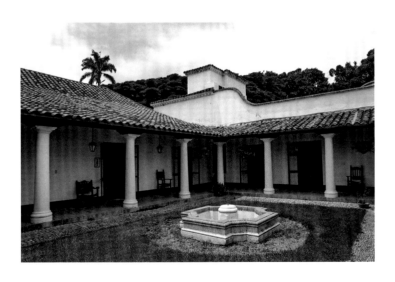

Hacienda La Vega, interior courtyard. Spanish Colonial architecture in Caracas, Venezuela.

helping friends out, and we would ask each other for assistance in drawing up plans or drafting agreements.

I was pushing for our name to be R_ASHE, with a tagline, *It's Spreading: R_ASHE*. Thankfully, Ariel thought this was horrible. We landed at Ashe Leandro (A L).

It would not be until 2008 that we both quit our jobs to officially open the firm. The economic recession had not yet hit. I assume the transition would have been different if it had. Our previous firms enacted major layoffs. We wondered if we would have been let go, too — and if we had given up any chance of economic stability. Fortunately, we had a hotel project in Caracas, an art gallery space in SoHo, and the decoration of actress Jennifer Carpenter's home in Los Angeles, which was published in *O at Home*. We timed our big launch with the article in the last issue of *O at Home* going on newsstands and the *Pin-Up Magazine*, Issue 3, "ones to watch" list.

We never talked about what would happen if A L did not work out. Being friends is very different from being partners. Occupying an office with twenty to 250 employees is very different from working with one other person day to day. It's an intense social dynamic. As in a lover's relationship, in a business relationship sometimes the love and respect for the other person, even with the best of intentions, is not enough. We have seen so many people try and fail no matter how talented each of them is. So, what makes Ariel and me so special?

In a business it is helpful to be able to turn to another person. In this business it is healthy to have someone there to critique, edit, or encourage decisions. Another set of eyes is grounding. You can't really do whatever you want because another person is counting on you, especially when you are young. Academia, particularly architecture school, encourages working in teams. That background proved helpful to us. Our families' common structures also helped. I was not only ready, but I wanted to have an alpha-female partner. I grew up among them.

More things have worked out in our favor than not. For starters, our backgrounds provided a solid DNA. And Pierce

Allen was a great model for us to use to reinvent ourselves. Ariel would lead the interior decoration, and I would lead the interior and architectural design. These clearly defined roles delineated our responsibilities, making us accountable. That is not to say we don't cross the boundaries in our work often, but it helps that each one knows what they oversee.

Ariel and I also complement each other very well. I wish our roles were confined to design, but a business takes a lot more than the skills you know and enjoy. We rely and lean on each other's different strengths. I thrive on project management and problem-solving. Ariel is a savvy and careful business manager. I'm good with creative computer programs and Ariel at negotiating contracts. I am good at dealing with contractors and office dynamics, whereas Ariel has impeccable networking skills.

Have we remained as good of friends as when we met in 2004? Yes. We still care about each other's happiness and well-being. We obviously hang out less after work hours since we now see more of each other than we do our spouses. But, above all, we respect, value, and admire each other. Without those qualities, I don't think that any partnership—let alone a friendship—could survive all these years.

So, in 2008, with the best of intentions, we embarked on the A L journey. While the American economy collapsed, an aggressive recession hit Venezuela as well, brought on by the unstable political situation. Family friends from home who wanted to take some money out of the country saw an opportunity to buy properties in New York City—pieds-à-terre as investments—and they hired us to renovate them. These small projects were great ways to acquire experience as we learned the ropes of working in New York: alteration or decoration agreements, board approvals, filing with the Department of Buildings or the Landmarks Preservation Commission, not such fun things that over time have only become more complicated. These jobs also provided us with steady work for the first two years or so.

For the first three years it was pretty much Ariel and me. We designed our logo, I took the photographs of completed projects,

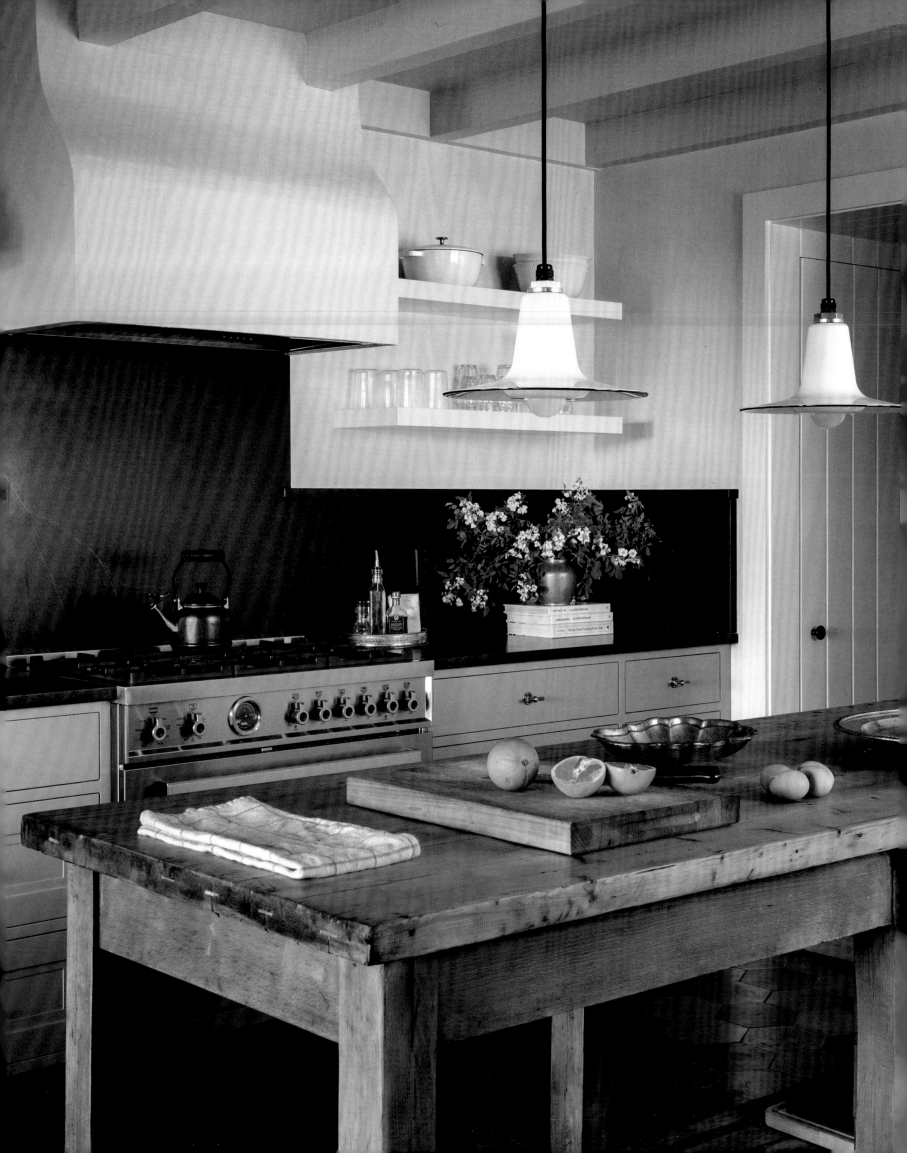

and Ariel created the website and uploaded the photos. We had a Tumblr account that we loved and took turns posting on. Getting picked up by design blogs was always exciting. We hustled and did not turn down work. We usually had eight to ten jobs running, ranging from a simple bathroom rehab to a gut renovation or helping update the furniture in the living room of a friend of a friend.

One thing was clear, though: without realizing it we started to fill a void in the design world. Most of the clients were people our age, young couples who had just bought their first apartments or had just moved in together and needed small architectural upgrades and/or decorating help — something that was fresh, yet comfortable, and not overly designed or fussy. These initial clients were looking for designers who understood their lifestyle; they were not necessarily bringing the most challenging projects to us, but these clients would grow up with us. They would remain clients when they married and had kids and turn to us again when they needed to expand to new and bigger spaces or when they purchased summer houses upstate or on Long Island.

Ariel's home in Martha's Vineyard, with plastered walls, a plastered kitchen hood, and rough-sawn painted beams, reminiscent of New Mexico's Pueblo Revival architecture.

We brought on our first employee when we got our first ground-up commission on Martha's Vineyard. After that first hire, we fluctuated from one to two employees. With the twenty-first century coming, the game kept changing. The arrival of Pinterest and Instagram opened design to the masses: people became more design educated and savvy. However, trends would easily look dated. From early on we decided that our Instagram would mostly be devoted to A L projects and would take precedence over our website. Luckily, by the time Instagram became important for businesses we had recorded in pictures a lot of our work and so had a good archive.

In 2016 the publication of actress Naomi Watts's home in *Architectural Digest* was a turning point for us. We had been in the pages of *AD* before with Seth Meyers's greenrooms for his new show, *Late Night with Seth Meyers*. For Naomi Watts we employed a lot of those features that we had grown up with: terracotta tiles and rounded archways that demarked entryways or

framed views, and the images of that story became a success in social media.

In 2017, almost a decade after we started, we made the *AD100* list and the *Elle Decor* A-list. We never get used to seeing ourselves there. It is always incredibly humbling and exciting to be included among so many talented people we admire. It also makes us want to do better work.

Today we have a practice of fifteen people — big enough to take on the work we want but small enough that Ariel and I can be involved in all the projects and do what we enjoy best: design.

In 2018, we launched Ruemmler, along with designer friend Mia Todd and another friend, Max Polsky. Mia Todd was our first intern and later became a lead designer. Ruemmler came about as a collaboration between friends with a passion for design. It evolved into a contemporary furniture line inspired by French and Italian design of the 1930s and 1940s, defined by clean lines, soft curves, and the expression of raw material typical of that design era and true to the A L aesthetic.

Reinaldo's home in New York, with Venezuelan artist Jesús Rafael Soto's sculpture against a mahogany paneled wall, was inspired by twentieth-century Latin American architecture.

III. ETHOS VERSUS STYLE

Ariel and I always feel uncomfortable when we are asked what our style is. Worse, when someone says, "Describe your style in a couple of words." This has always been difficult for us. Why was it so hard? We have been described as "comfortable luxury," and sure, that works, but the designation encompasses little of who we are. We also cringe at the word *eclectic*. We are decidedly not that, even though we like mixing periods or highbrow with low. Everything we do has a clear vision to be executed. Naturally, these visions or styles change because not all projects are the same — after all, clients have varying lifestyles.

When we talk about our style, we prefer to talk about our ethos, which, over time and practice, we have narrowed down to three pillars:

Instinct

We are both very quick. We know instantly what we like.

Our approach is much more about reaction. First, consider the client's desires and needs. Second, respond to the site, bearing in mind its historical or nonhistorical precedents. Third, understand the space or site's constraints and its surrounding environment.

At the end of the day, let go and create an environment that looks and feels good. As designers, trusting our guts and creative instincts is of upmost importance.

Honesty

We are drawn to the tactile and earthy qualities of materials, letting them show wear and age. This is what makes a project ageless — the honest wear of its surfaces.

We feel the same way about fabrics in terms of their tactile and earthy qualities — velvets, wools, linens. We rarely use wallpaper or patterns.

Honesty is always present when it comes to a space if it has details from a historical period or is in a building or neighborhood that calls for a certain acknowledgment of its setting. We want to let those qualities show, enhance them, or bring them back. Decidedly modern spaces should also adhere to the stylistic precepts of the period to which they belong.

Honesty also shapes the designer-client relationship. High-end residential design can be both physically and mentally challenging. Not only are we responsible for delivering flawless homes but also spaces that are true to each client's lifestyle. We must know how to listen to and understand clients, giving them the A L vision but staying true to who they are as individuals or as families.

Humor

This is not humor as in being funny, or whimsical, or creating tongue-in-cheek spaces. In fact, I would not consider Ariel or me necessarily funny or light. We can both be temperamental

and neurotic — and our humor is dark. Humor for us has more to do with setting up a mood. We do this through materials, color, lighting, and even art. Humor provides each space with a clear voice.

It's also crucial to bring humor to the field and into the office environment. We know that what we do is a luxury; this is a serious business where mistakes can be costly, but at the end of the day the most important thing is to keep the work challenging and exciting since that makes it fun. It's not as easy as it sounds — there are deadlines and expectations and financial prospects to be met. Still, we need to enjoy what we do.

IV. CONCLUSION

Ariel and I have made this book to show the projects we have been working on for the past four years. We are so excited about the work and the clients who have grown up with us and the new clients we have now. We have reached a point in our careers where we have a body of work that truly represents who we are as people, as designers, and as a company. The Ashe Leandro ethos and DNA run through every one of our projects.

A BODY OF WORK

.

ASHE LEANDRO

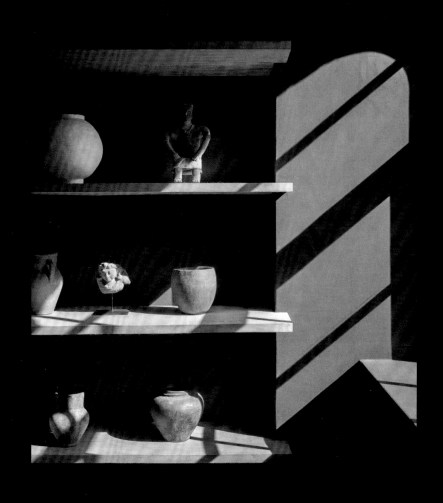

GRAMERCY

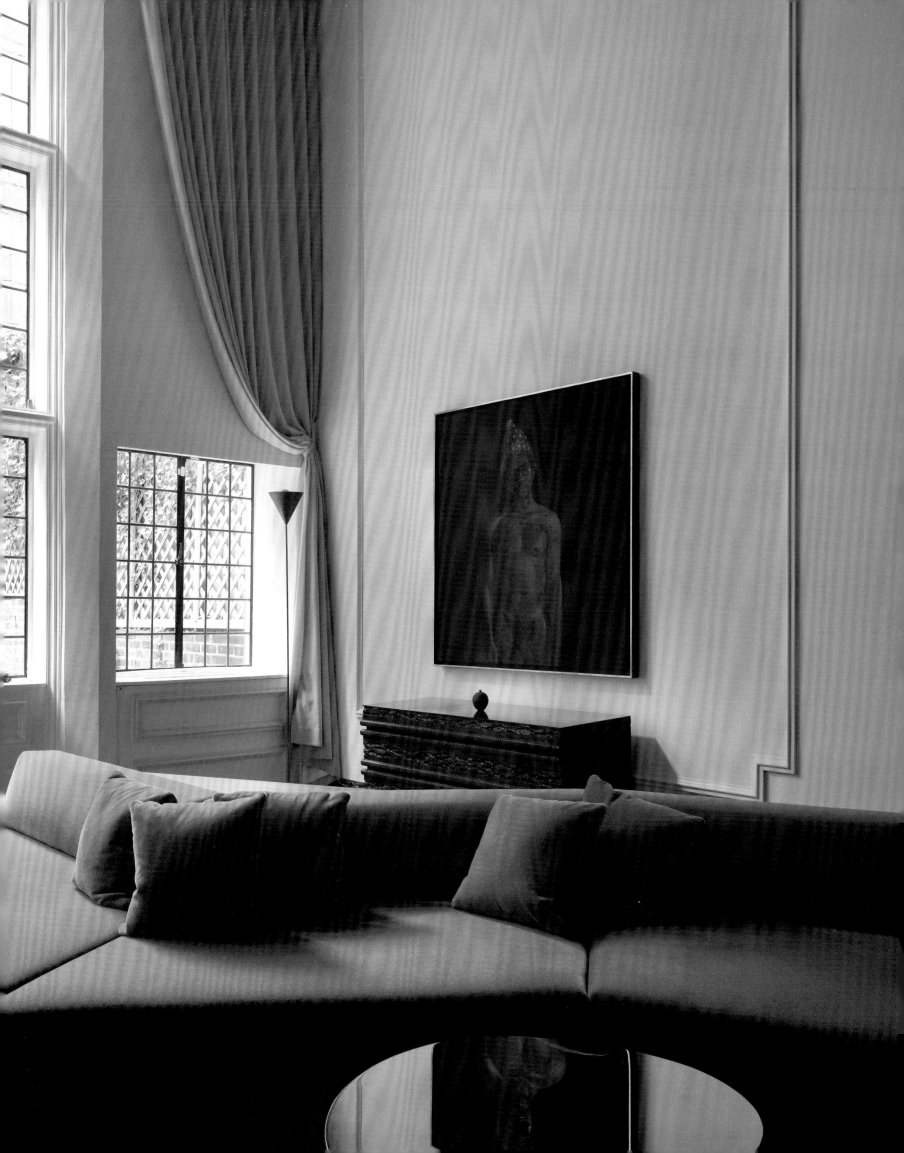

ASHE LEANDRO

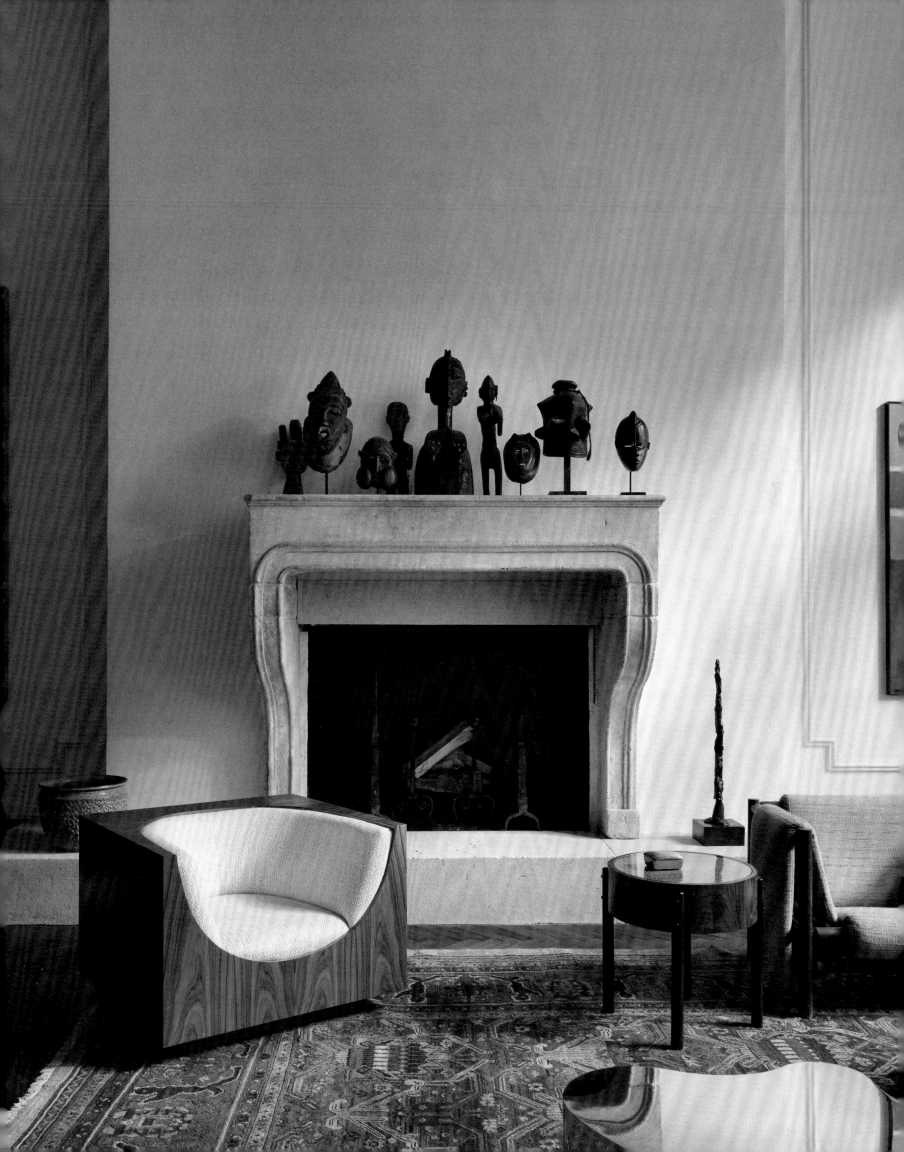

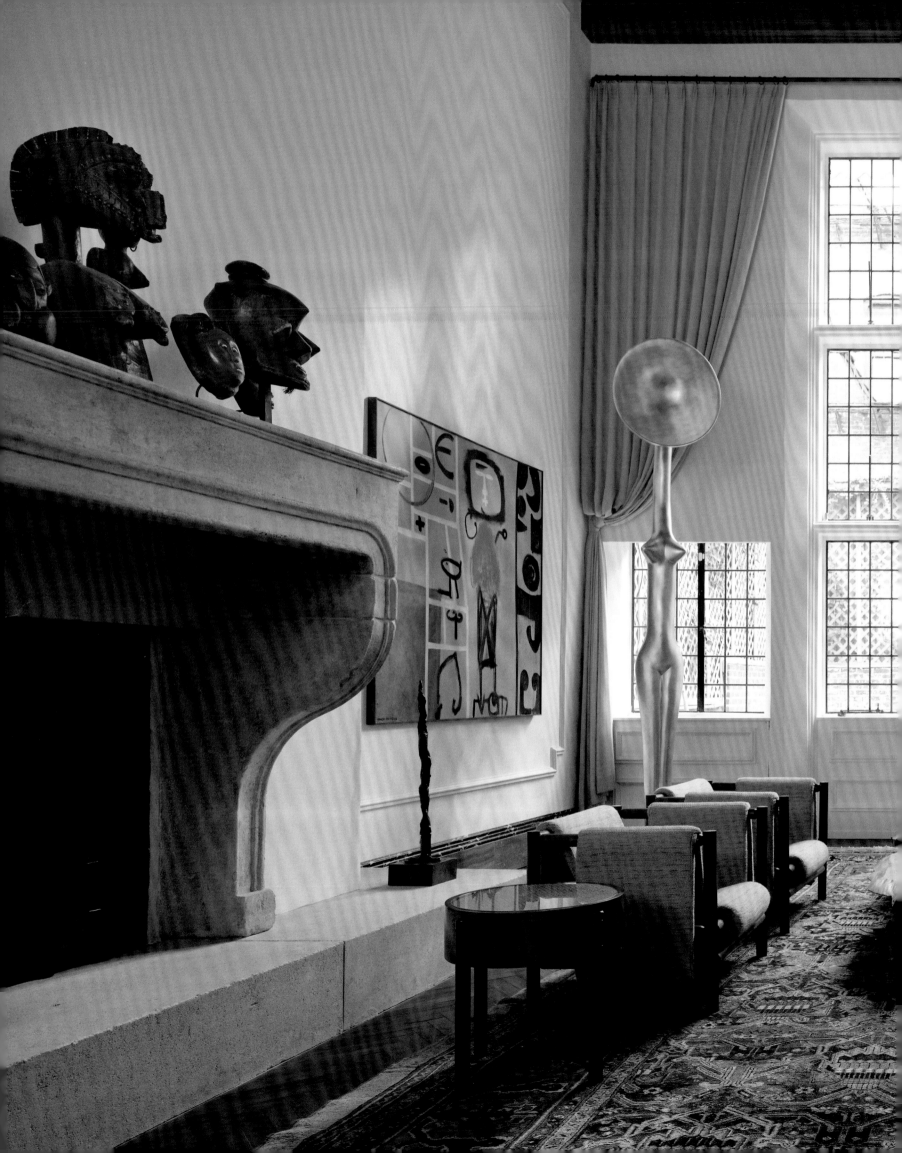

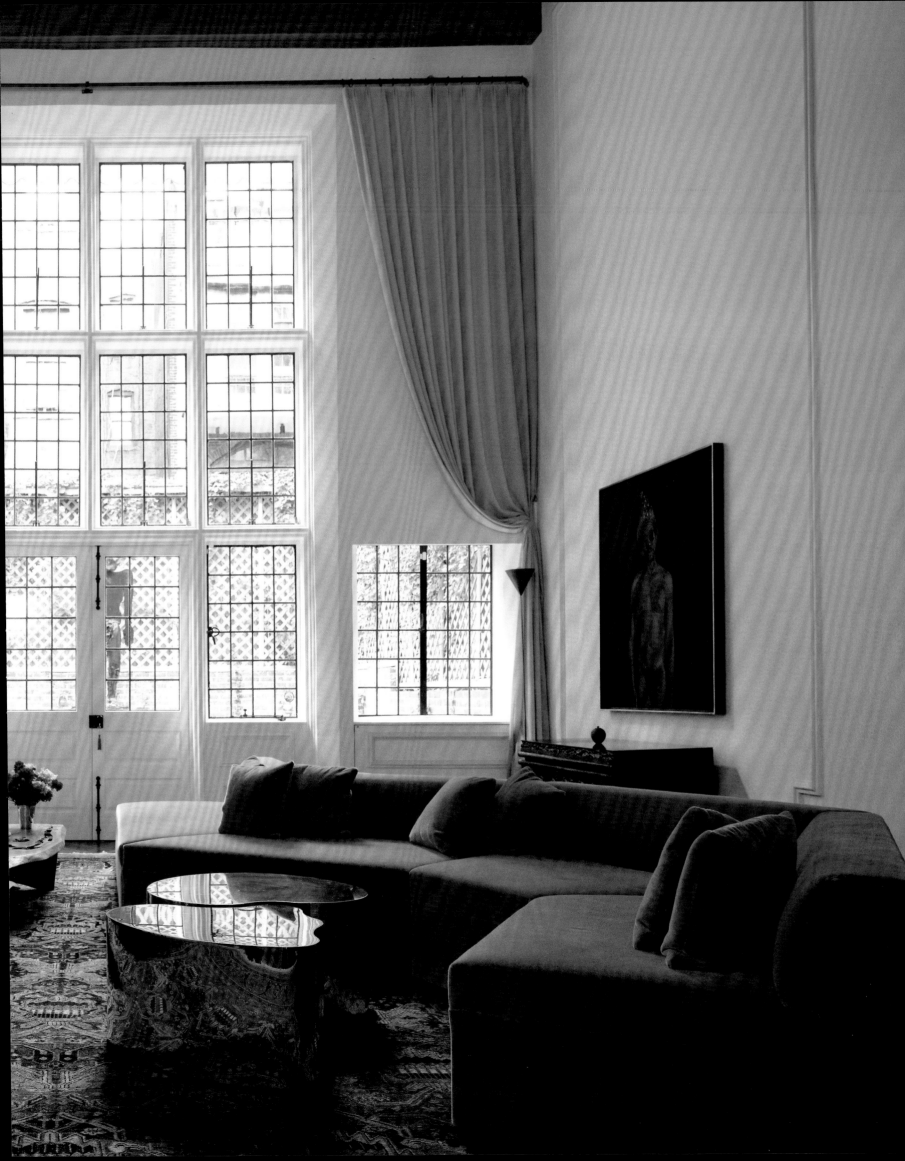

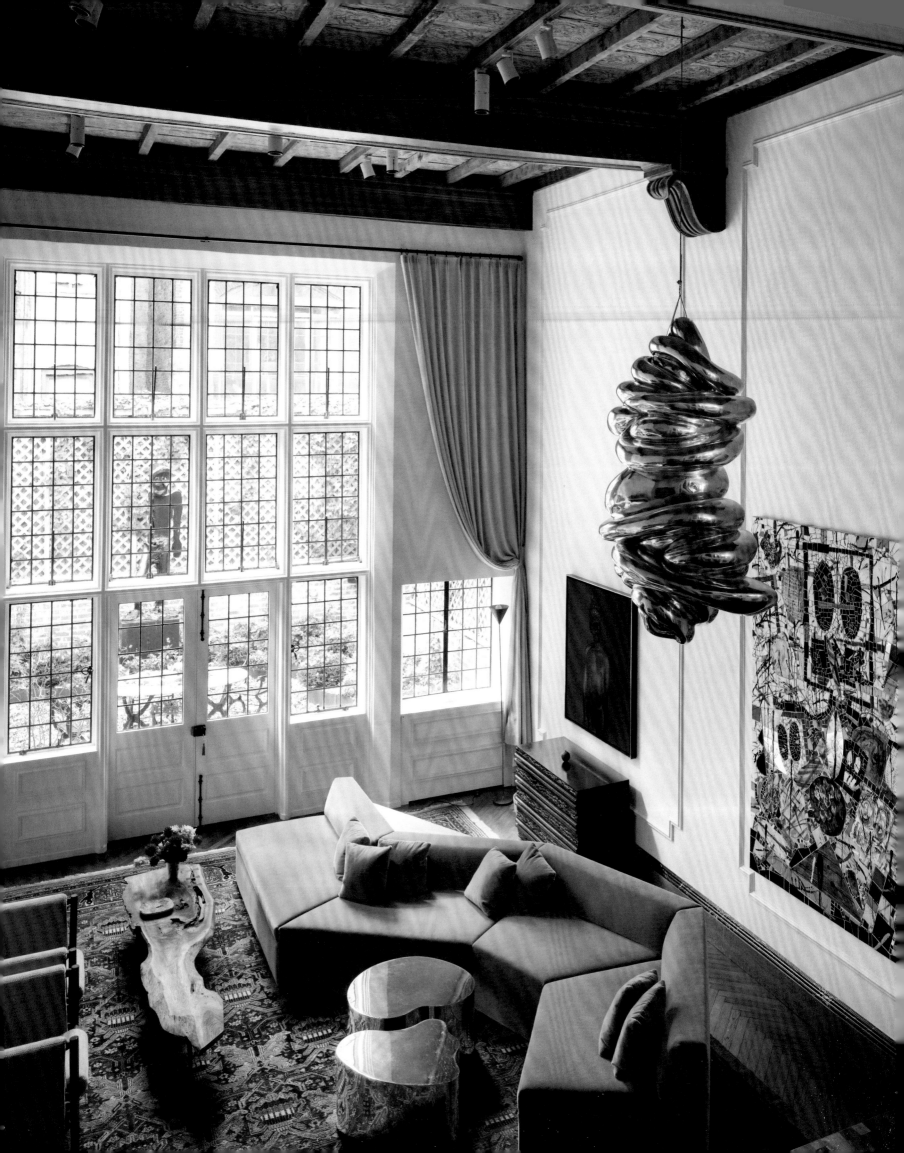

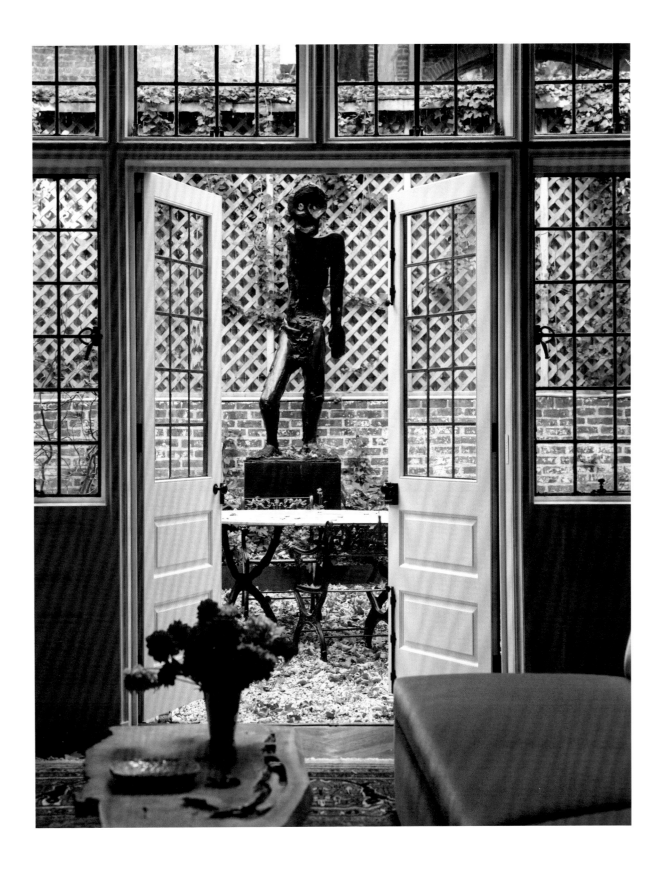

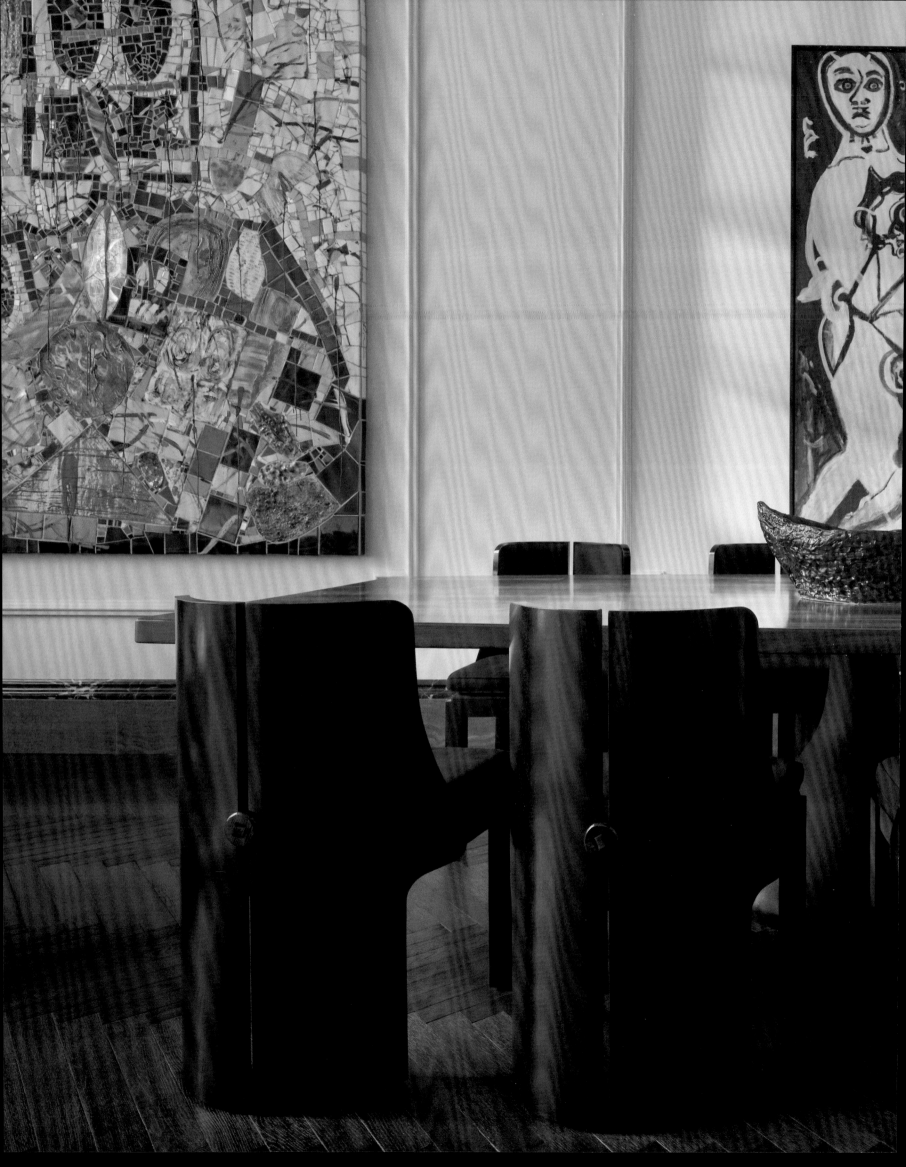

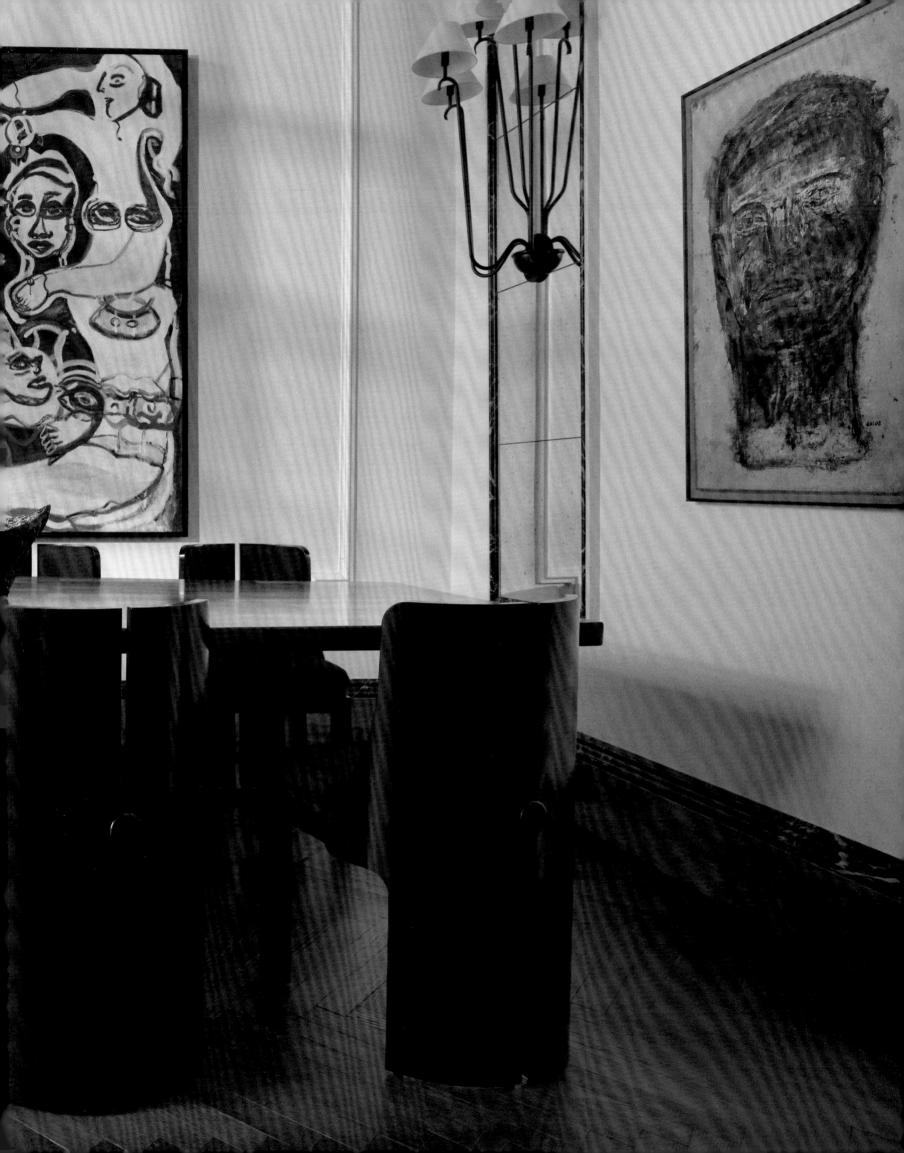

"Ashe Leandro projects deeply resonate with the personalities and personal histories of the individuals who inhabit them; you can feel in an Ashe Leandro space the past, present, and desired future of those who live there."

— RASHID JOHNSON

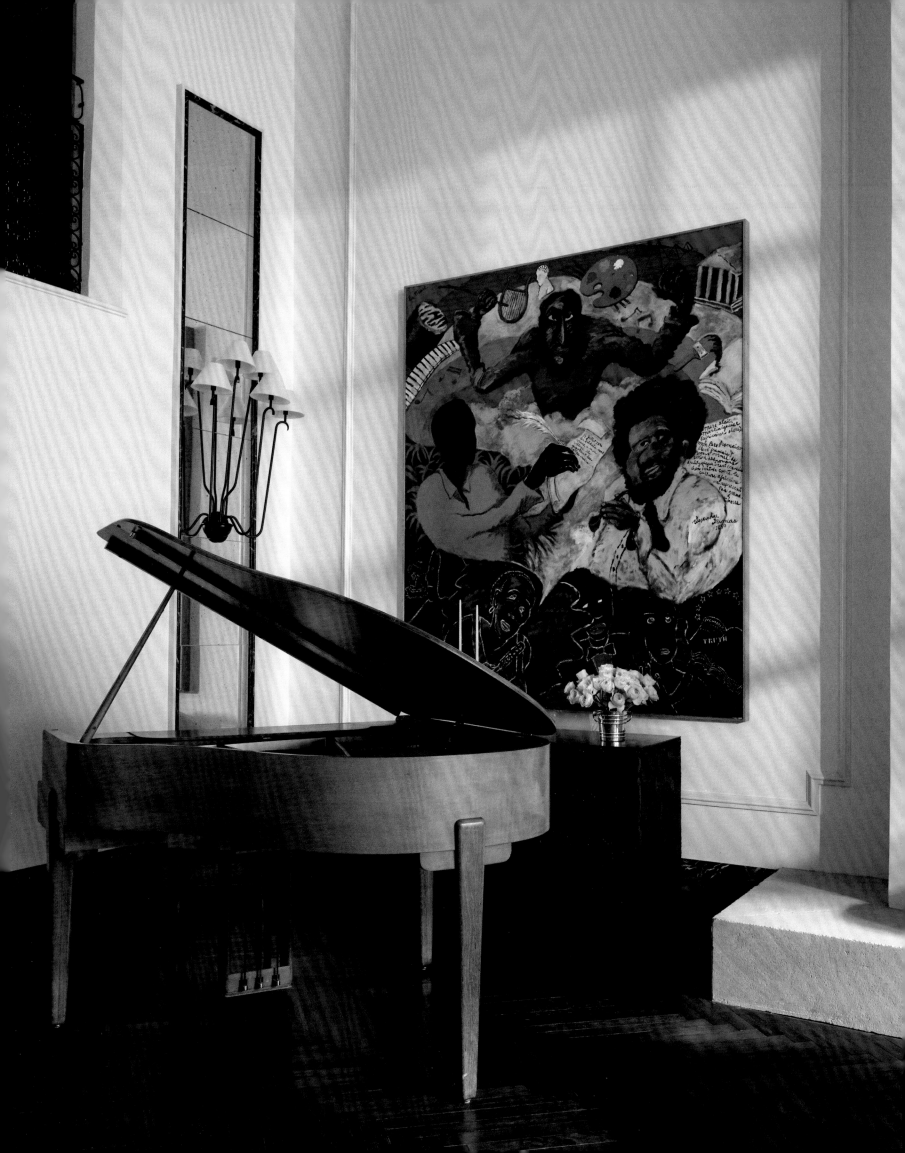

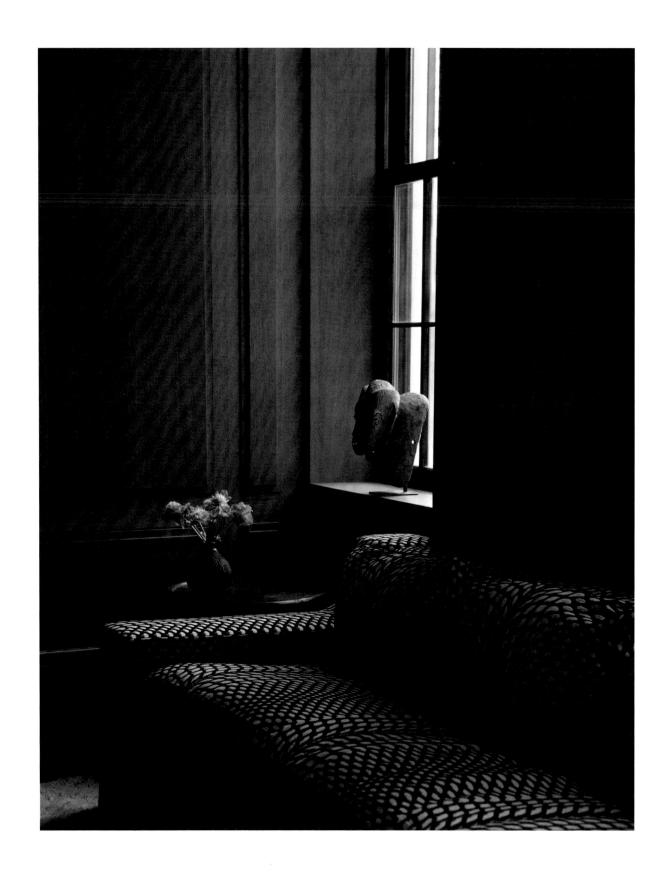

ASHE LEANDRO

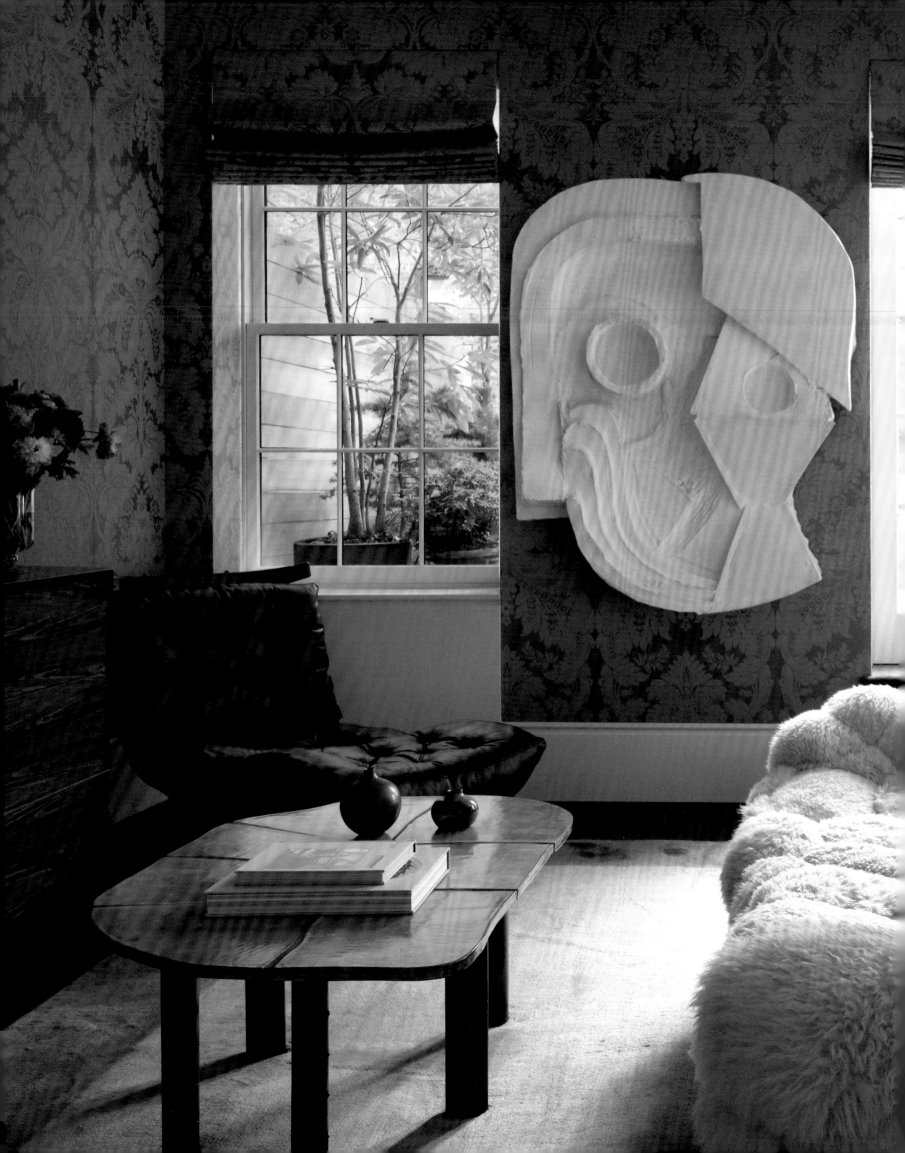

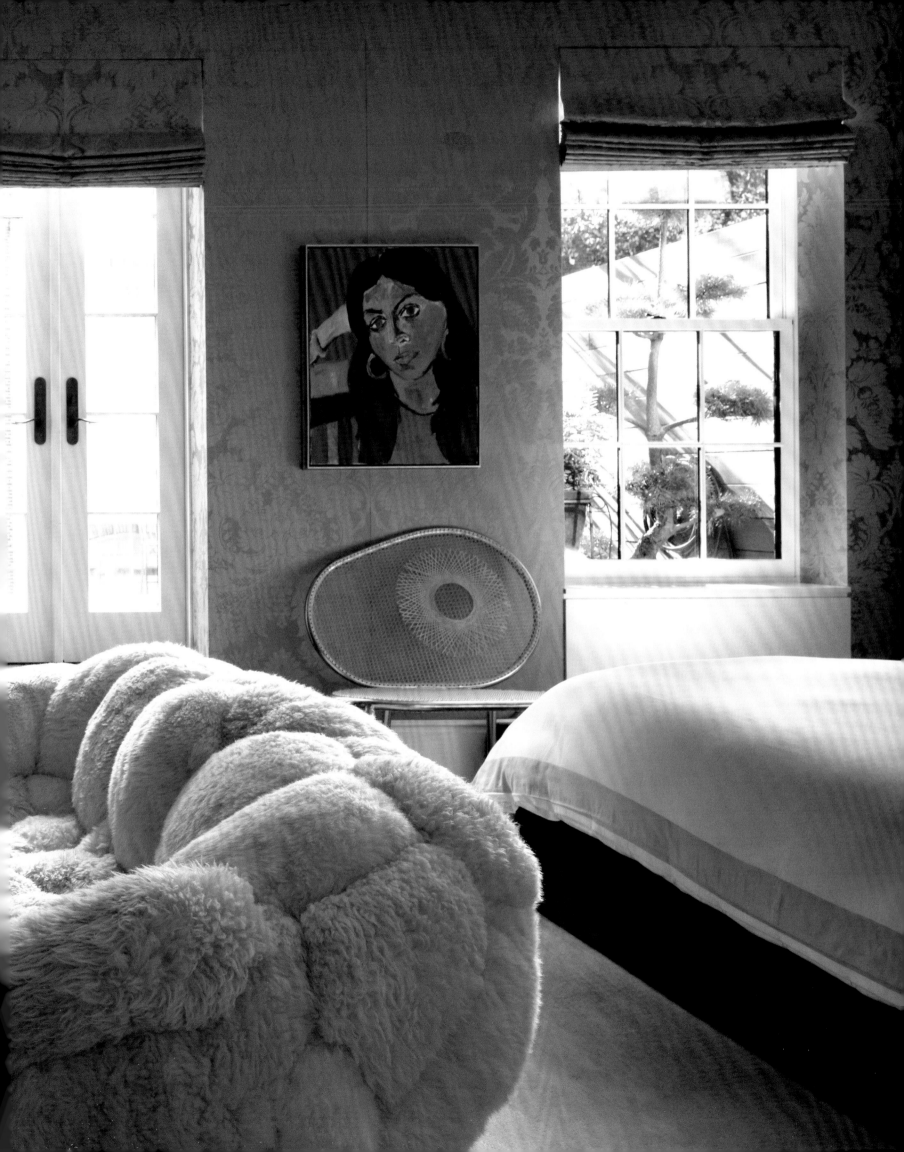

ASHE LEANDRO

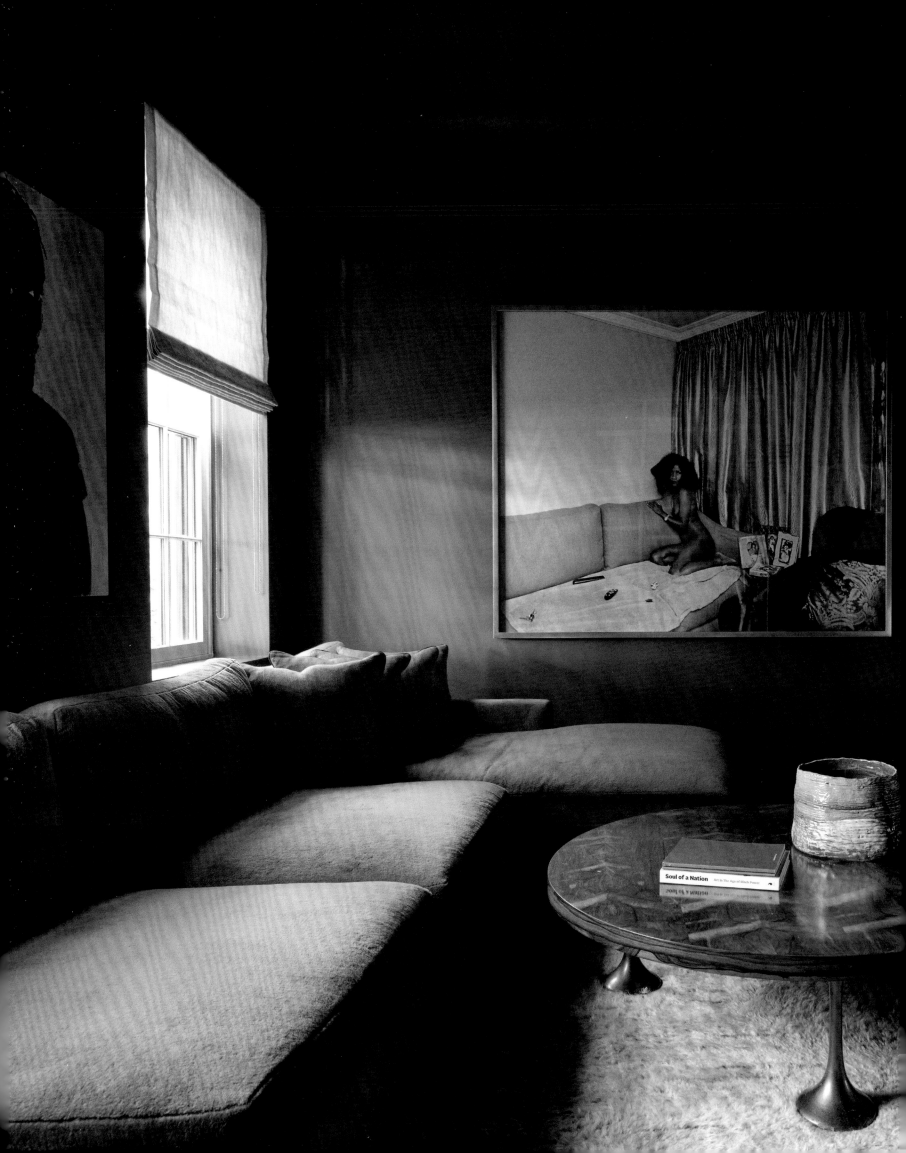

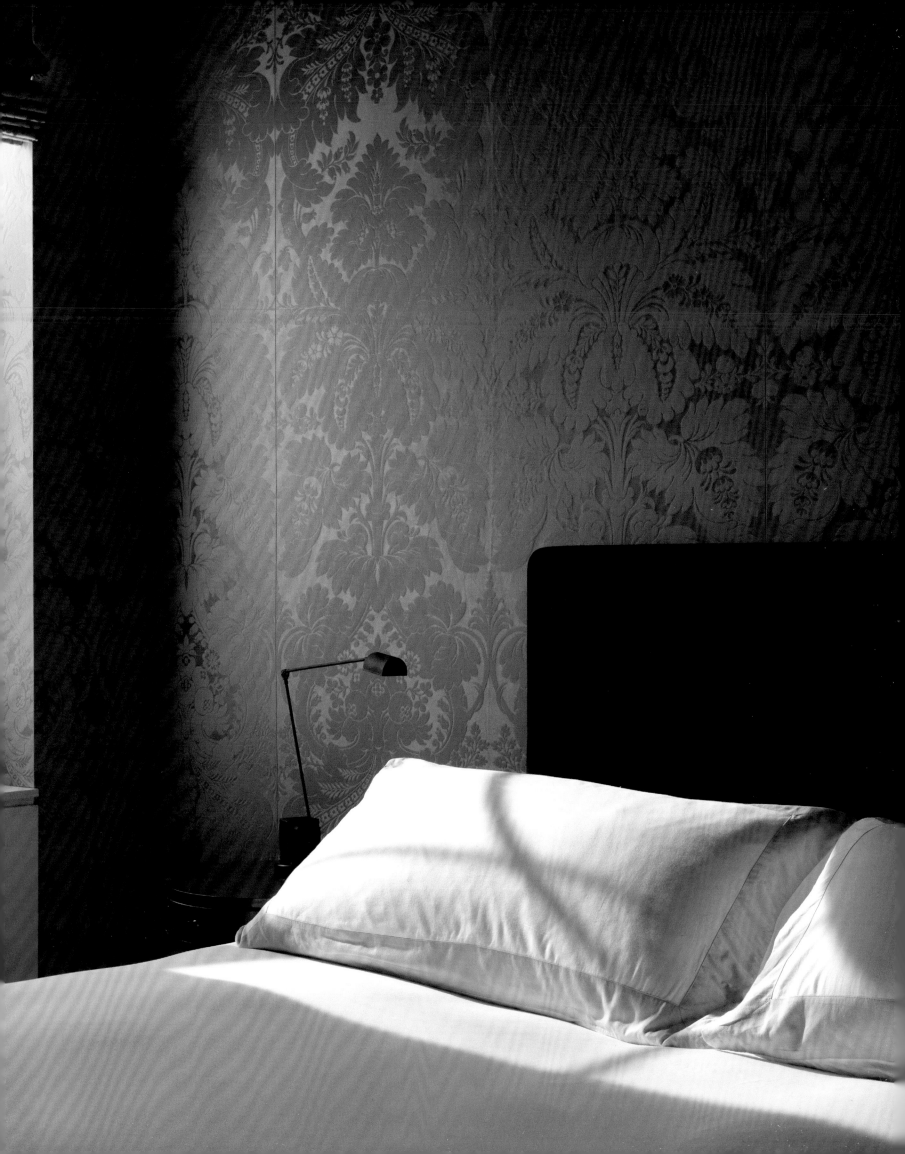

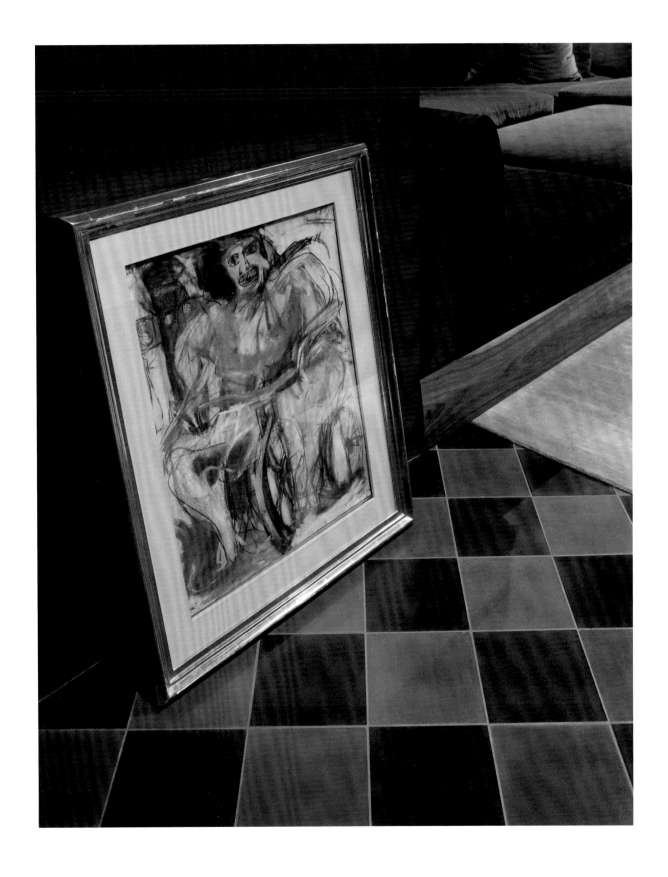

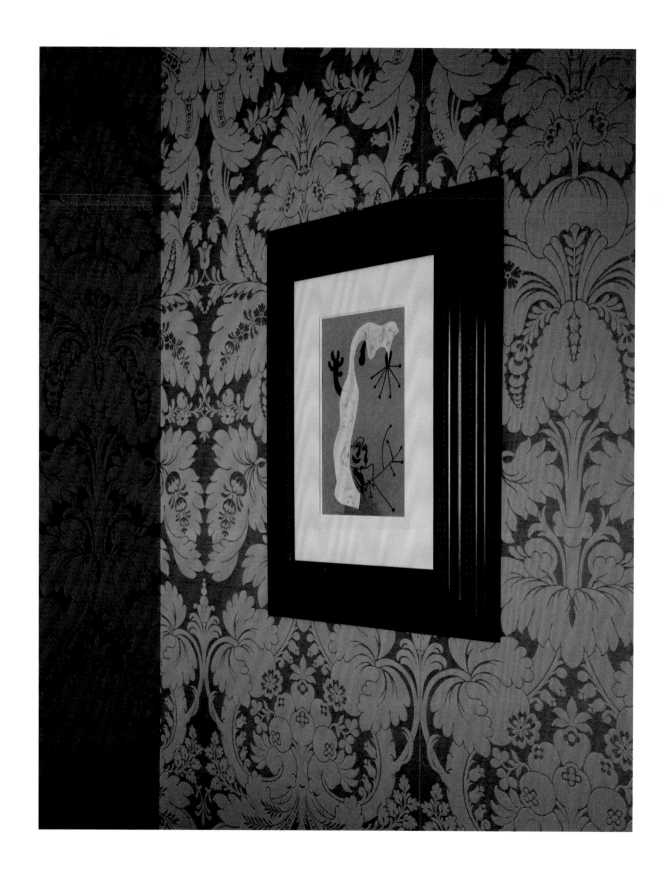

ASHE LEANDRO

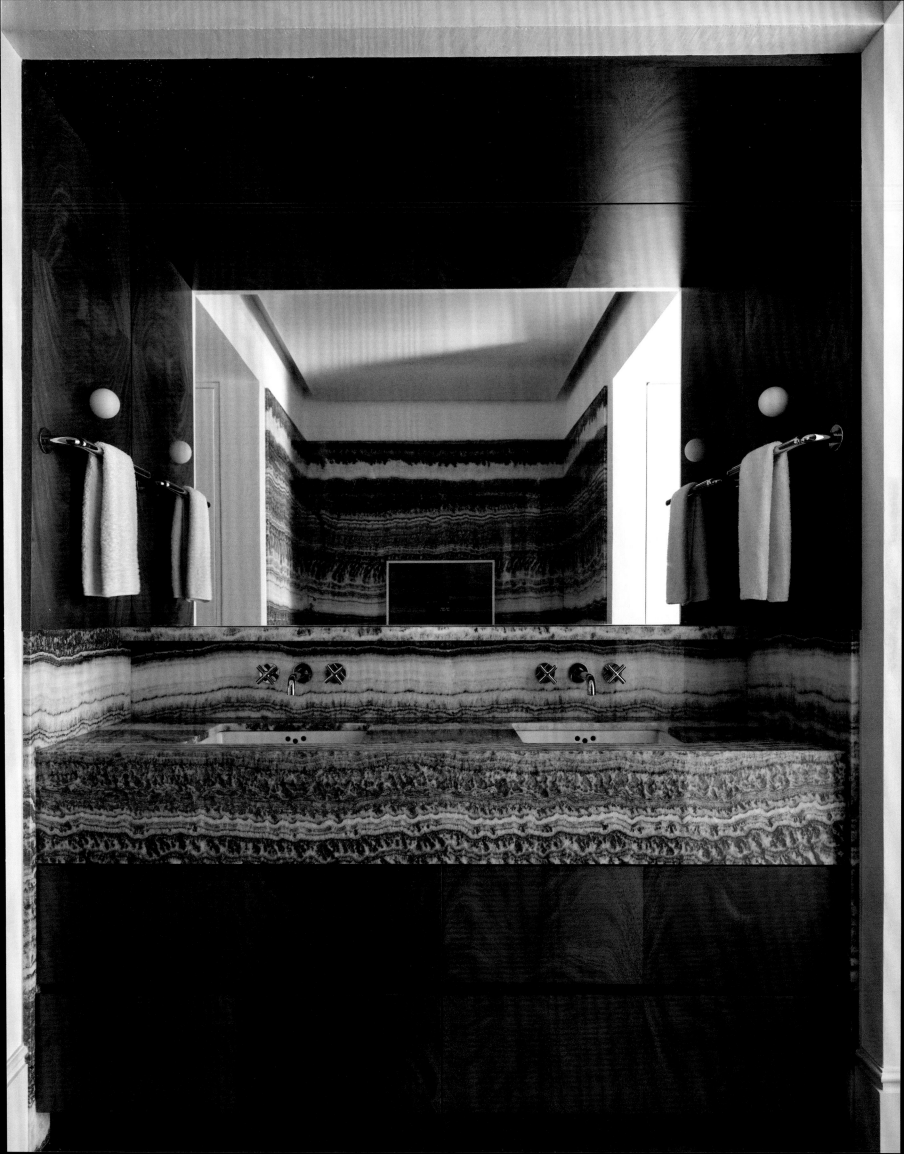

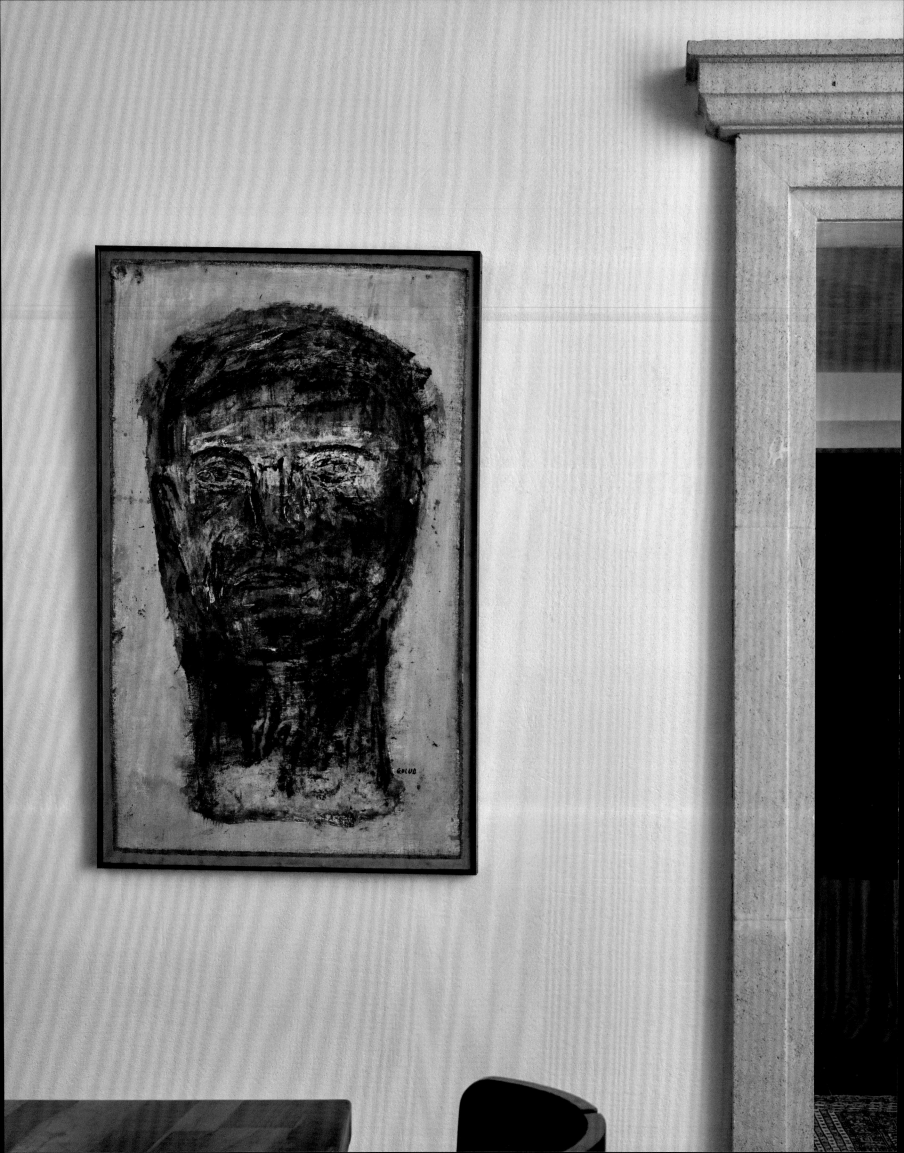

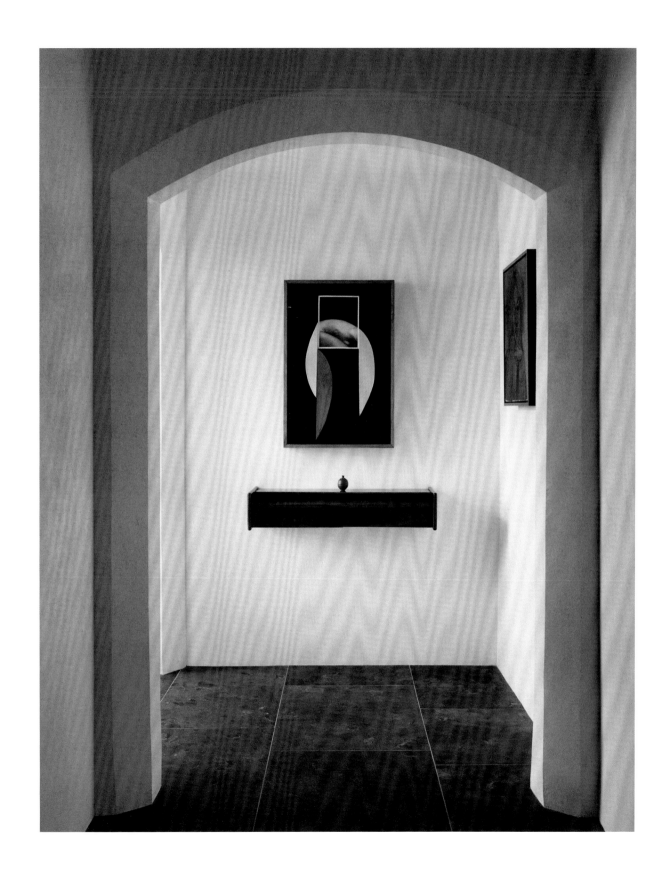

ARCHITECTURAL & INTERIOR DESIGN ASHE LEANDRO
LIGHTING DESIGN ORSMAN DESIGN | PHOTOGRAPHY ADRIAN GAUT

The flamboyance in the project came from the character of the space. None of the rich details existed. We introduced elements like faux-painted marble baseboards, stone thresholds, wall moldings, a hand-painted seventeenth-century wooden ceiling imported from Sicily, and a sixteenth-century fireplace mantel in the Great Room. The idea was to enrich the space with history and to give it more of an Old World character.

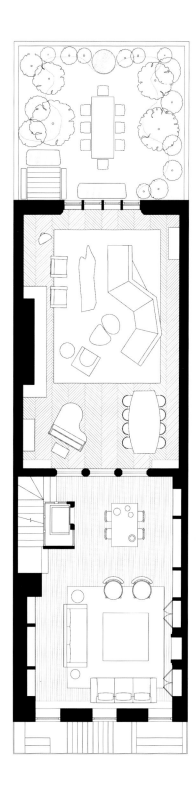

Above: Floor plan of the mezzanine
that looks onto the Great Room.
Opposite: Sketch of the Great Room with
new decorative architectural details.

0 10

WEST

VILLAGE

(II)

NEW YORK

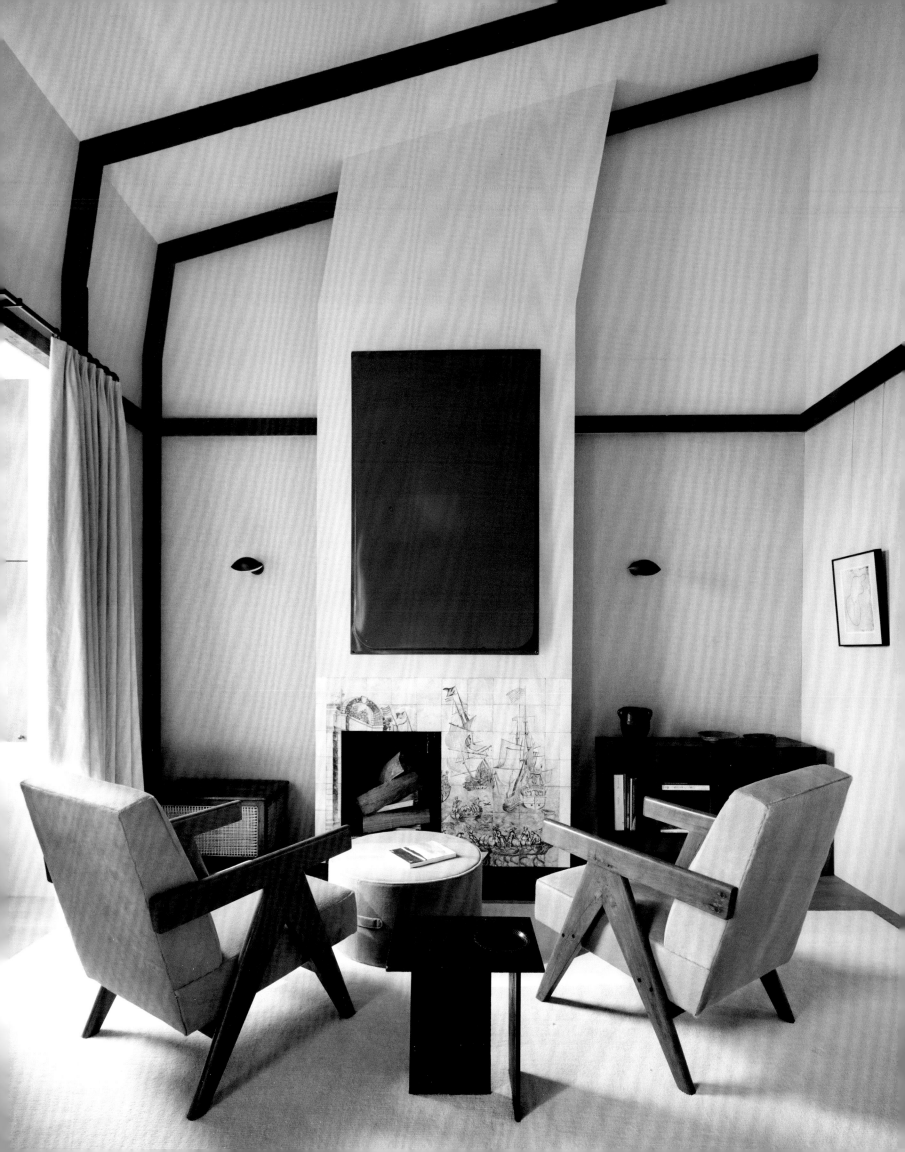

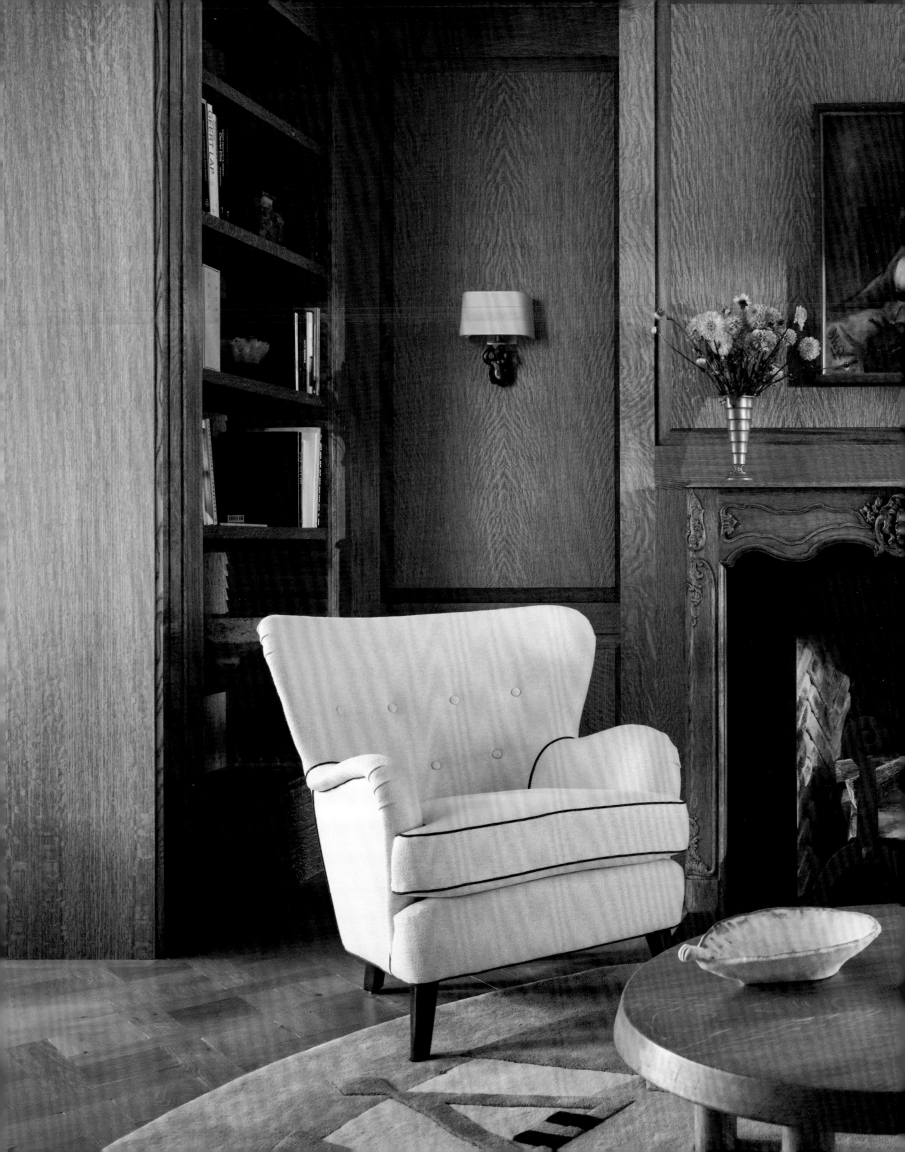

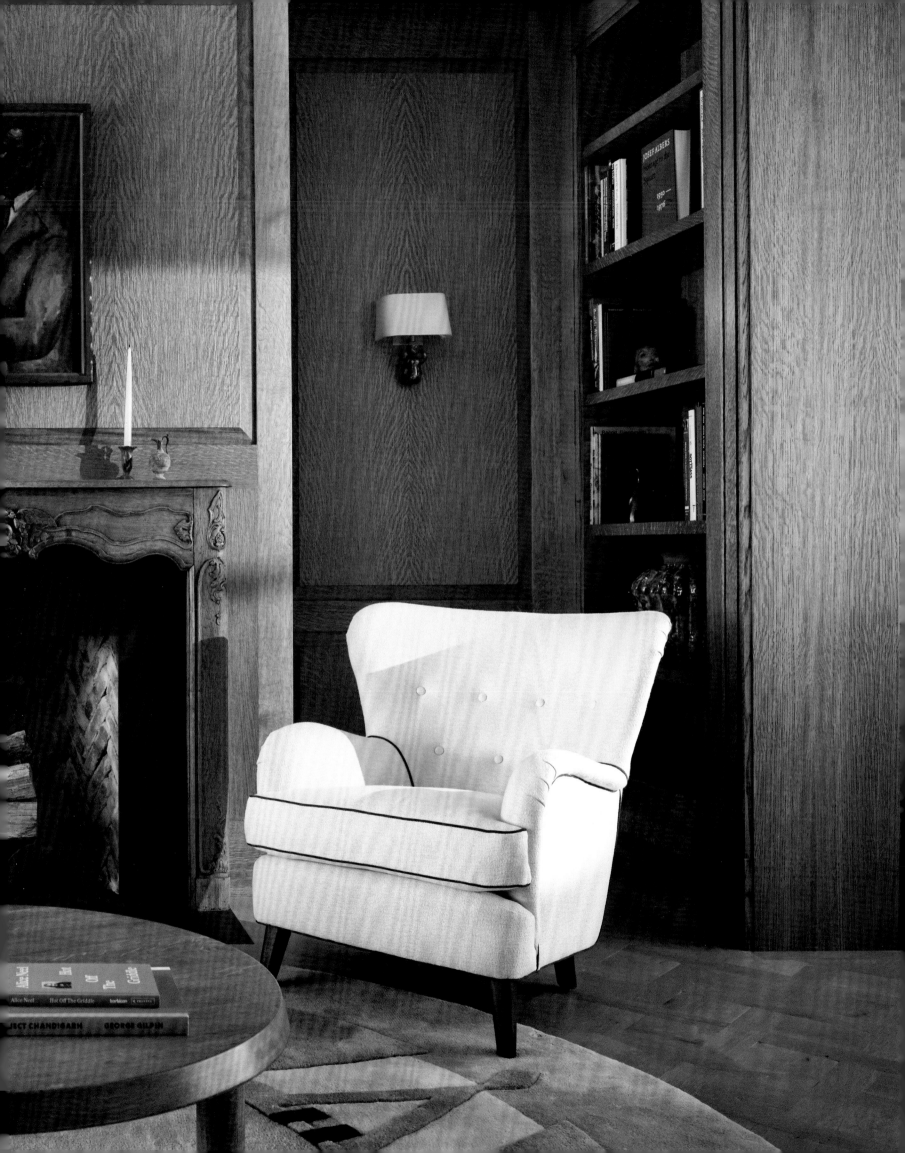

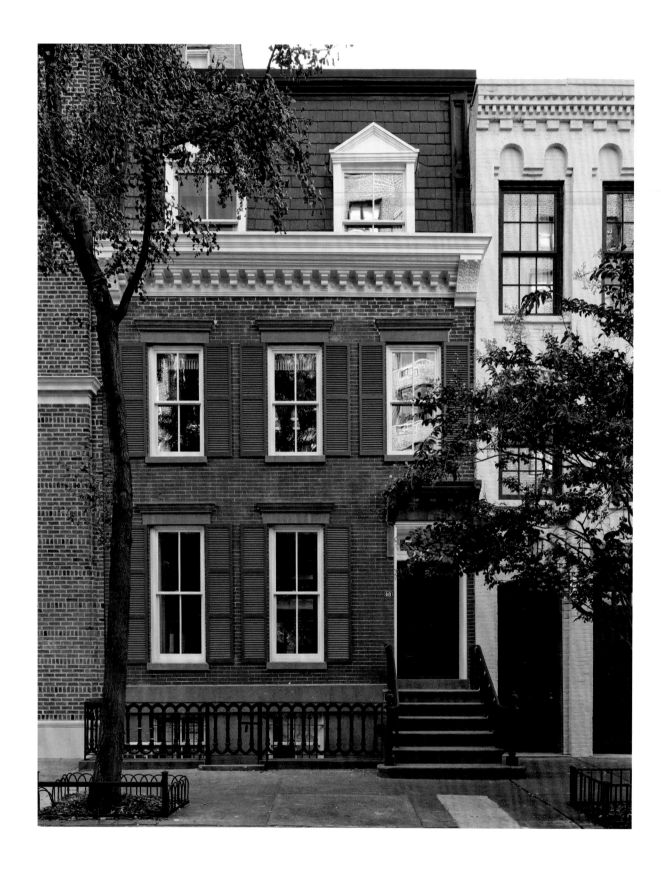

ASHE LEANDRO

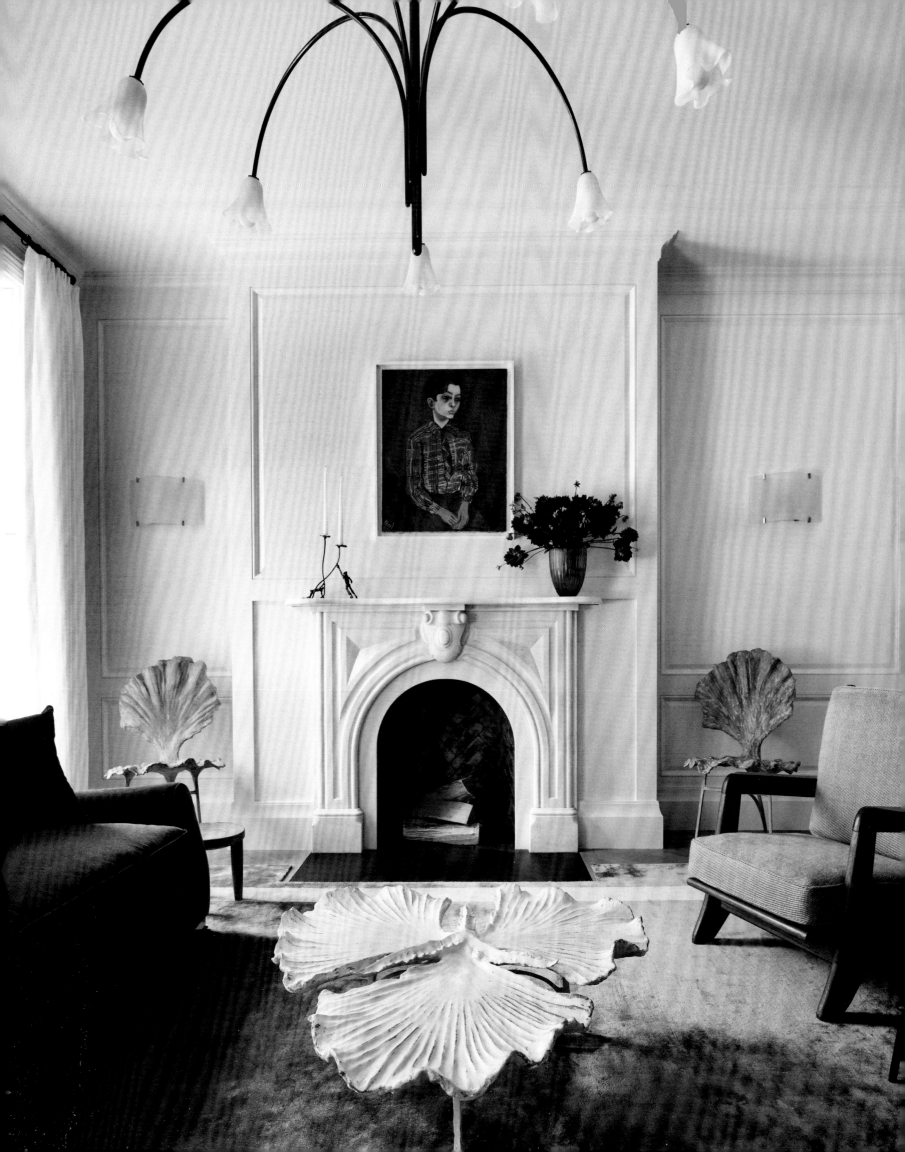

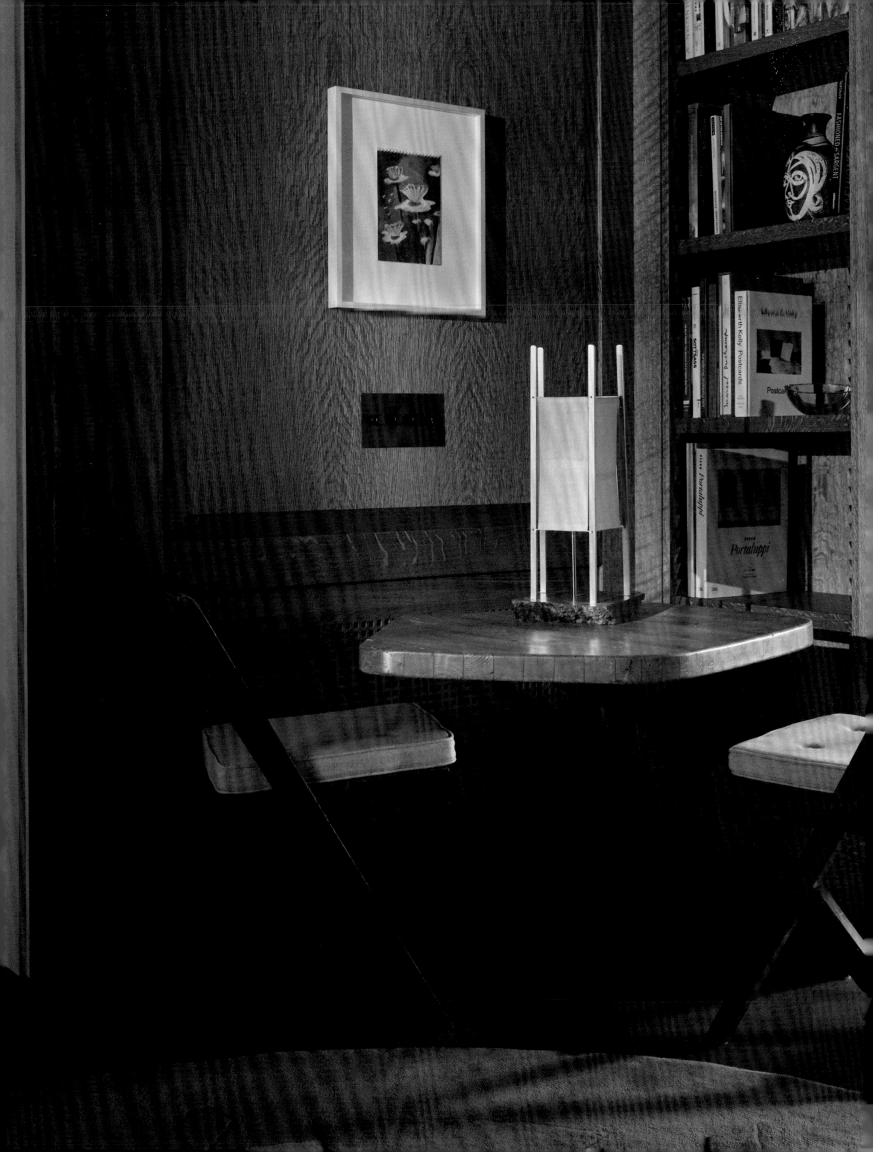

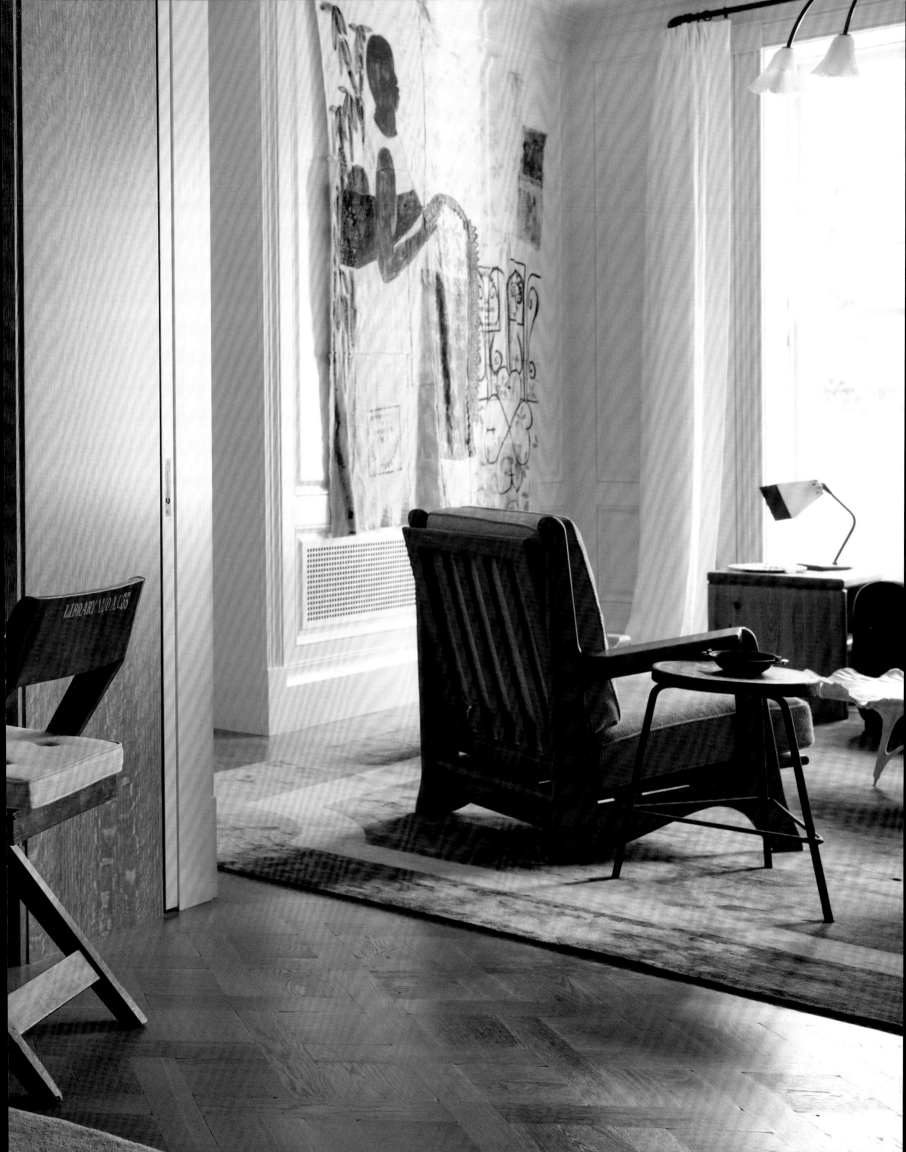

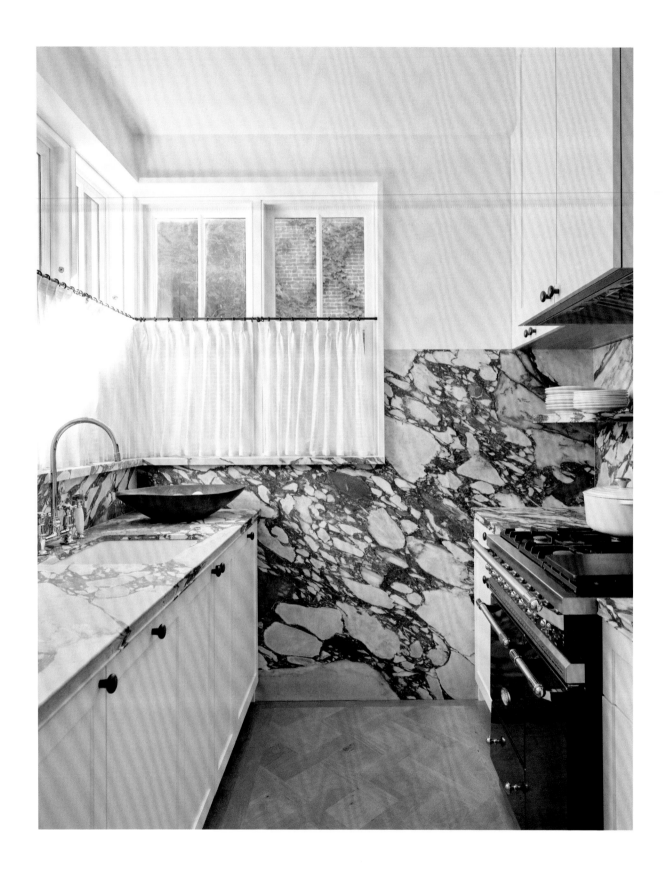

ASHE LEANDRO

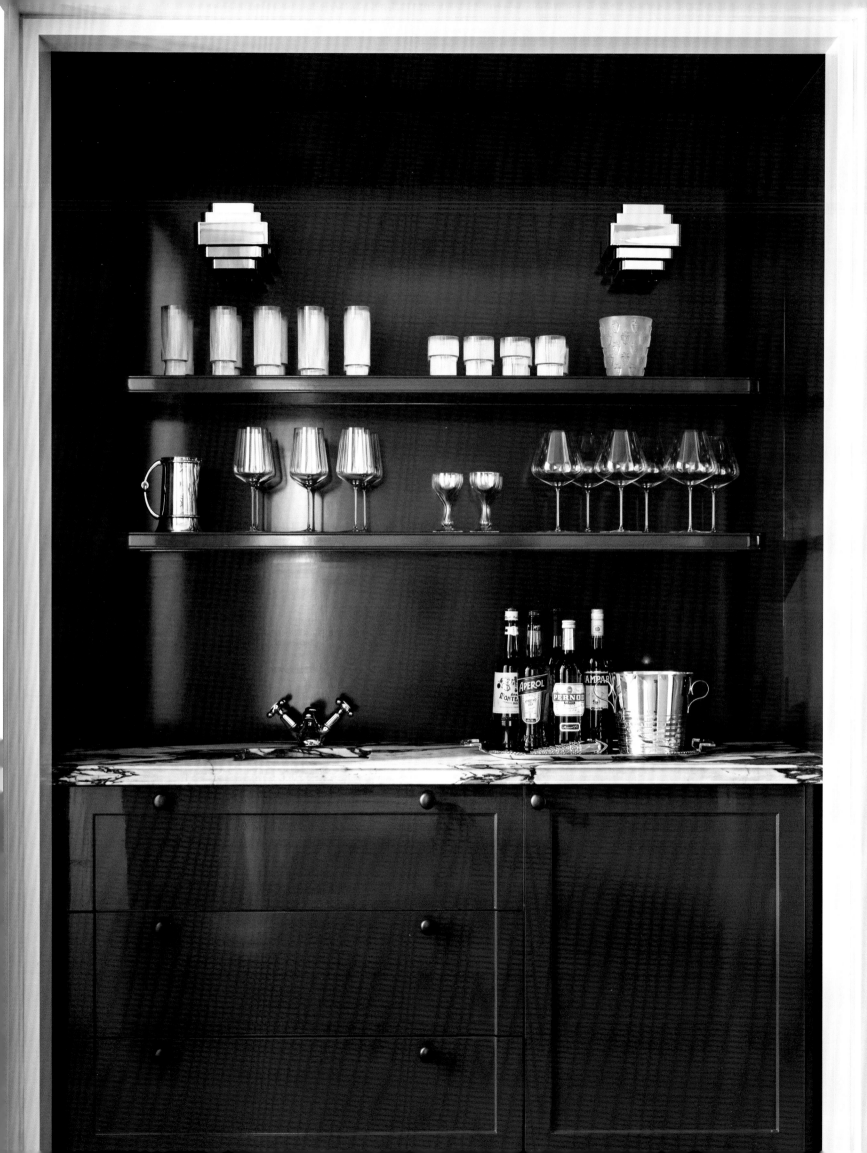

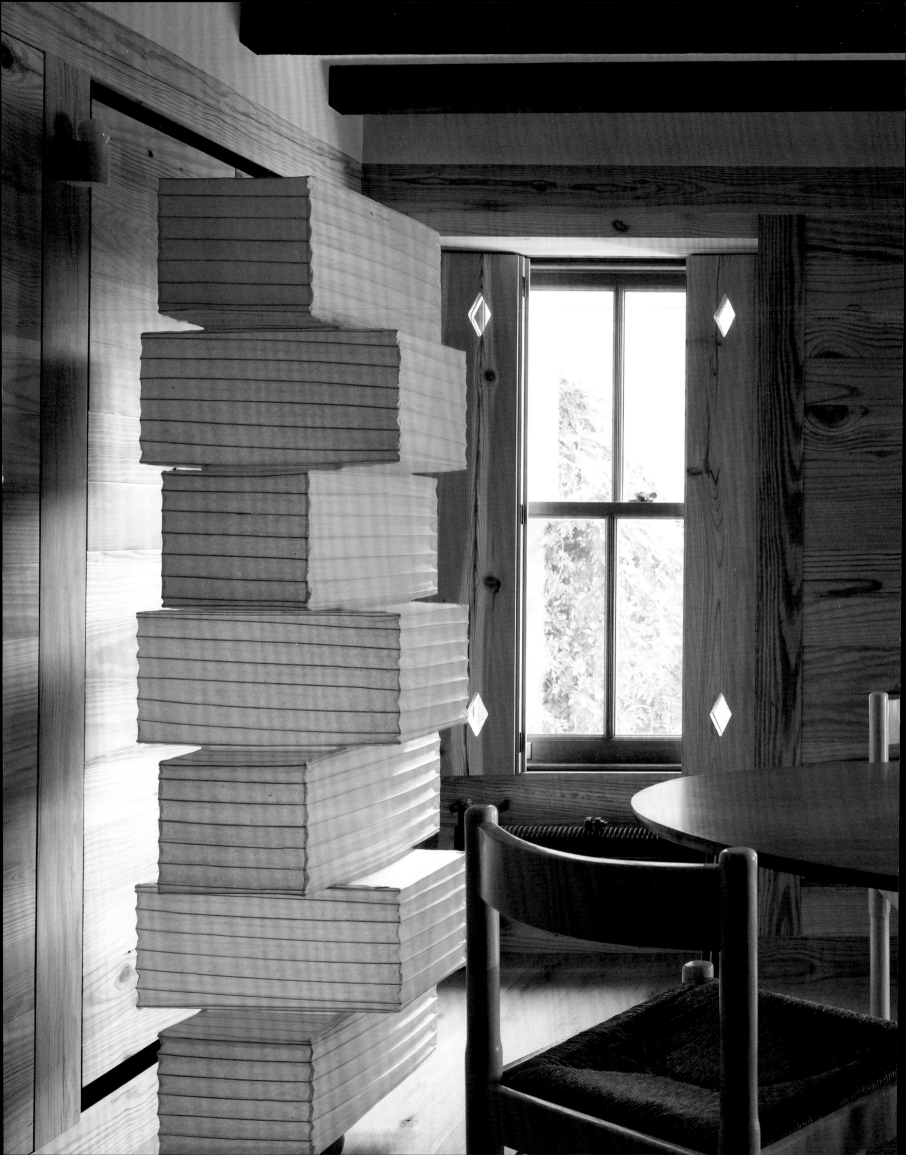

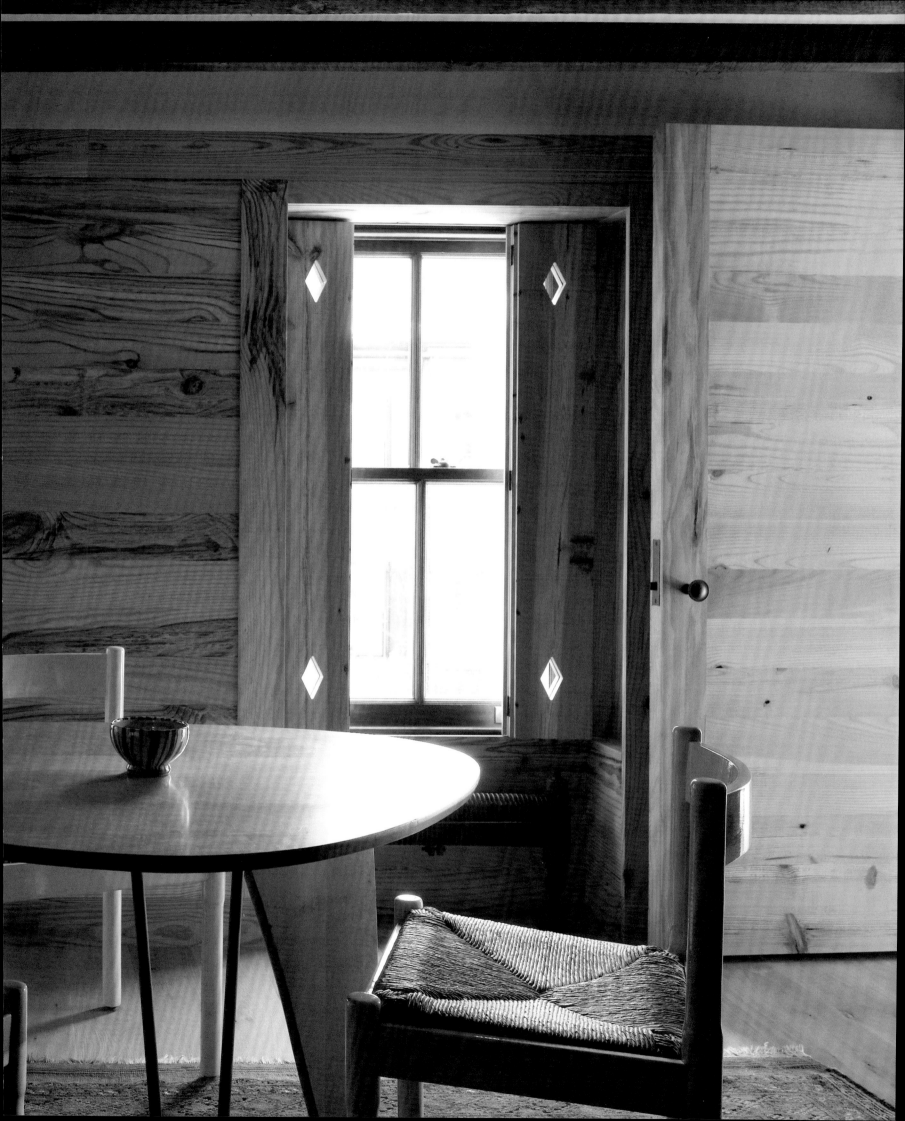

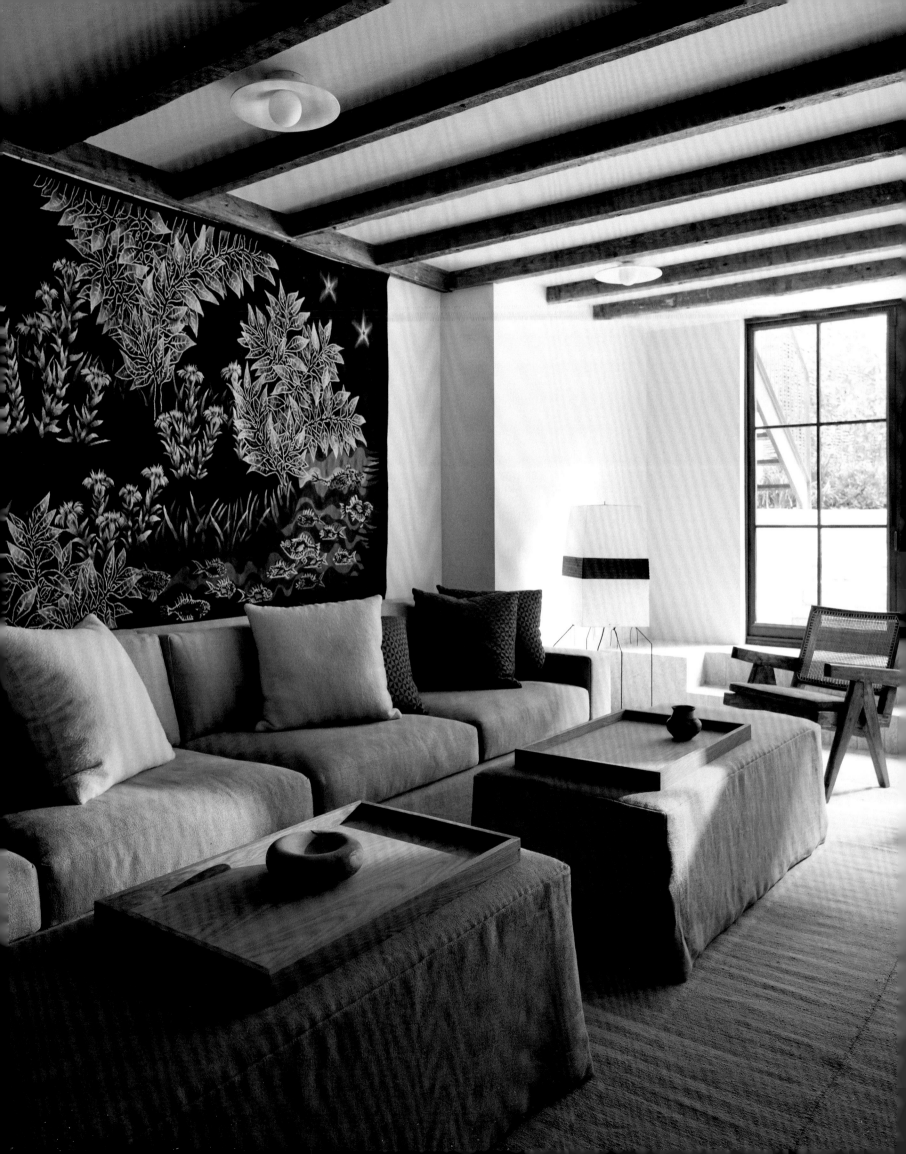

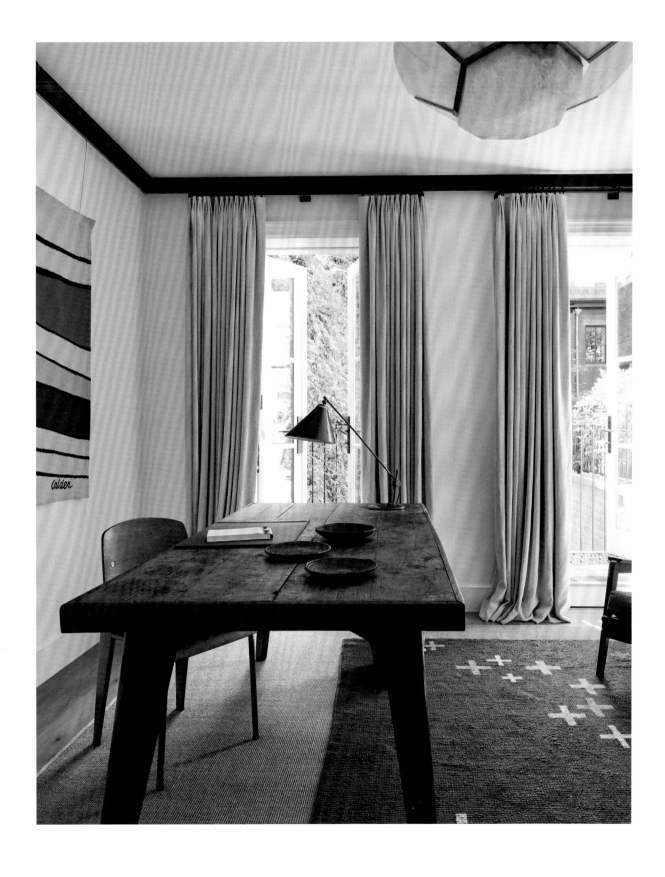

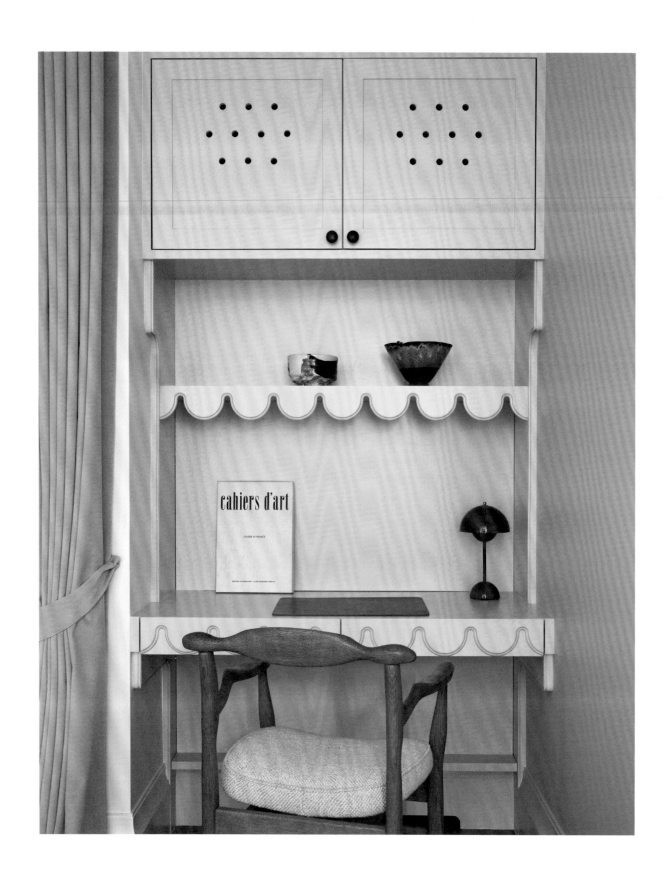

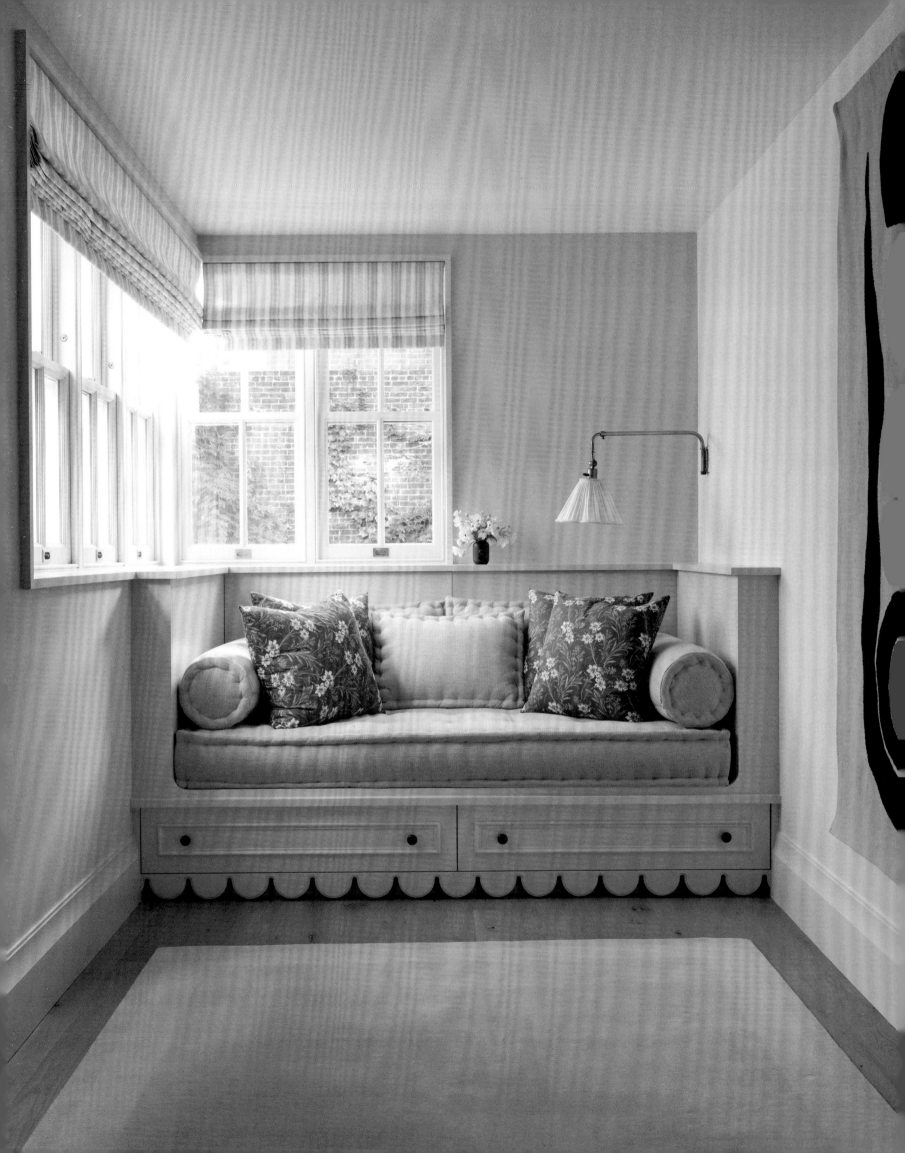

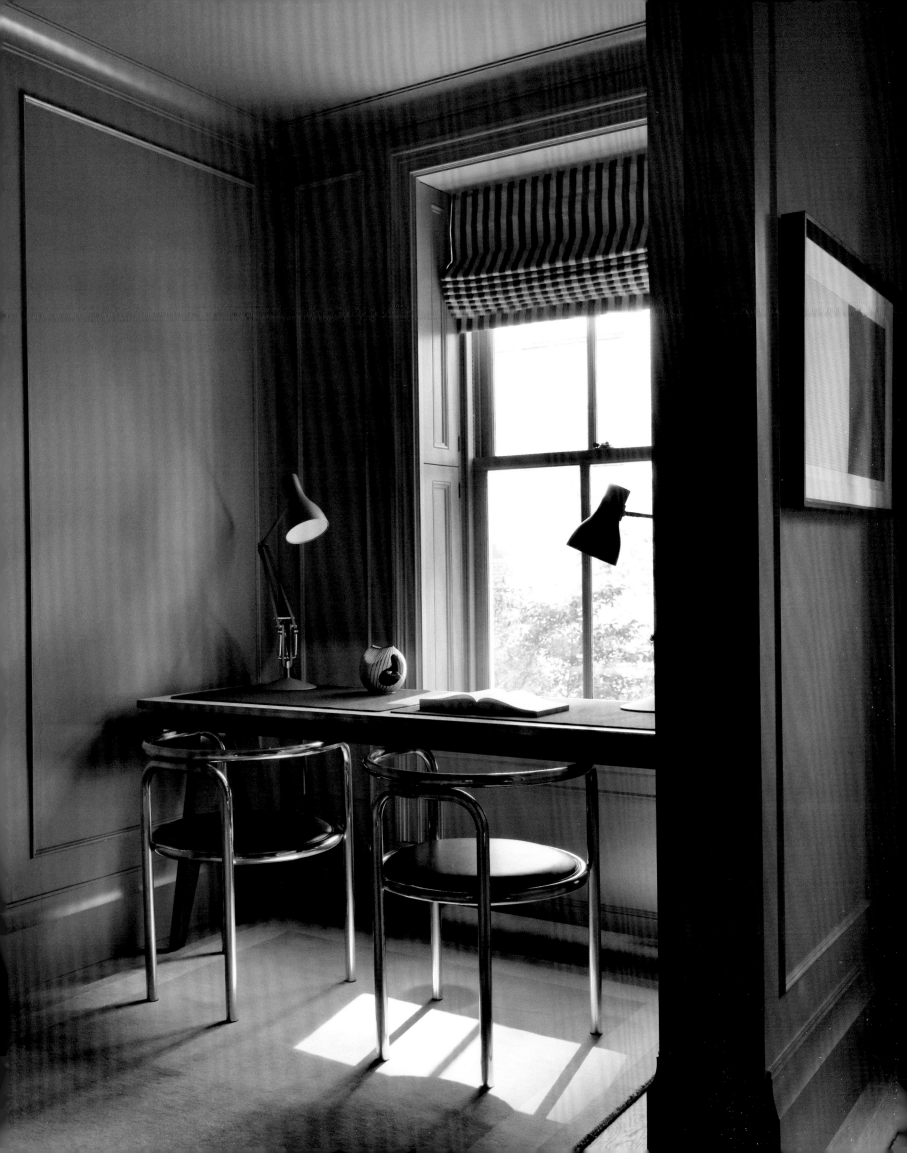

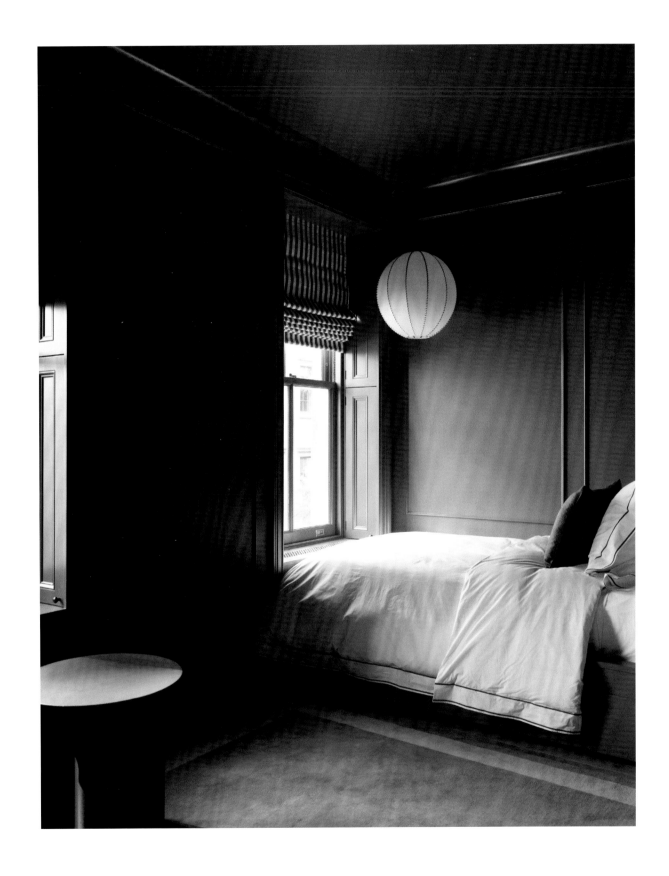

ASHE LEANDRO

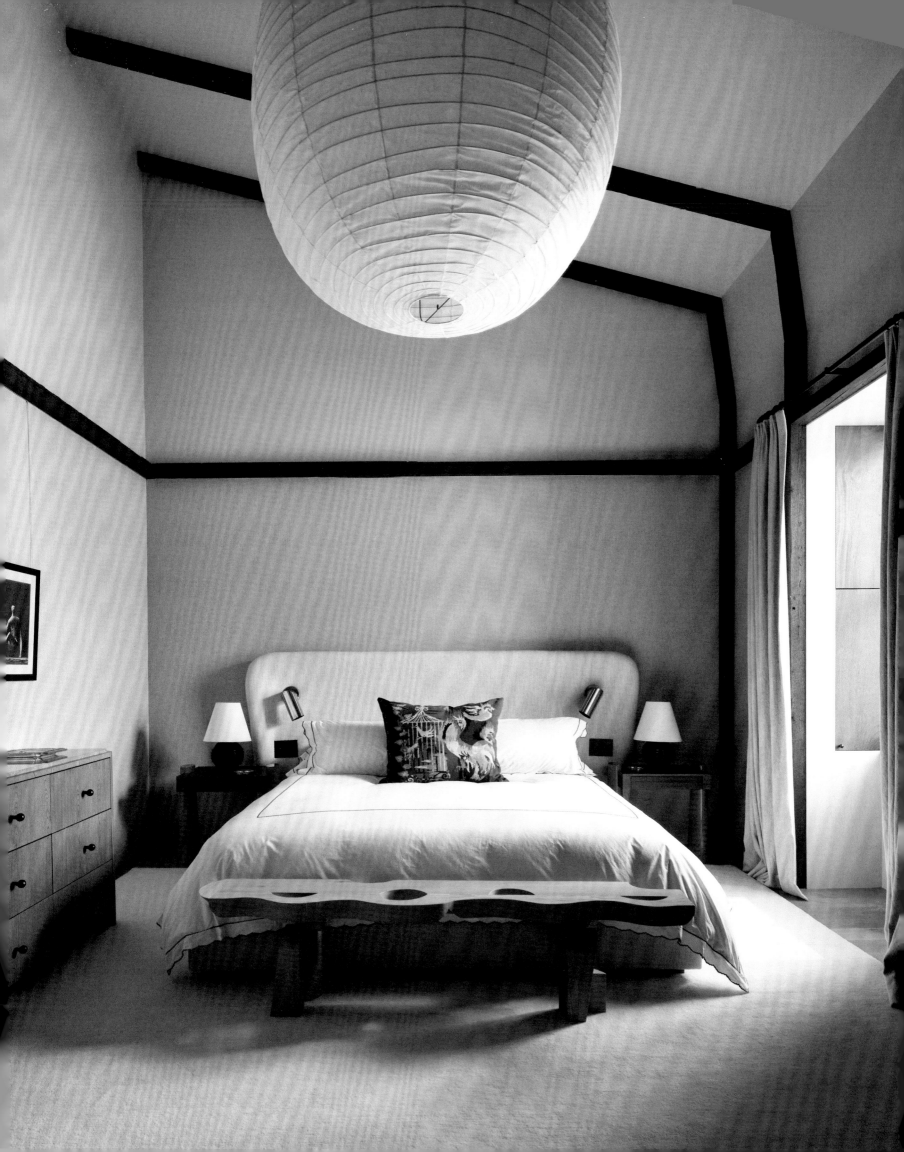

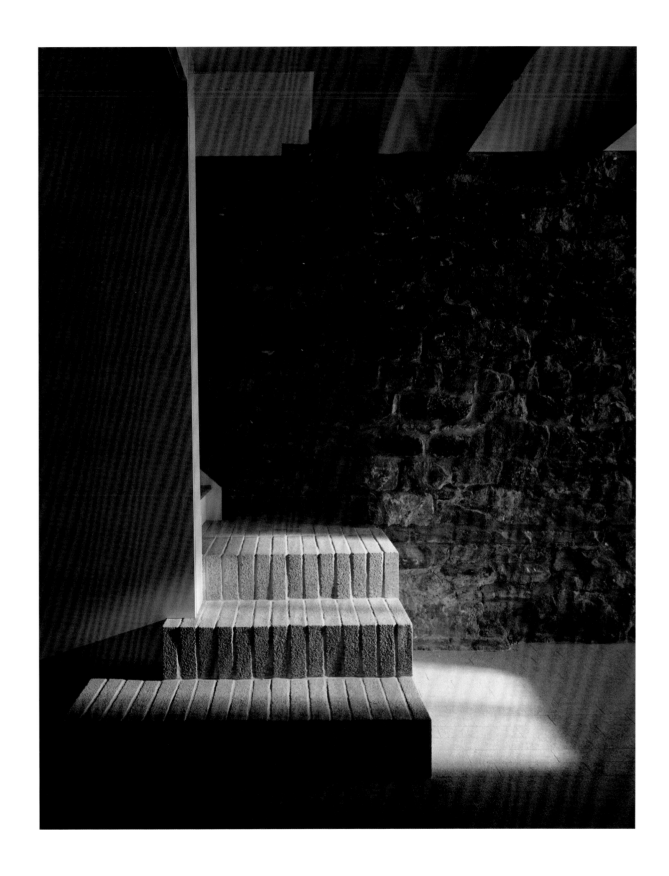

ARCHITECTURAL & INTERIOR DESIGN ASHE LEANDRO
PHOTOGRAPHY ADRIAN GAUT

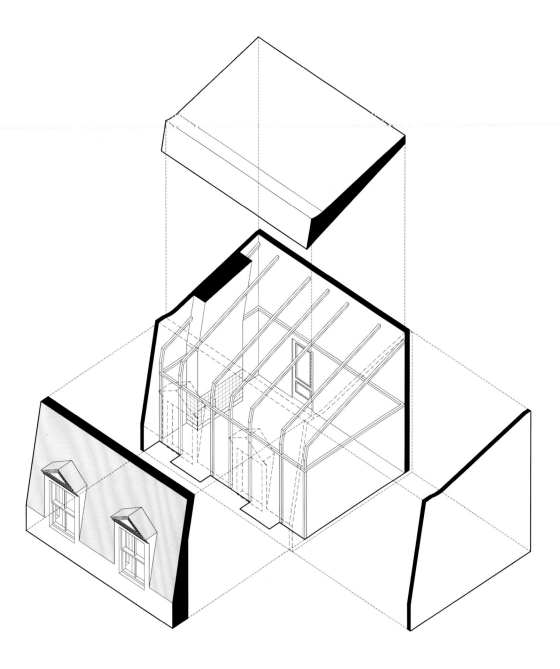

This was originally a Federal townhouse, built in 1899, with a fully timber-frame structure, which is very rare in New York. The clients fell in love with the quirkiness of it. To bring it up to contemporary standards, we had to demolish a lot of the original interior. So, our job was to bring the quirk back. We created a lot of little nooks and split-levels that each formed a distinct area.

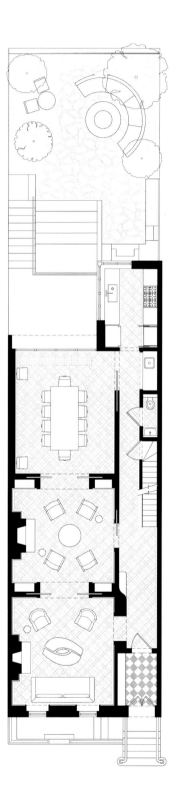

Above: Floor plan of the parlor level.
Opposite: Architectural diagram of
the bedroom with exposed structural
timber frame as part of the design.

0 10

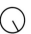

P
A
R
K

A
V
E

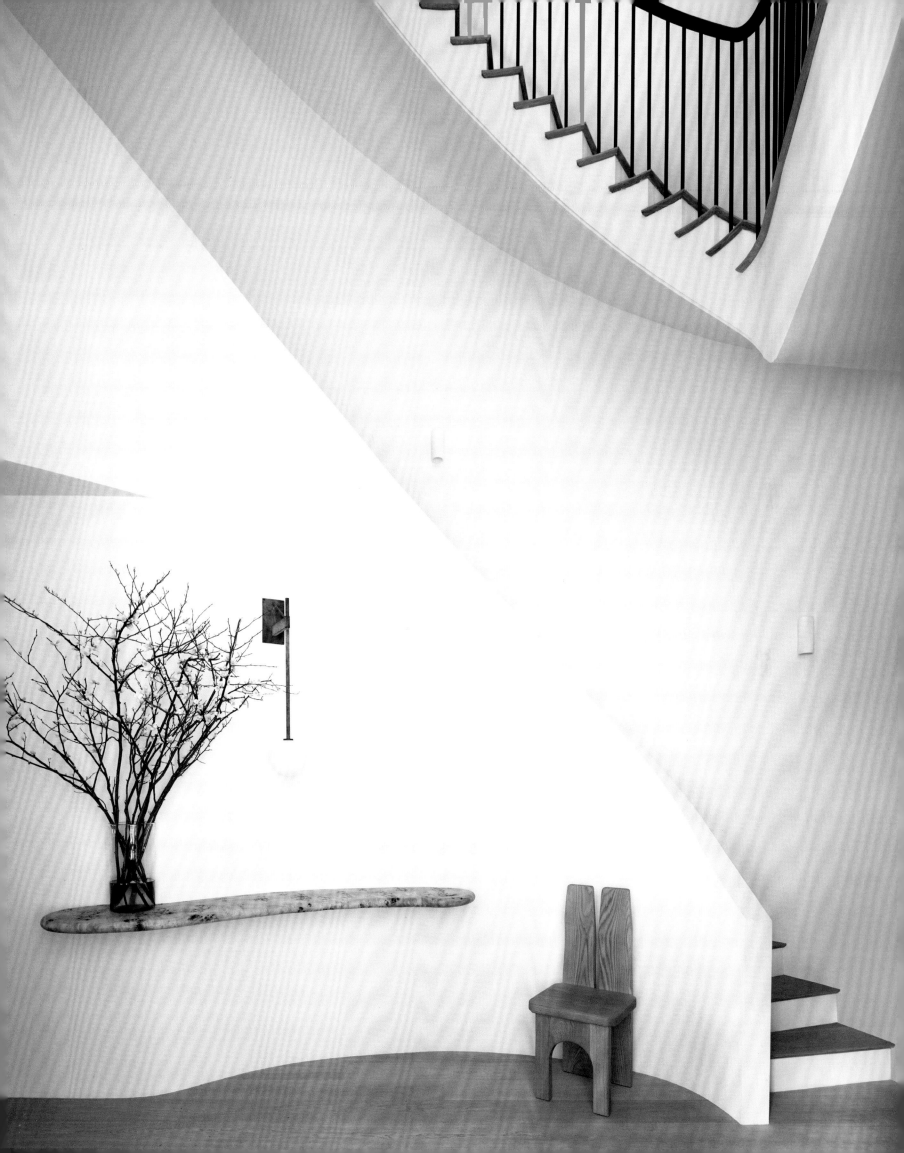

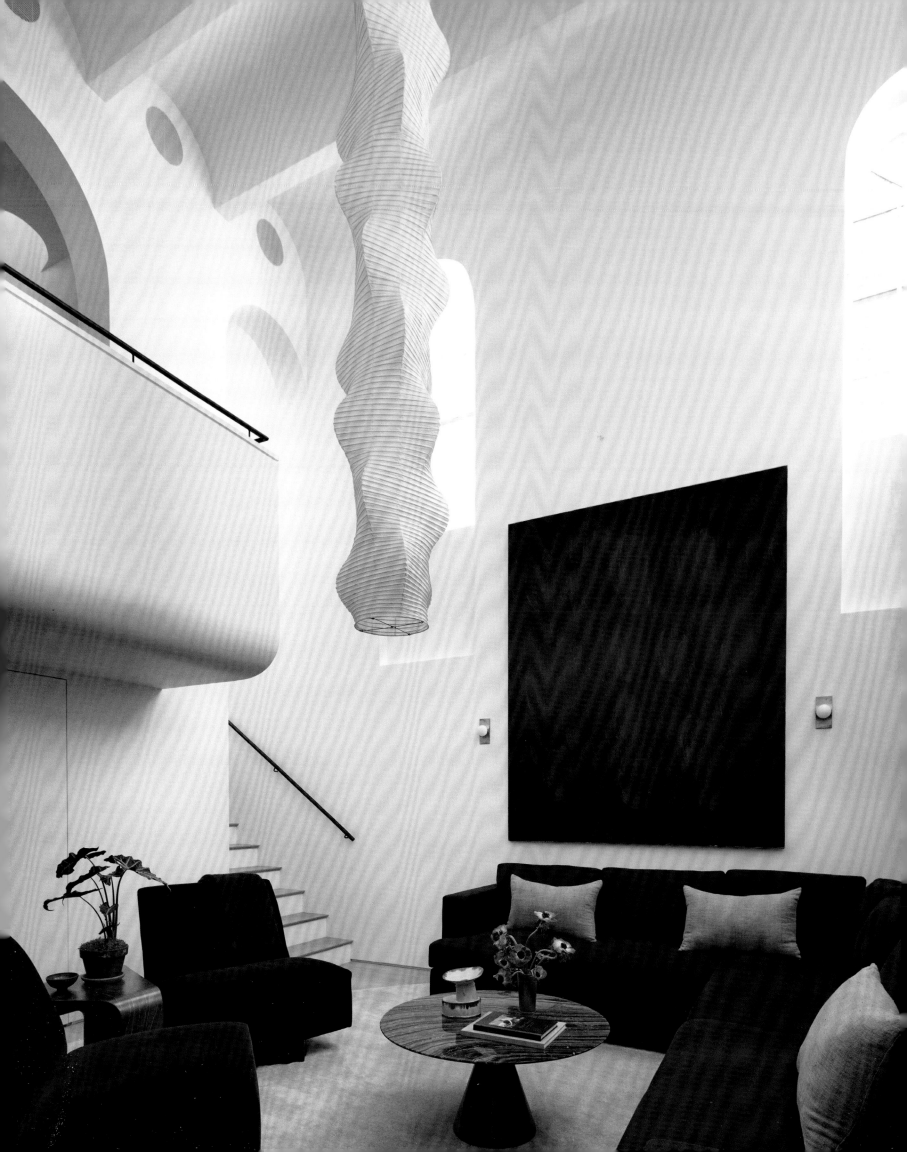

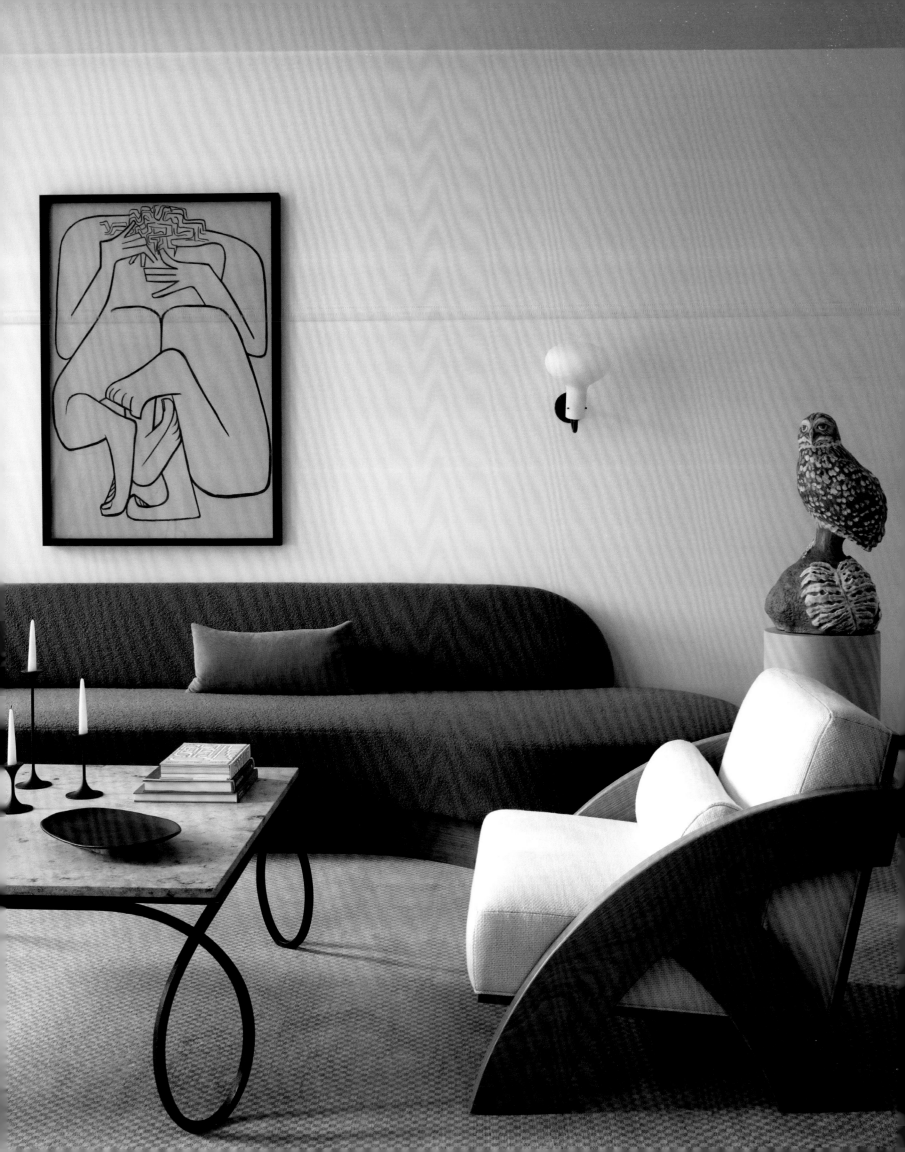

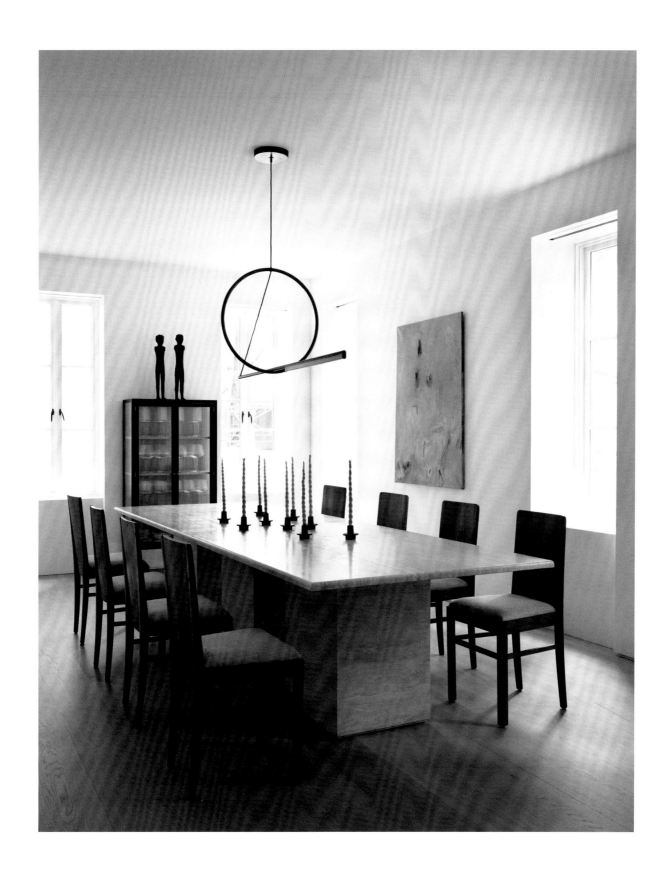

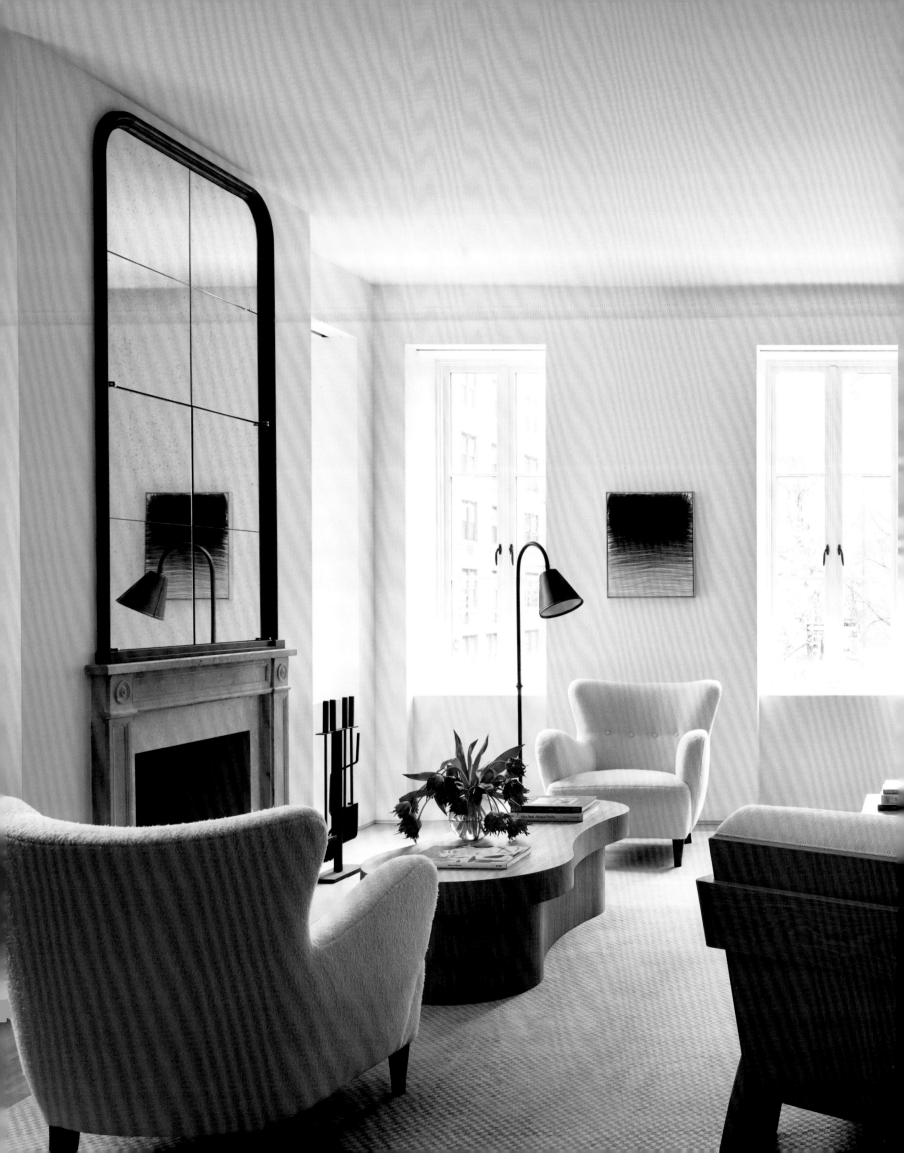

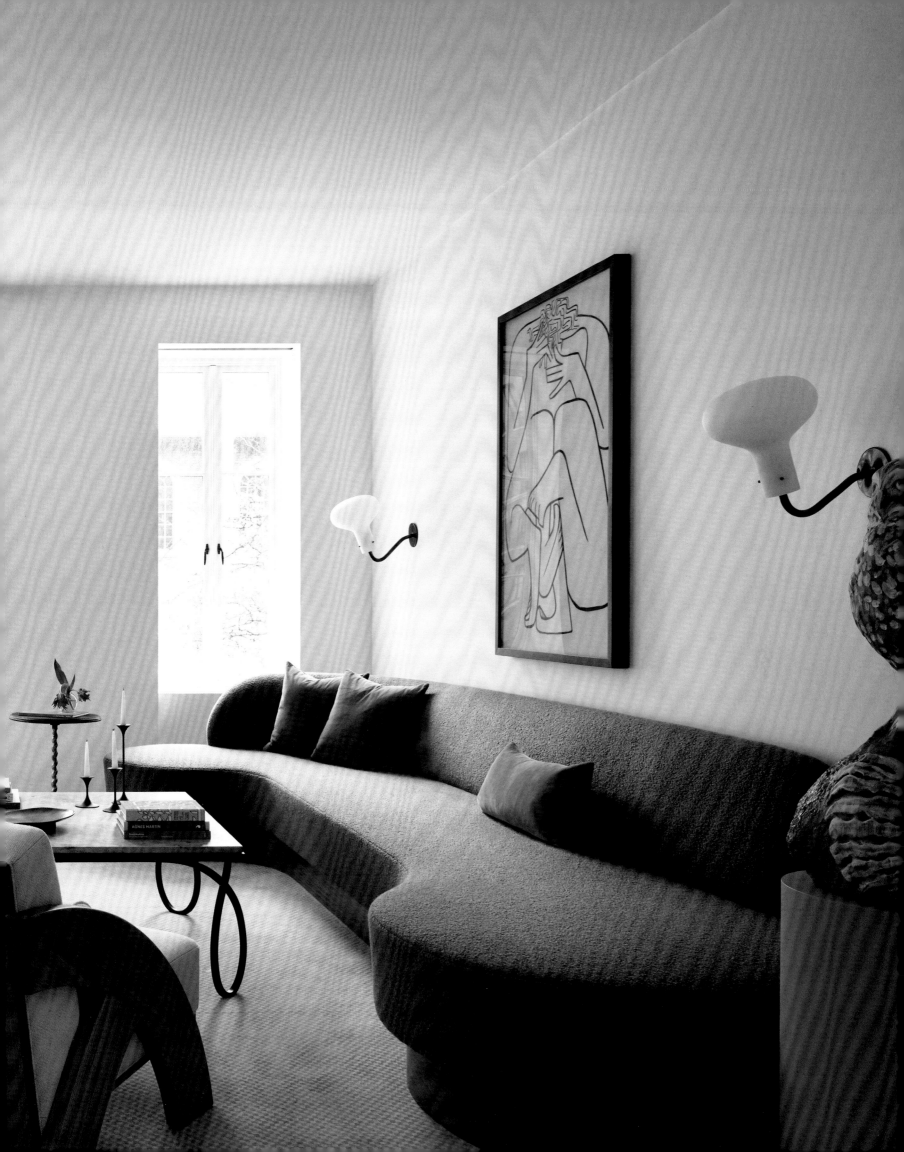

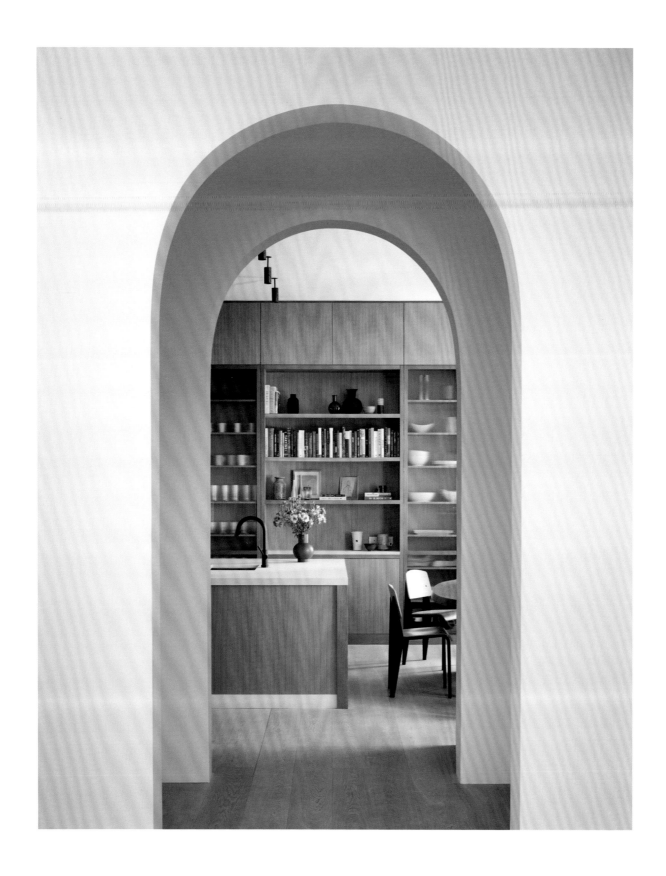

ASHE LEANDRO

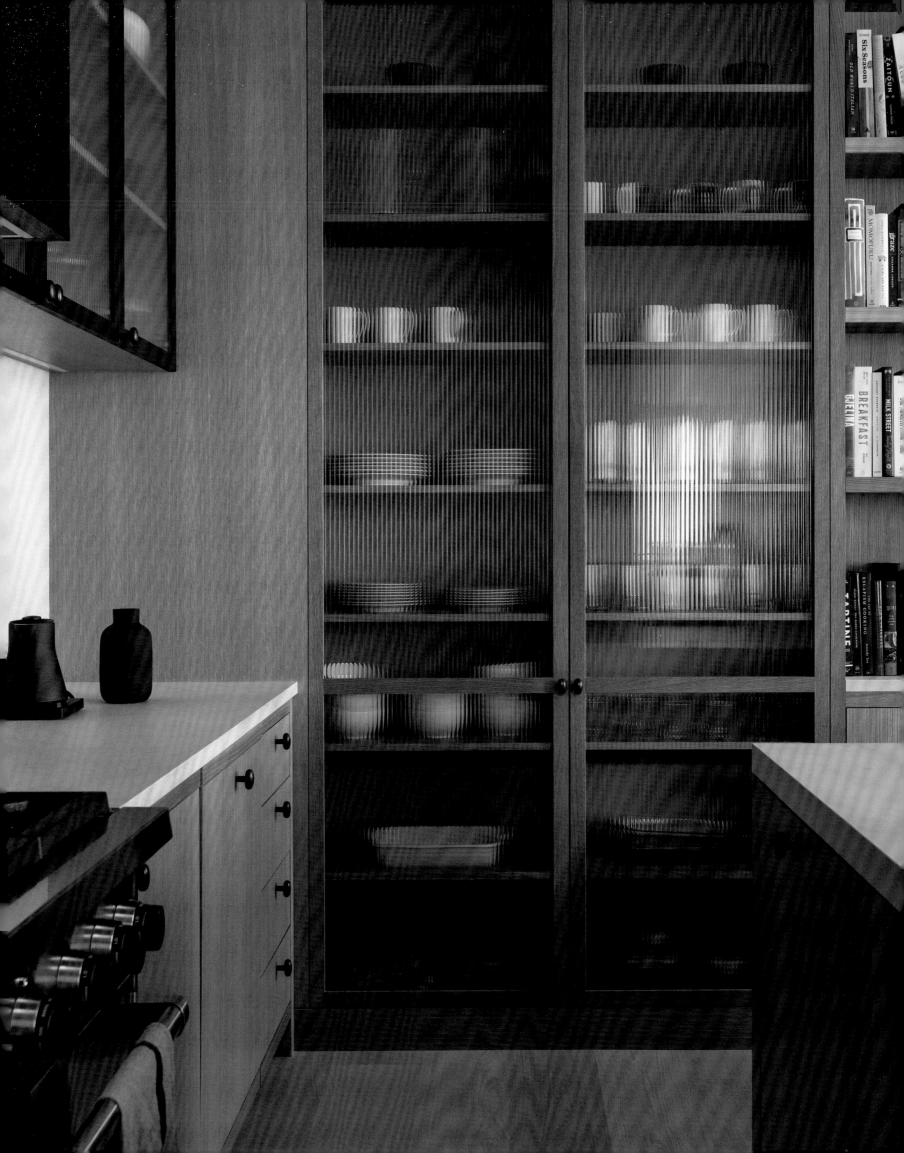

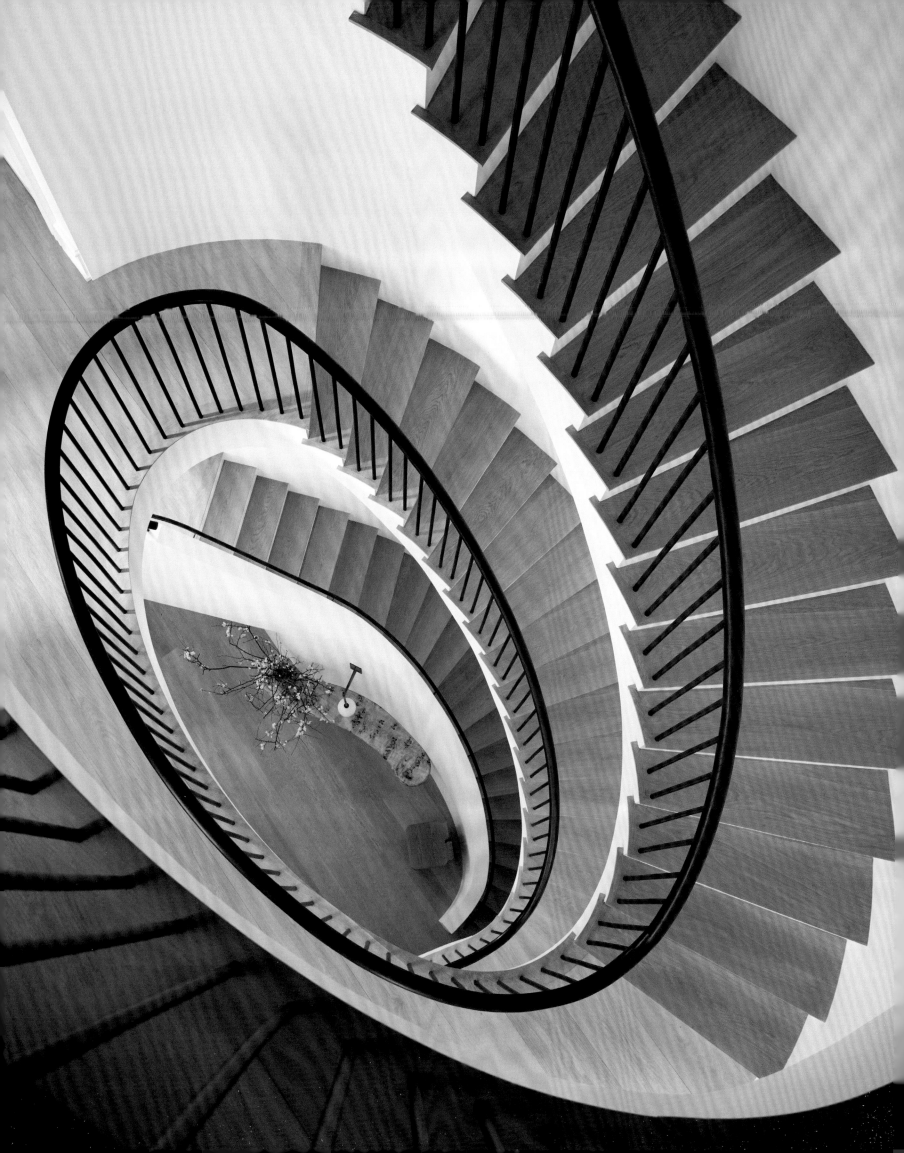

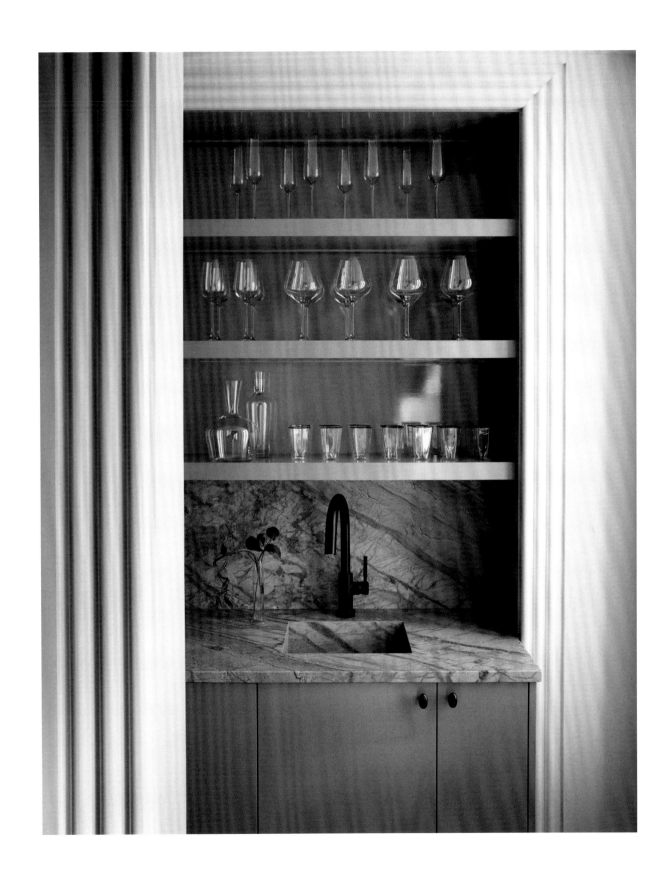

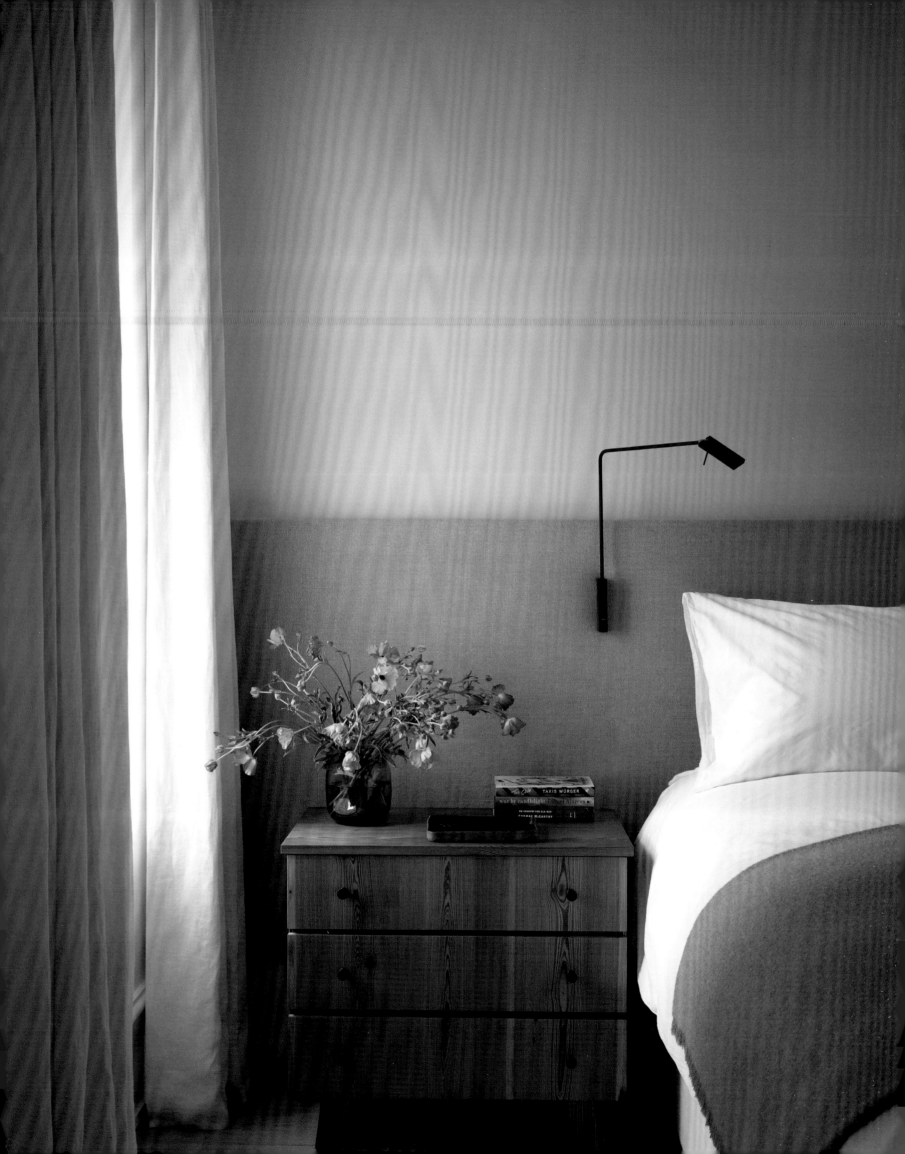

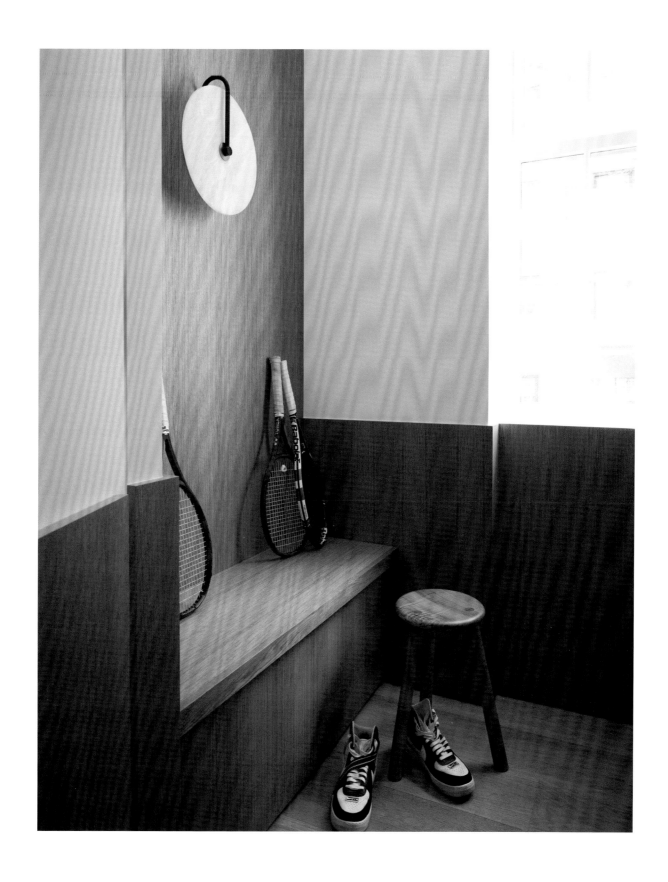

ARCHITECTURAL & INTERIOR DESIGN ASHE LEANDRO
PHOTOGRAPHY STEPHEN KENT JOHNSON AND SHADE DEGGES

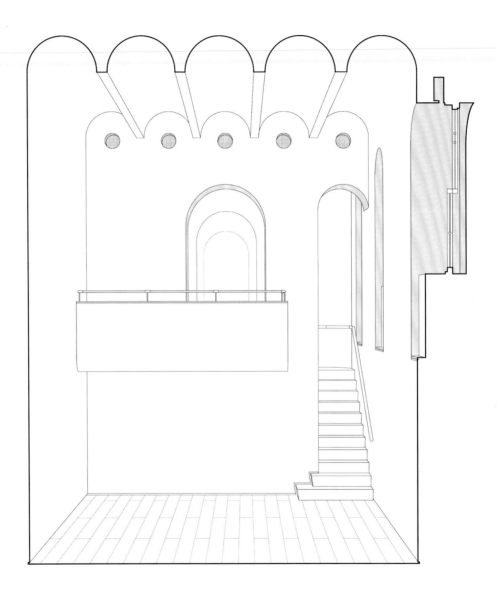

A pivotal reference to us was the original Calvin Klein store by John Pawson on Madison
Avenue (completed in 1995). We wanted to achieve that kind of pure space with minimal
detail. The vertical circulation was a key design component. For the family room, we made a
double-height space where we added a barrel-vaulted ceiling — a subtle homage to Ricardo
Boffill's La Fábrica.

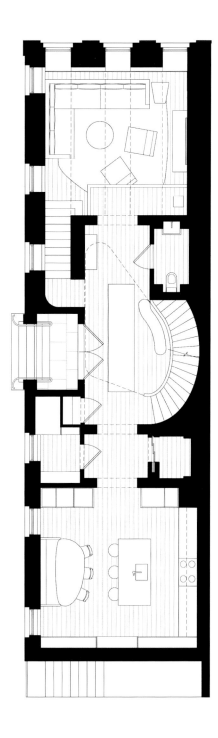

Above: Floor plan of the entry level.
Opposite: Sketch of the barrel-vaulted
family room.

0 10

(IV)

M
U
S
E
U
M

M
I
L
E

NEW YORK

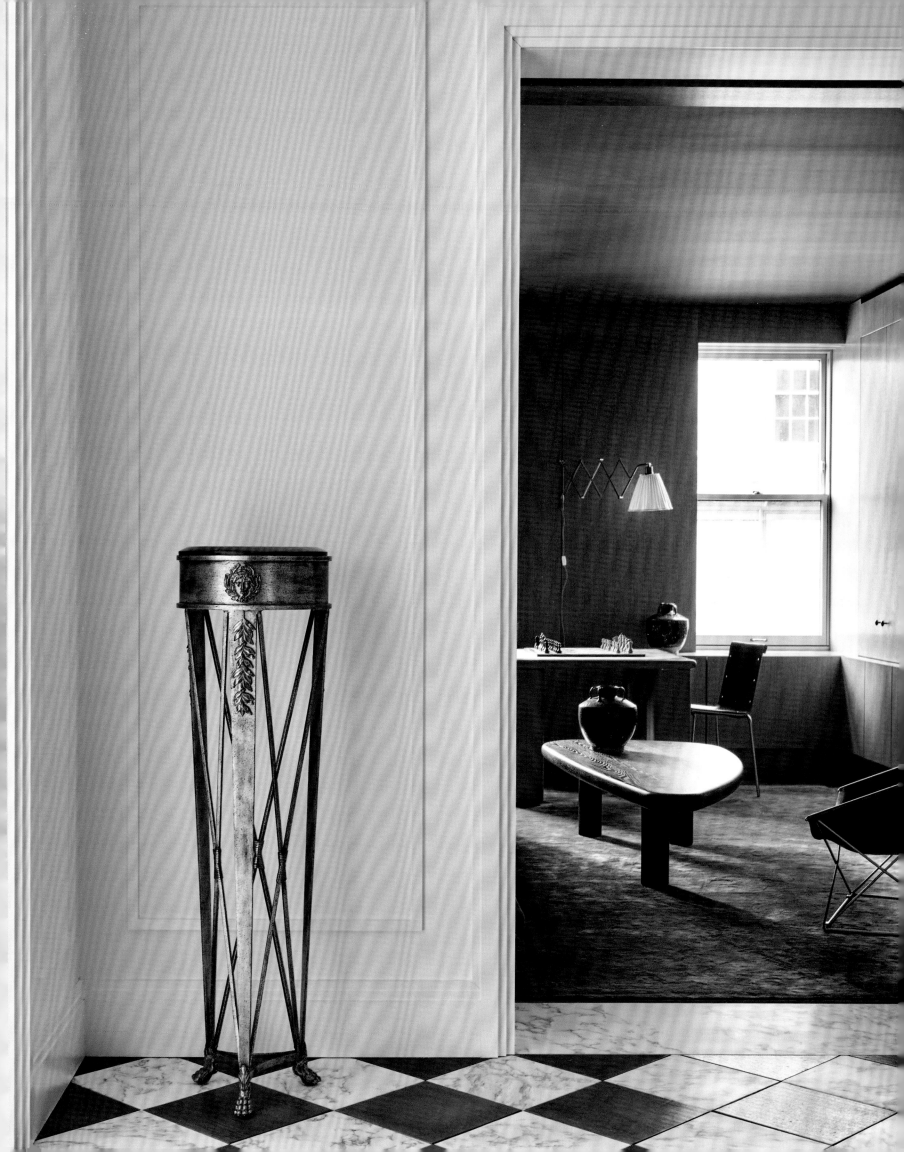

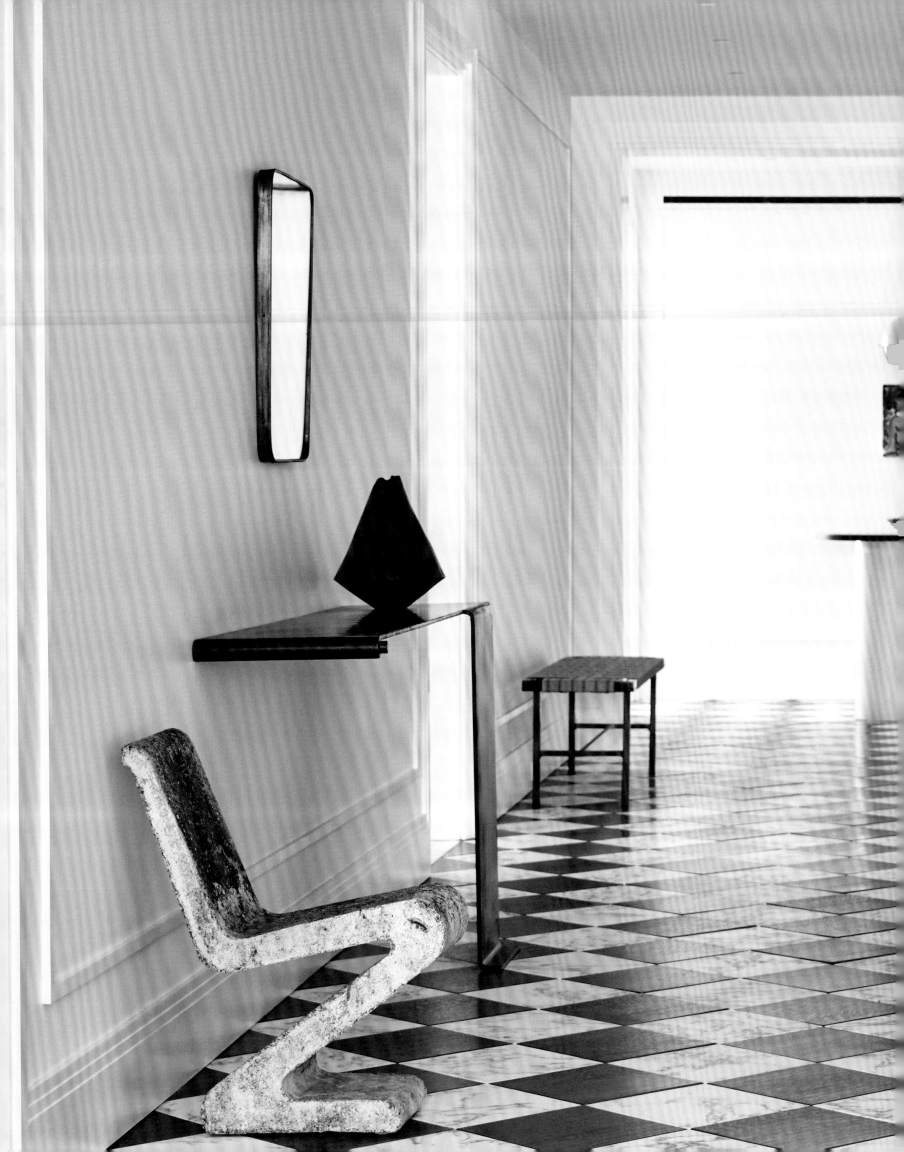

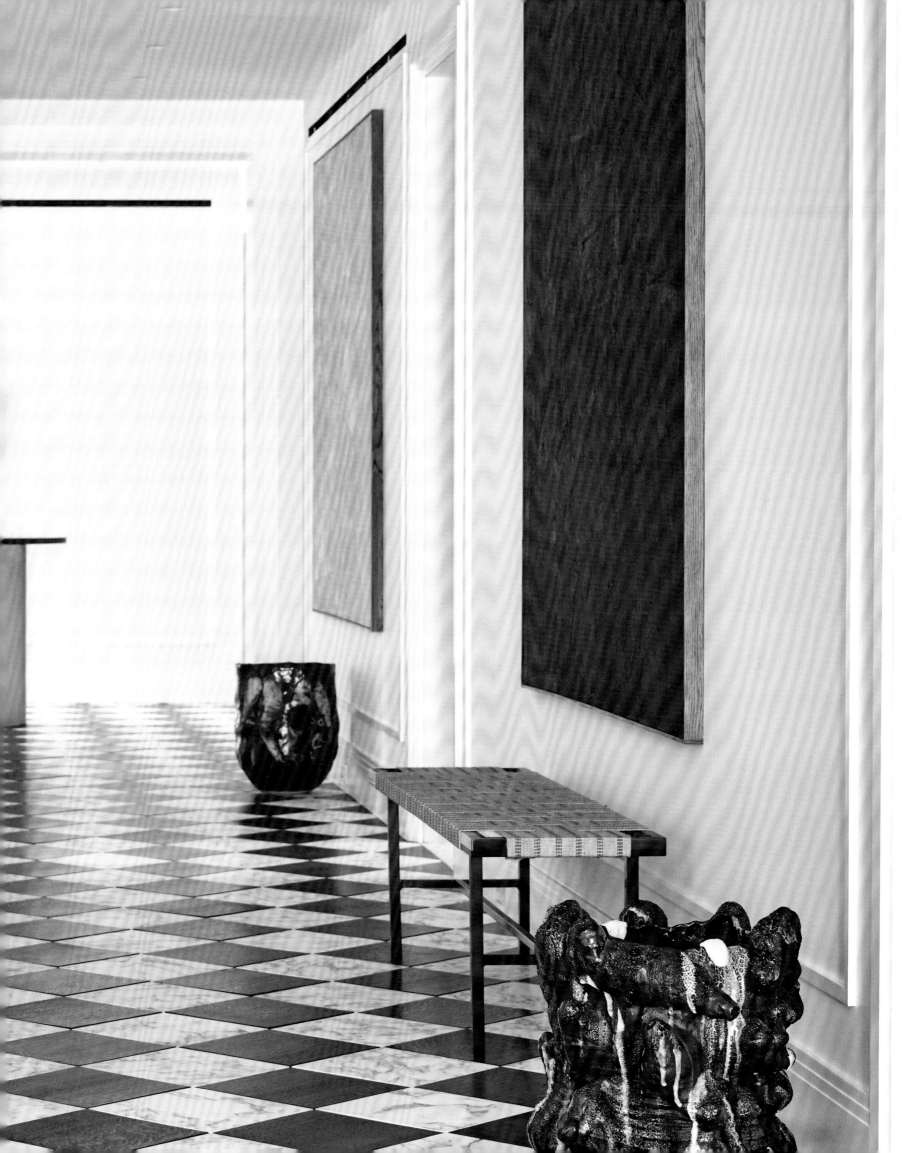

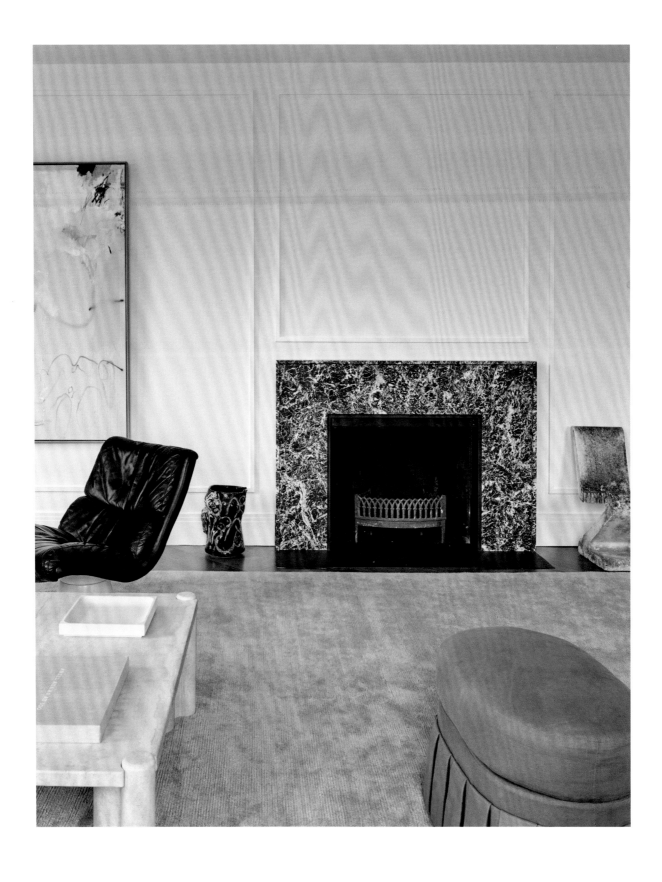

ASHE LEANDRO

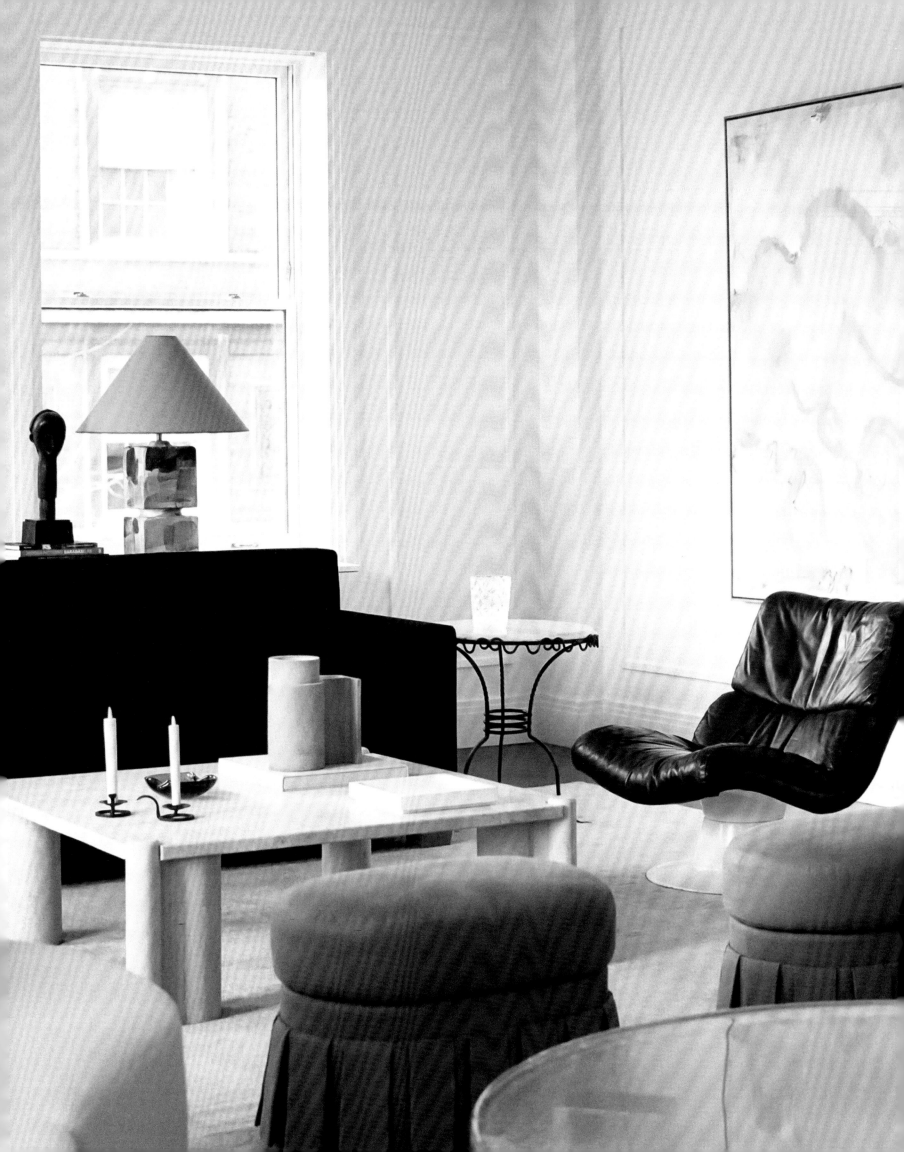

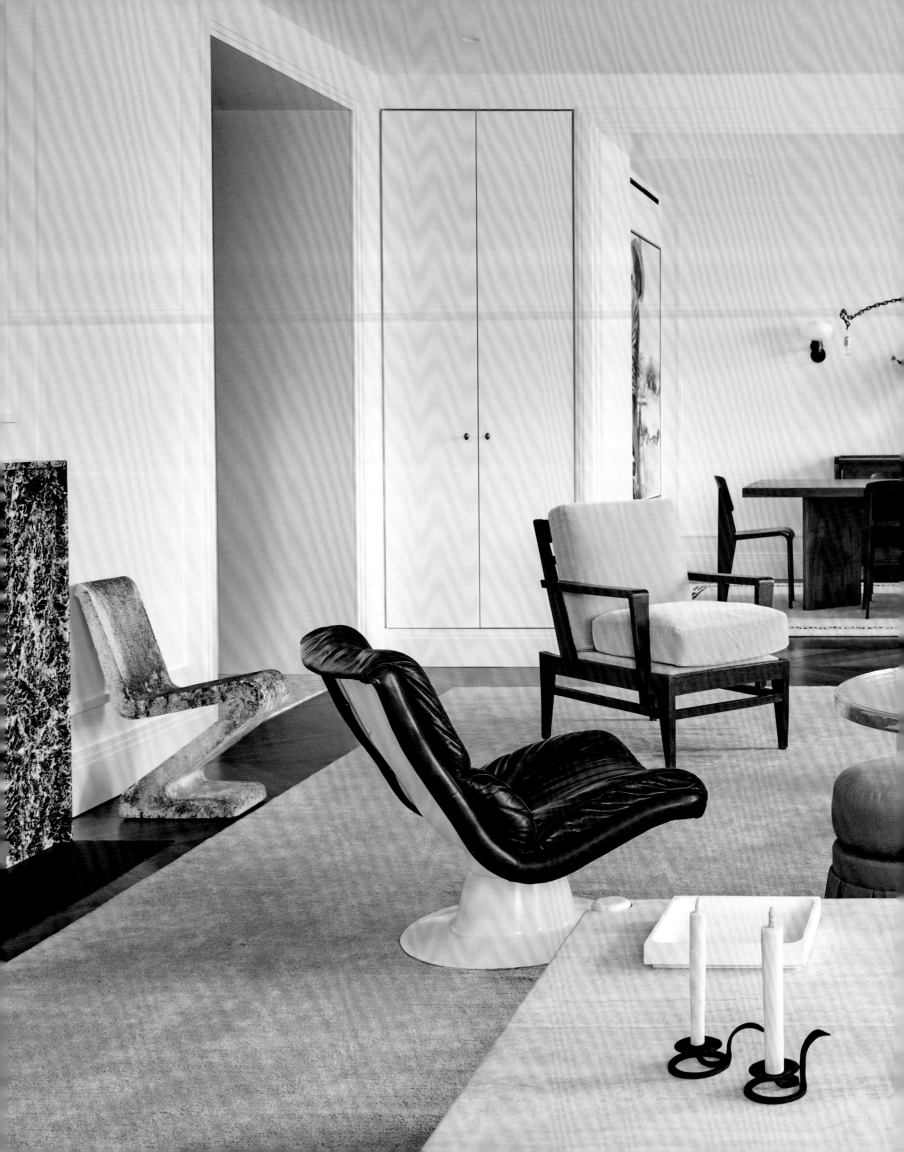

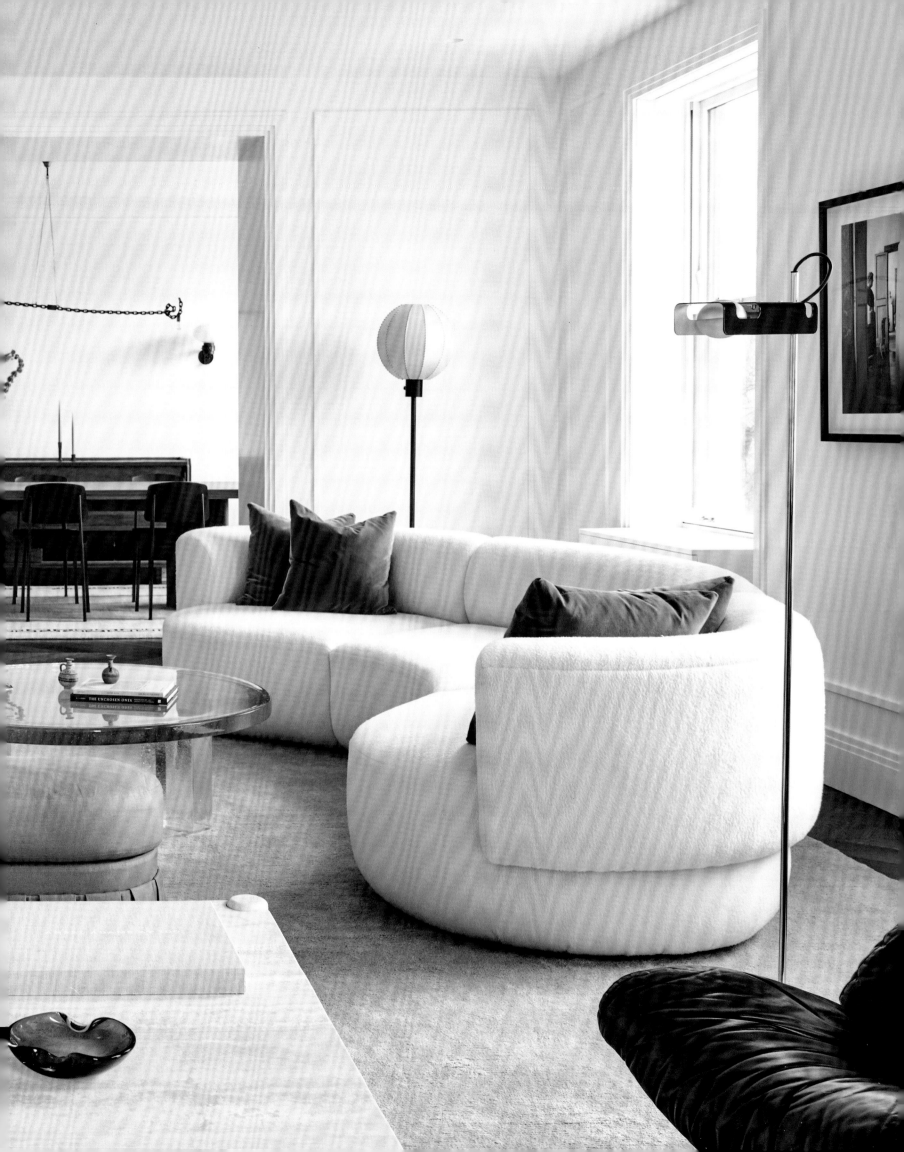

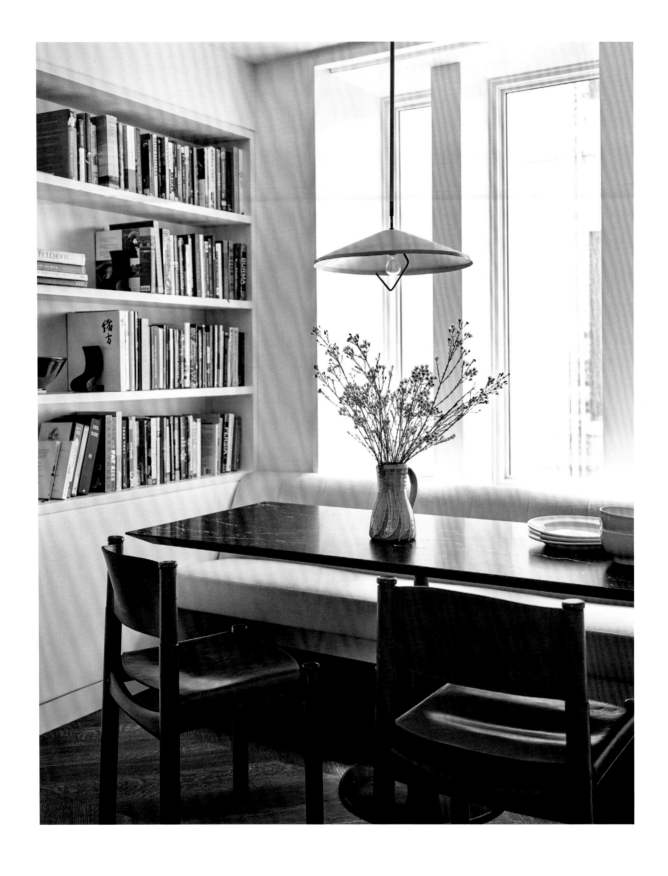

ASHE LEANDRO

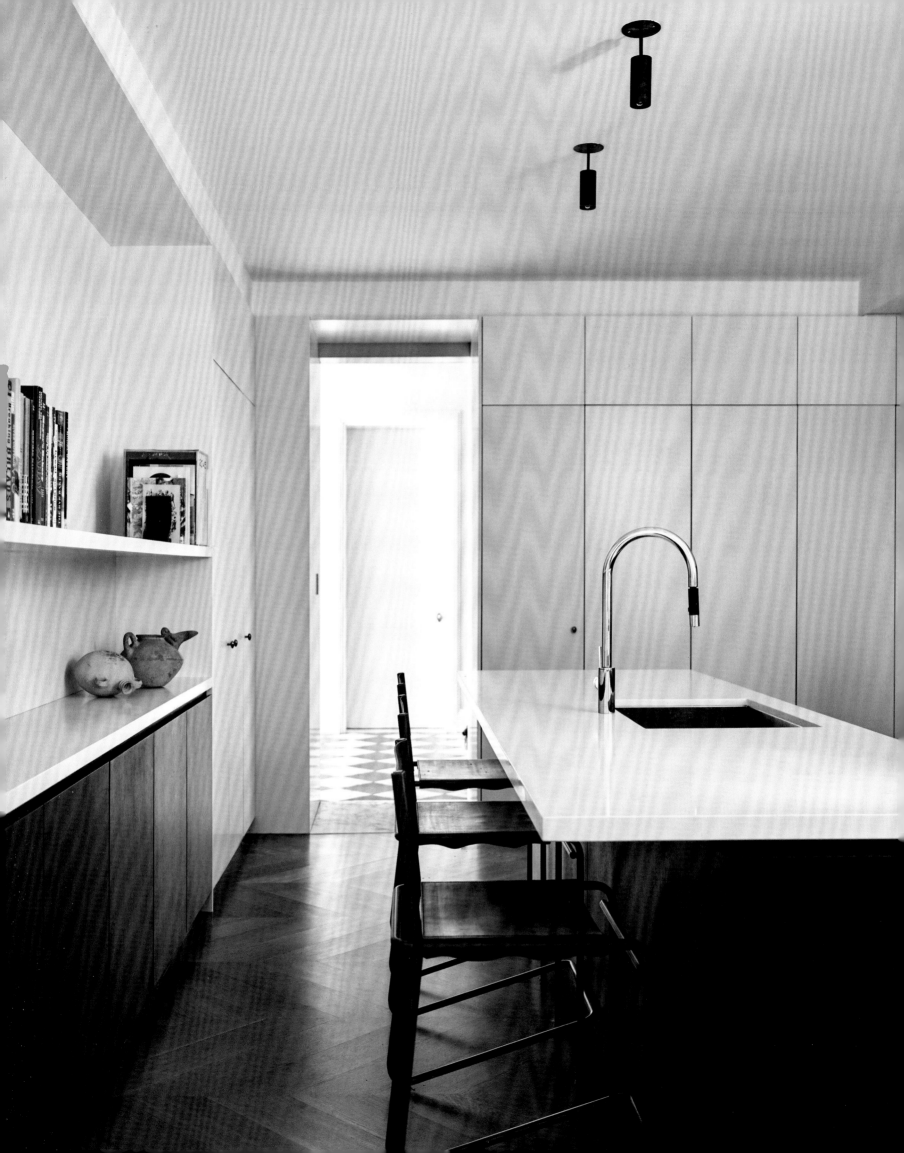

"The client wanted something very modern, but I was cautious that it wouldn't be too trendy. It feels contemporary but timeless. I like to call it our Milanese apartment."

— ARIEL ASHE

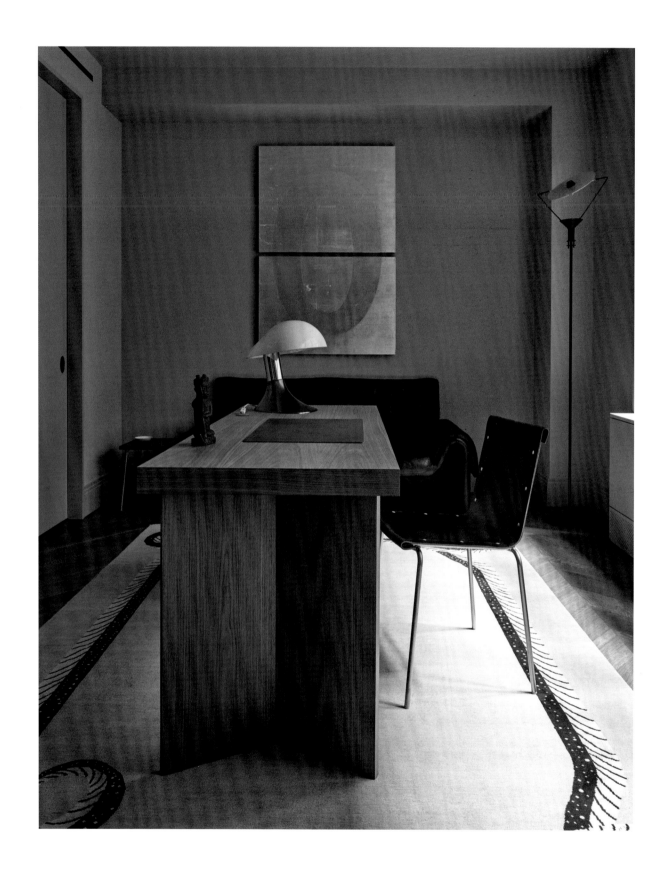

ASHE LEANDRO

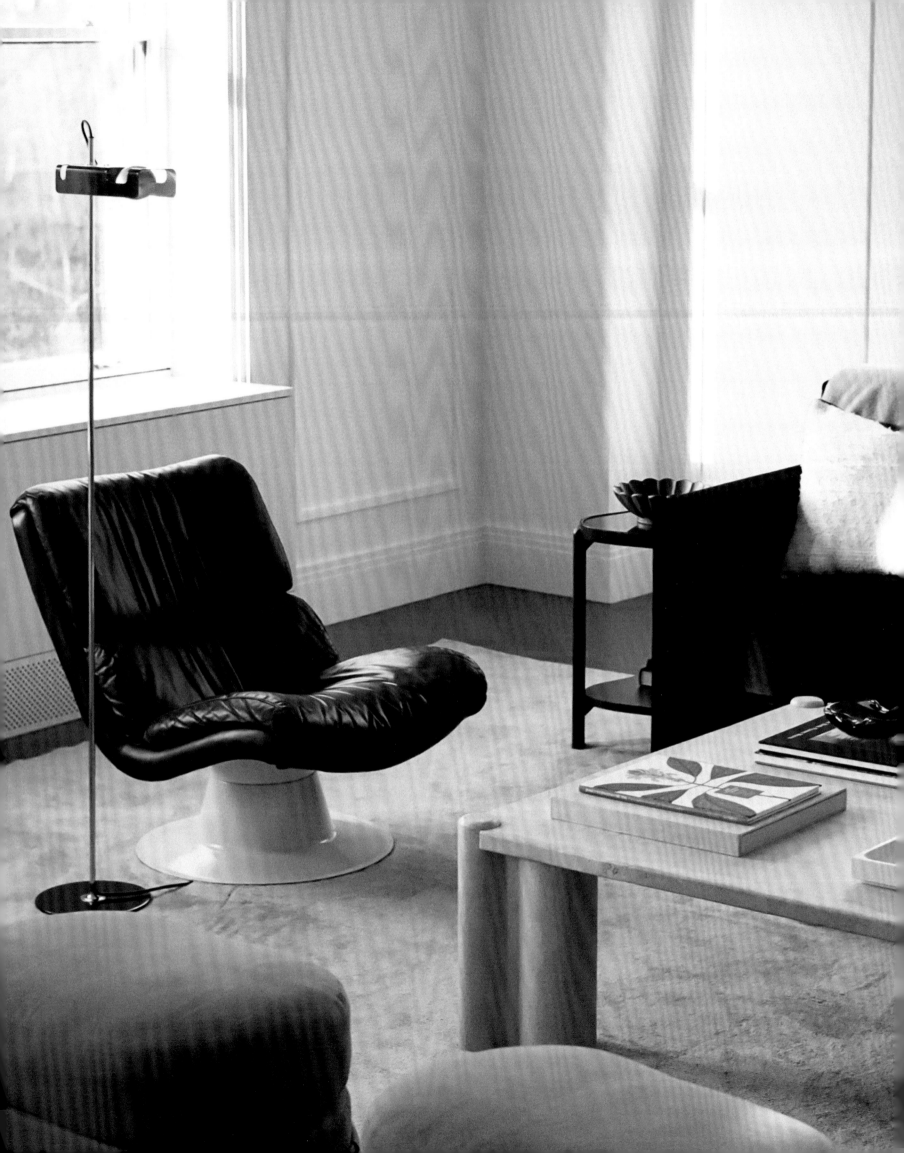

ARCHITECTURAL & INTERIOR DESIGN ASHE LEANDRO
PHOTOGRAPHY ADRIAN GAUT

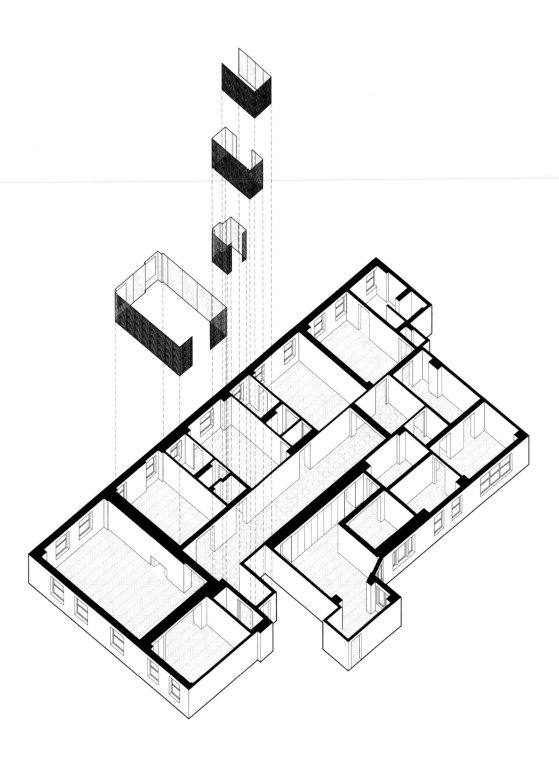

Spatially the layout was more or less defined; we kept none of the original details. It's an entirely different apartment than when we first saw it. We wanted to accentuate the generosity of the center hallway with a special floor of alternating blocks of wood and marble. The space functions both as an art gallery and the main hallway to the back of the house and the bedroom areas. The smaller social areas are free of decorative moldings and are wrapped in a layer of wood panels to make them more inviting.

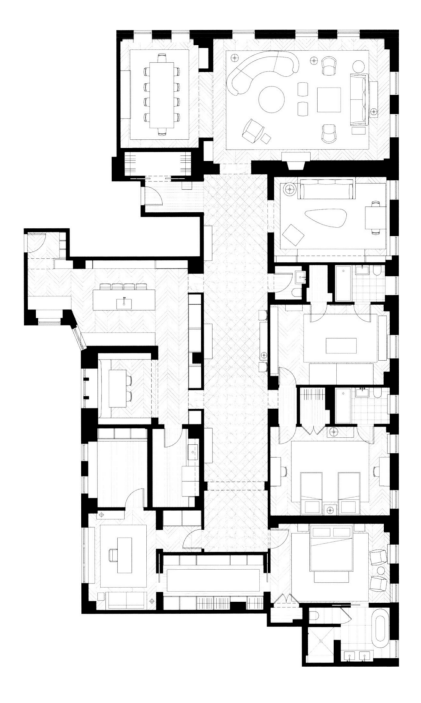

Above: Floor plan. Opposite: Architectural
diagram of wood-paneled areas.

0 10

T

R

I

B

E

C

A

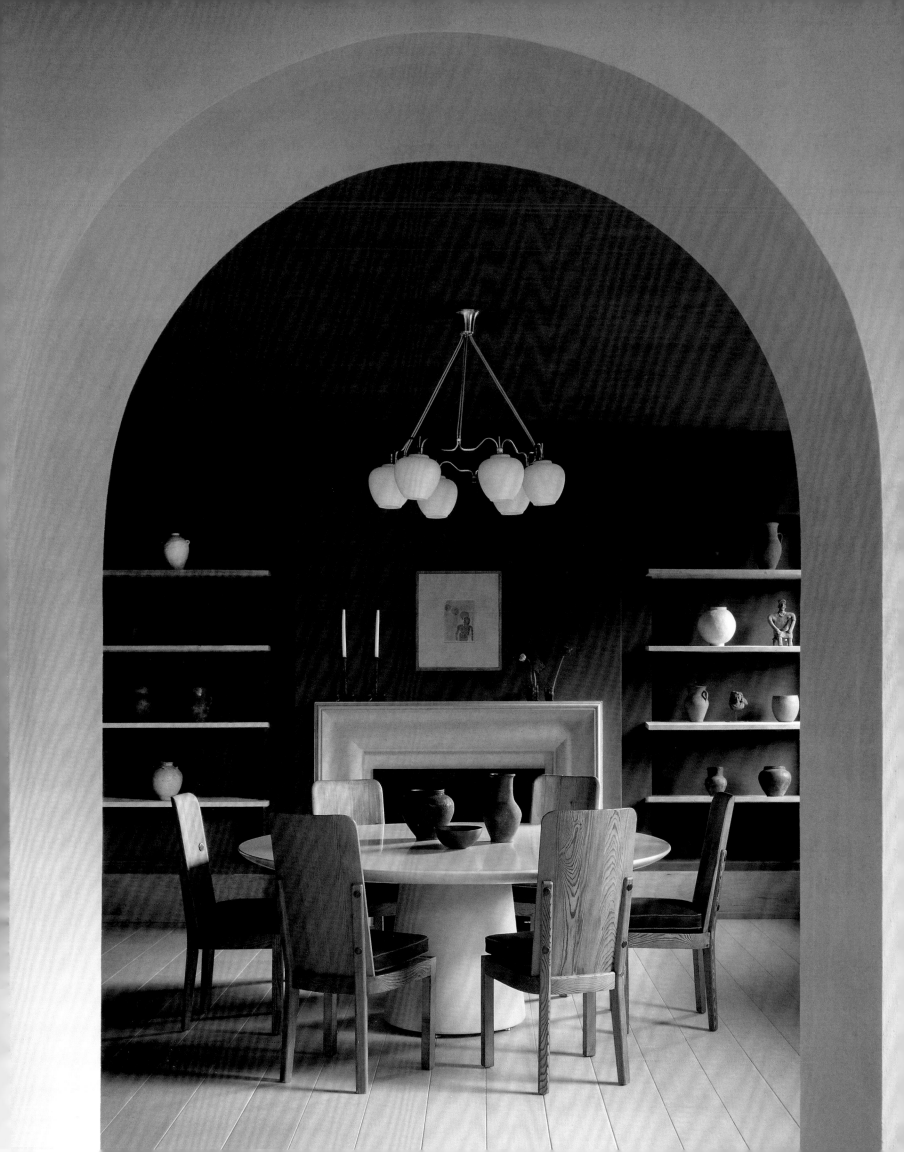

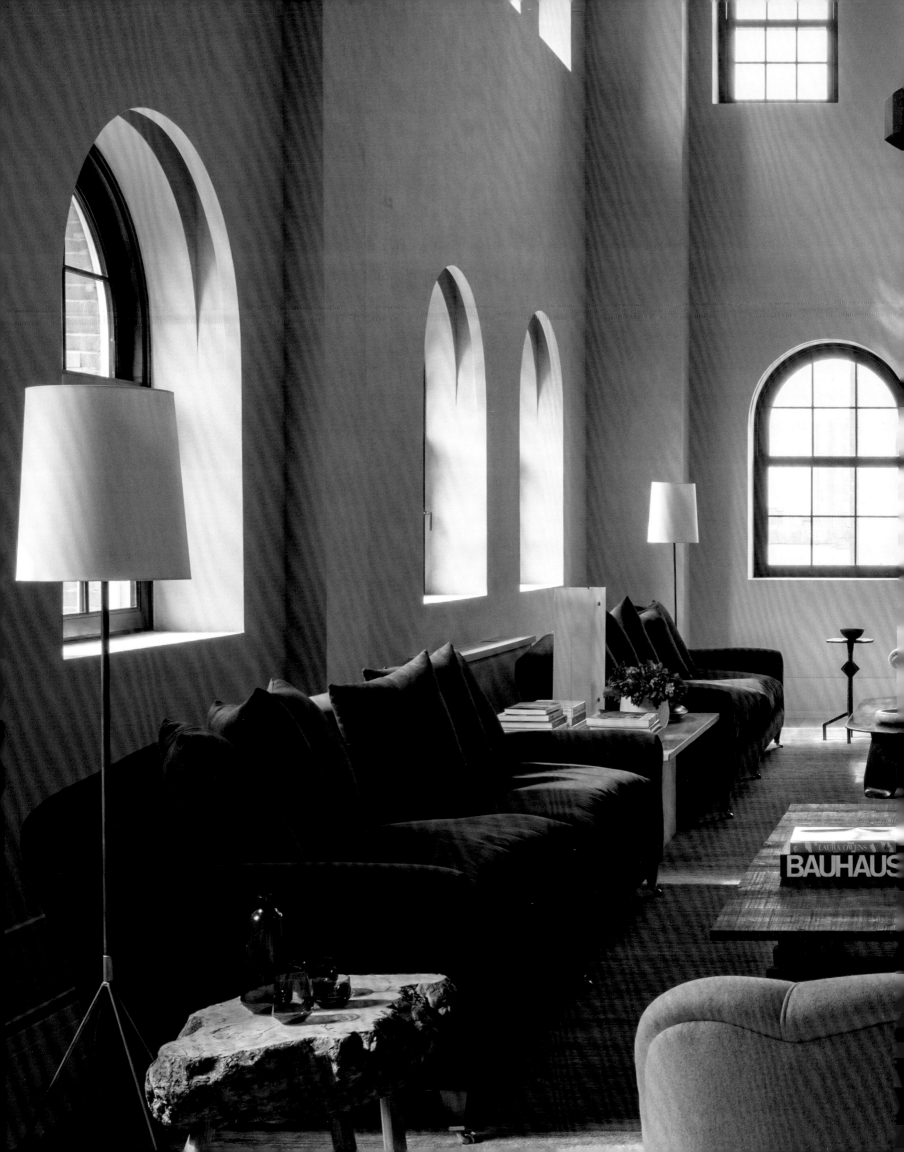

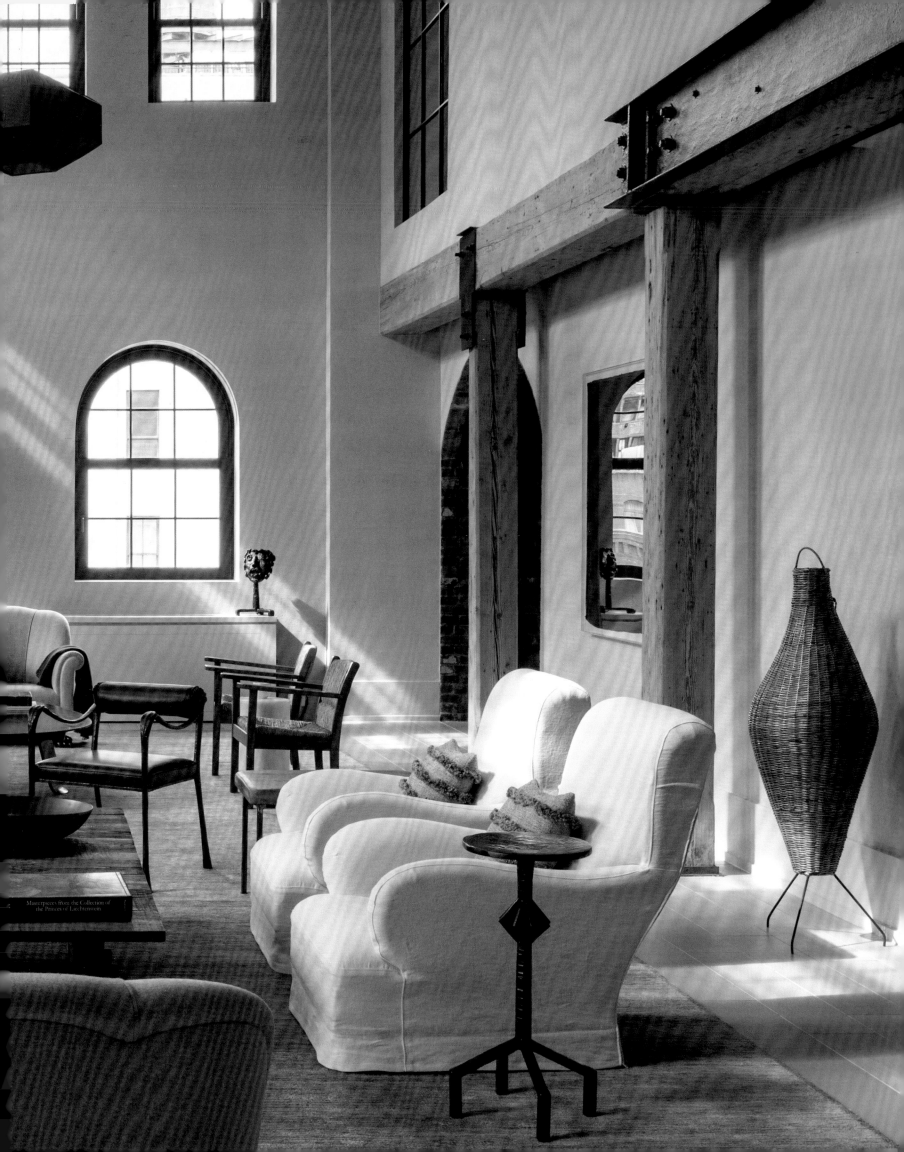

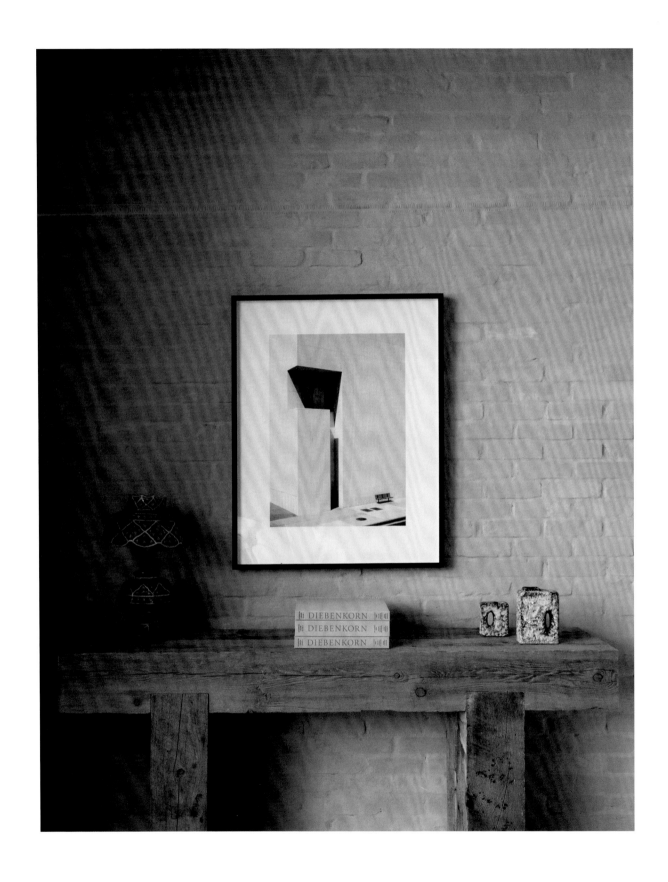

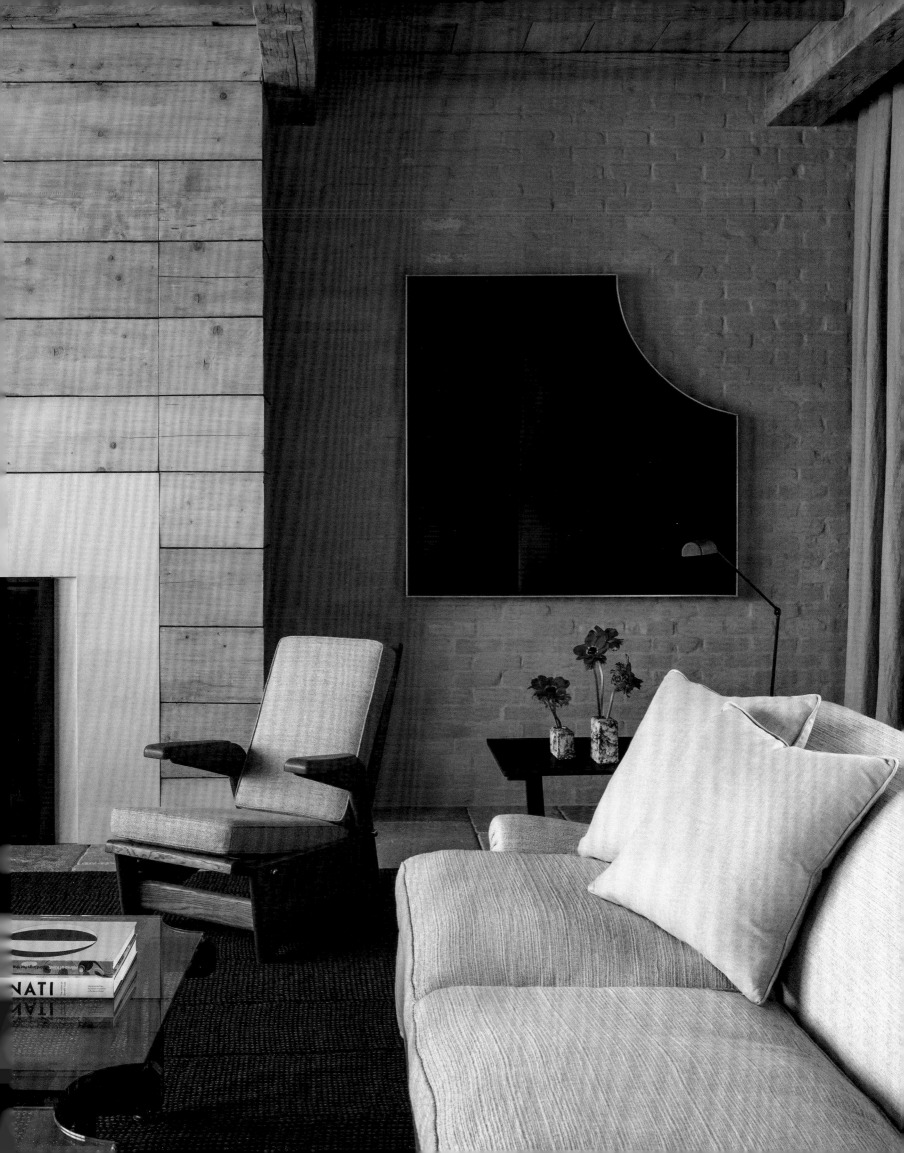

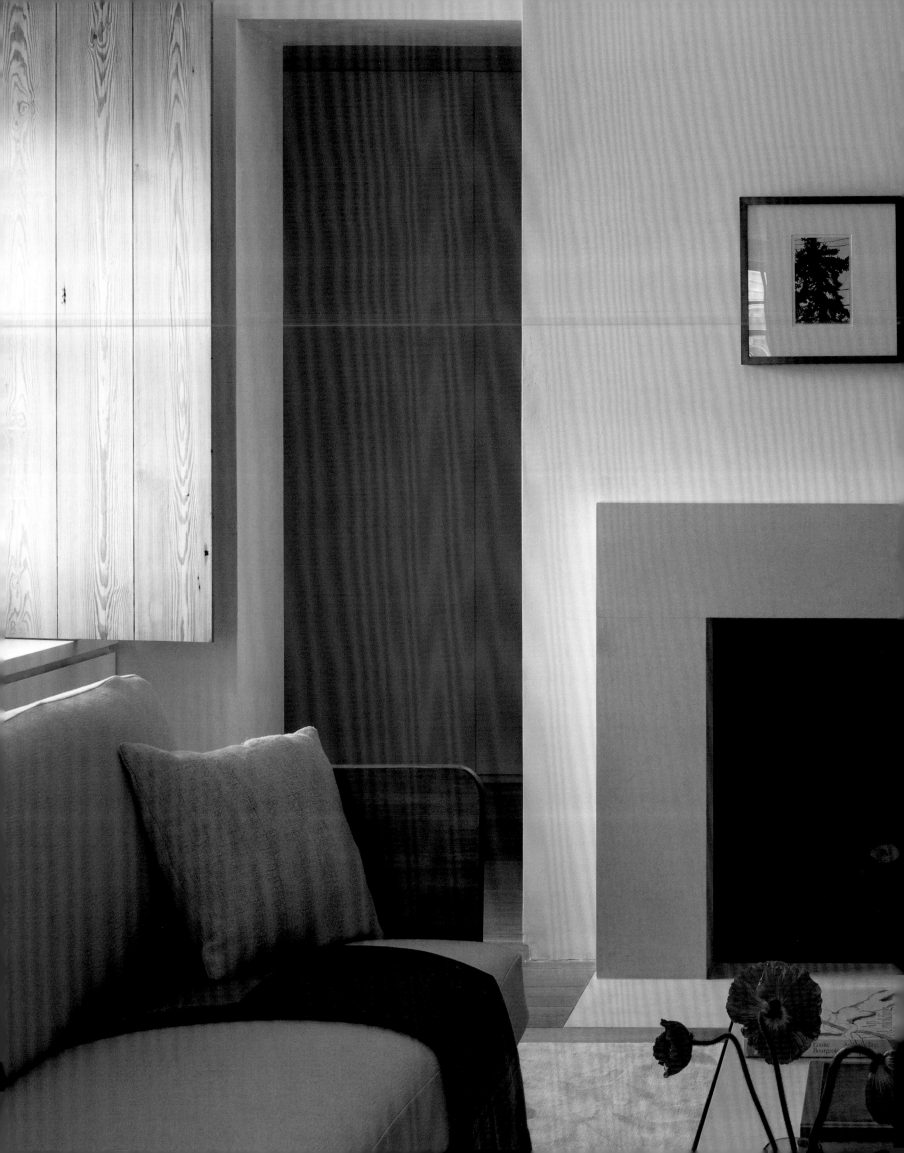

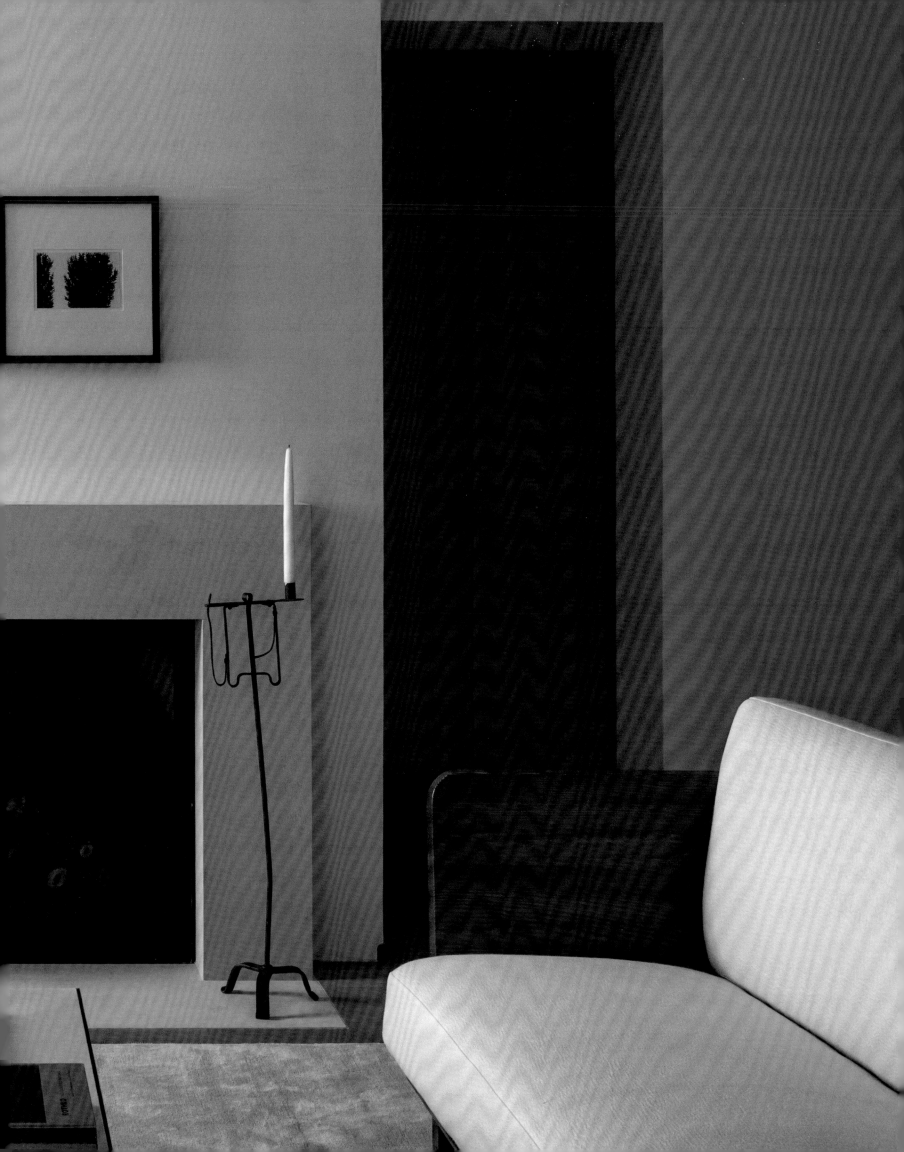

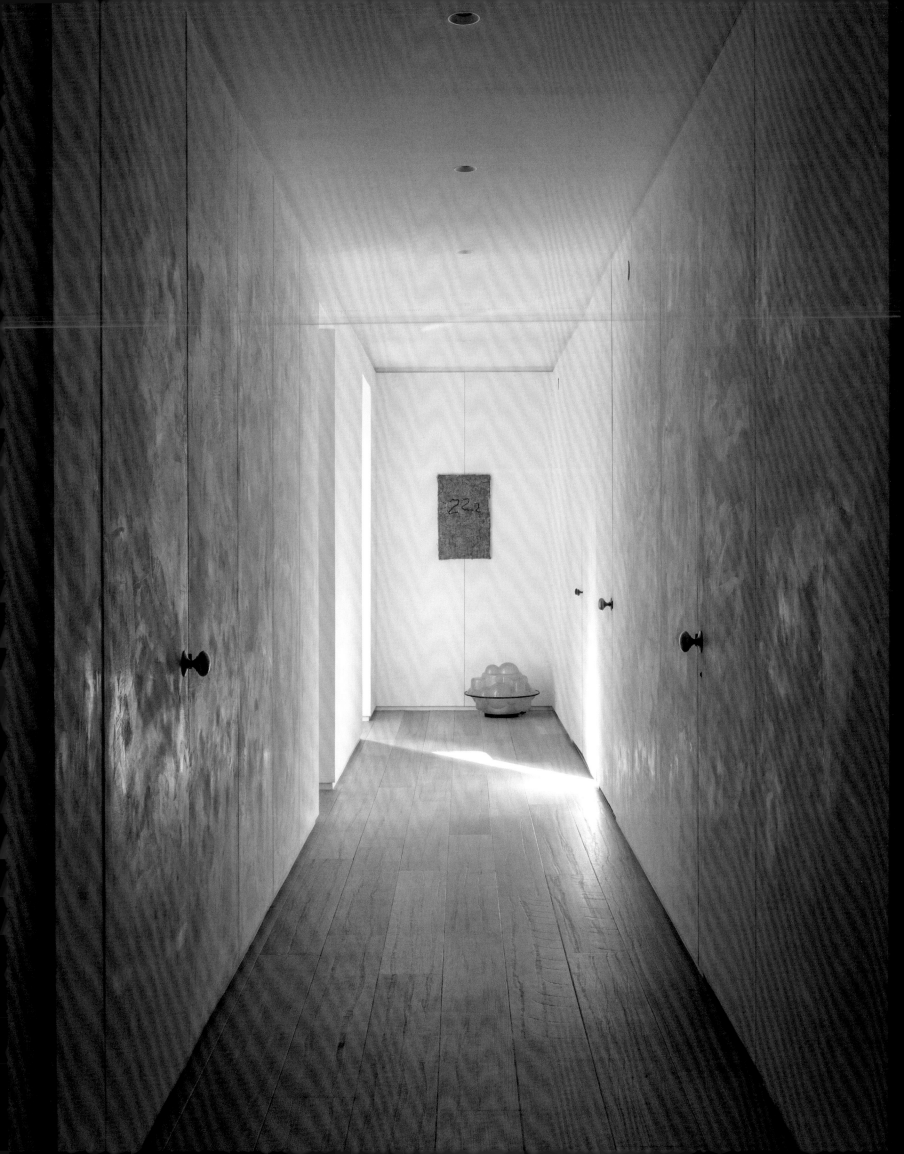

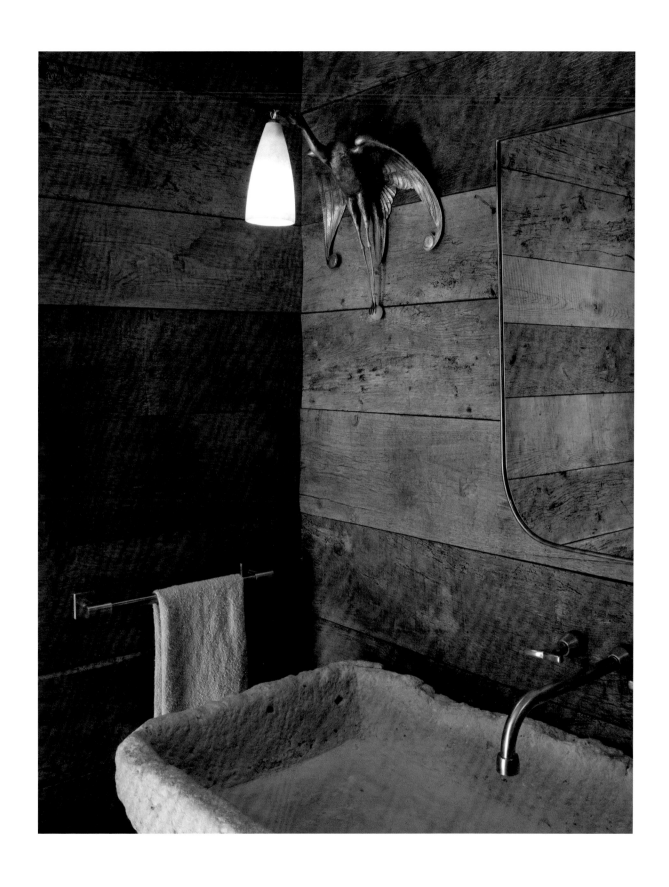

"The building where this home is located was an old
bookbinding factory, and we really wanted to express the history of that
when choosing the new material finishes."

— REINALDO LEANDRO

CREDITS

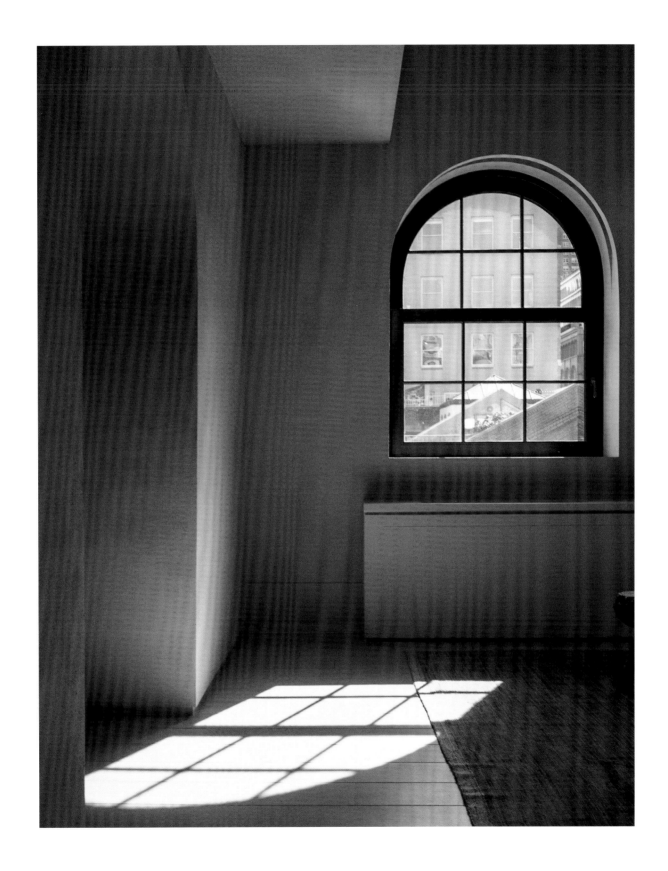

ARCHITECTURAL & INTERIOR DESIGN ASHE LEANDRO
PHOTOGRAPHY SHADE DEGGES

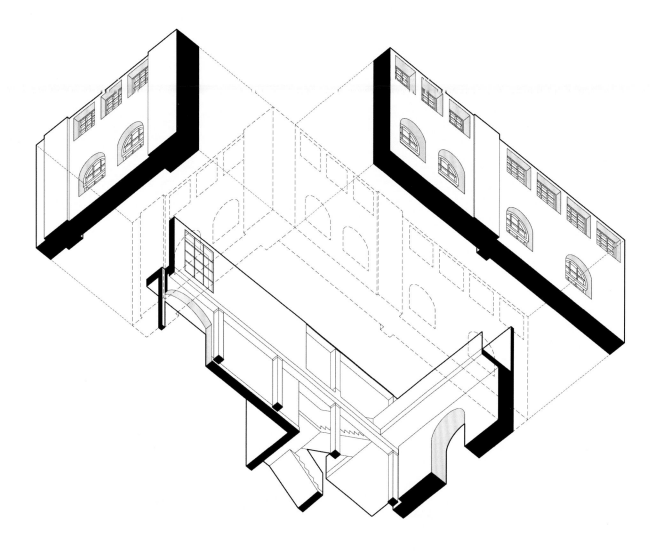

The home is in a Tribeca factory building, and we were able to employ great artisans, among them an amazing plaster and specialty finish team, and an incredible stonemason and millworker, to experiment with finishes and make the space feel raw yet comfortable and luxurious. Inspired by the original building facade, we played with repetition, mimicking and repeating arches where we could while creating deep windowsills and thresholds.

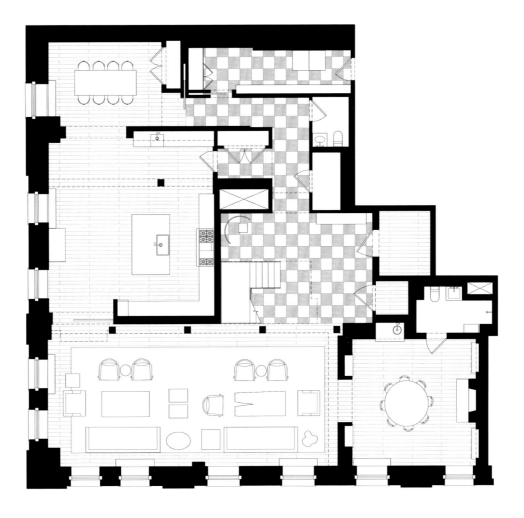

Above: Floor plan of the entry level. Opposite:
Architectural diagram of the Great Room with
deep windows and new arched thresholds.

0 10

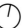

C
H
I
L
M
A
R
K

MARTHA'S VINEYARD

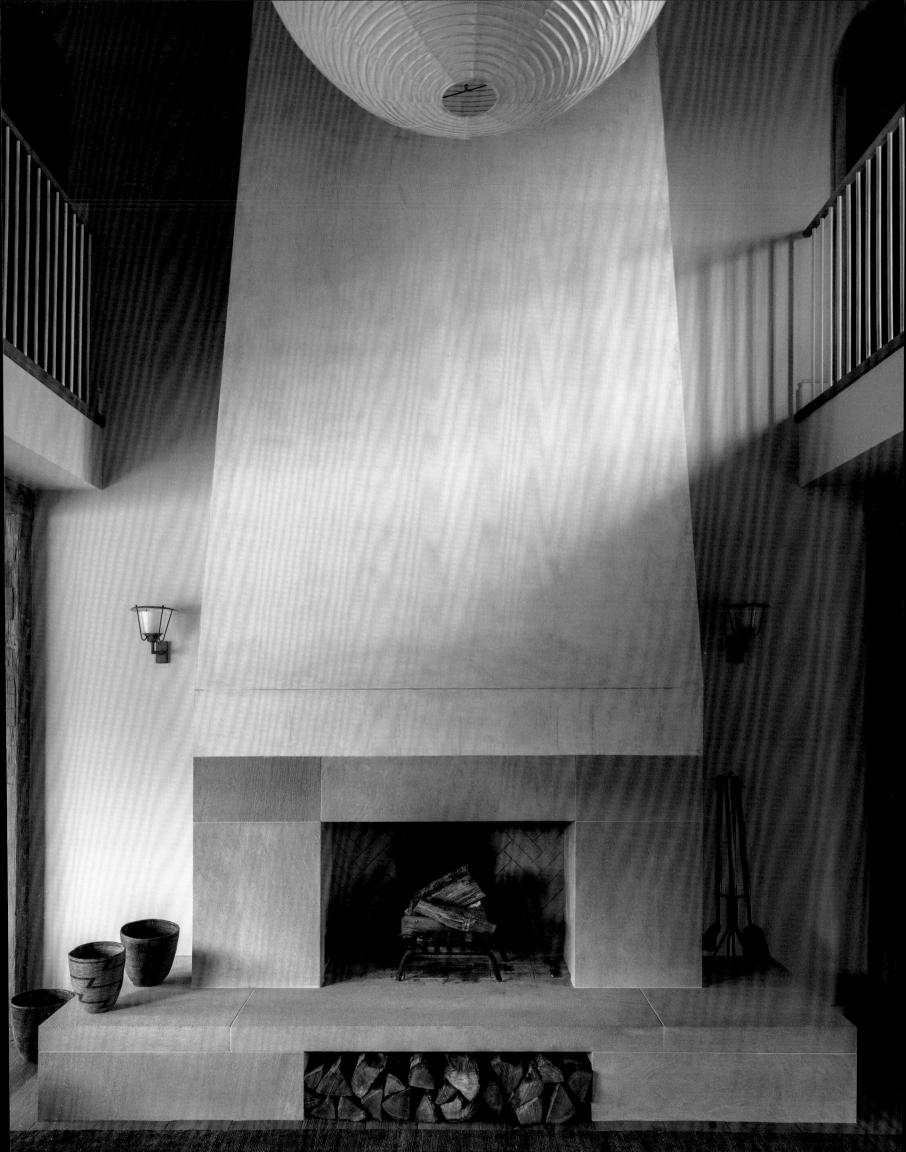

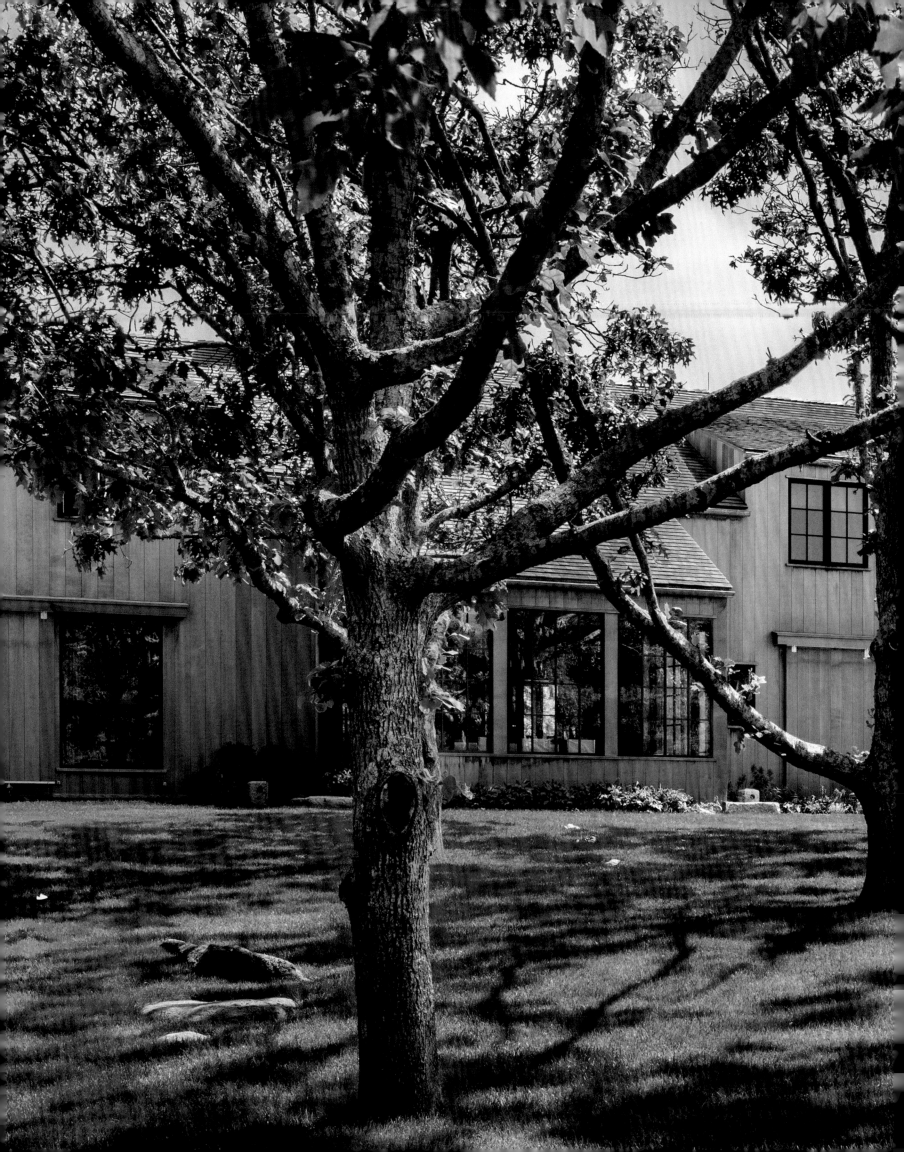

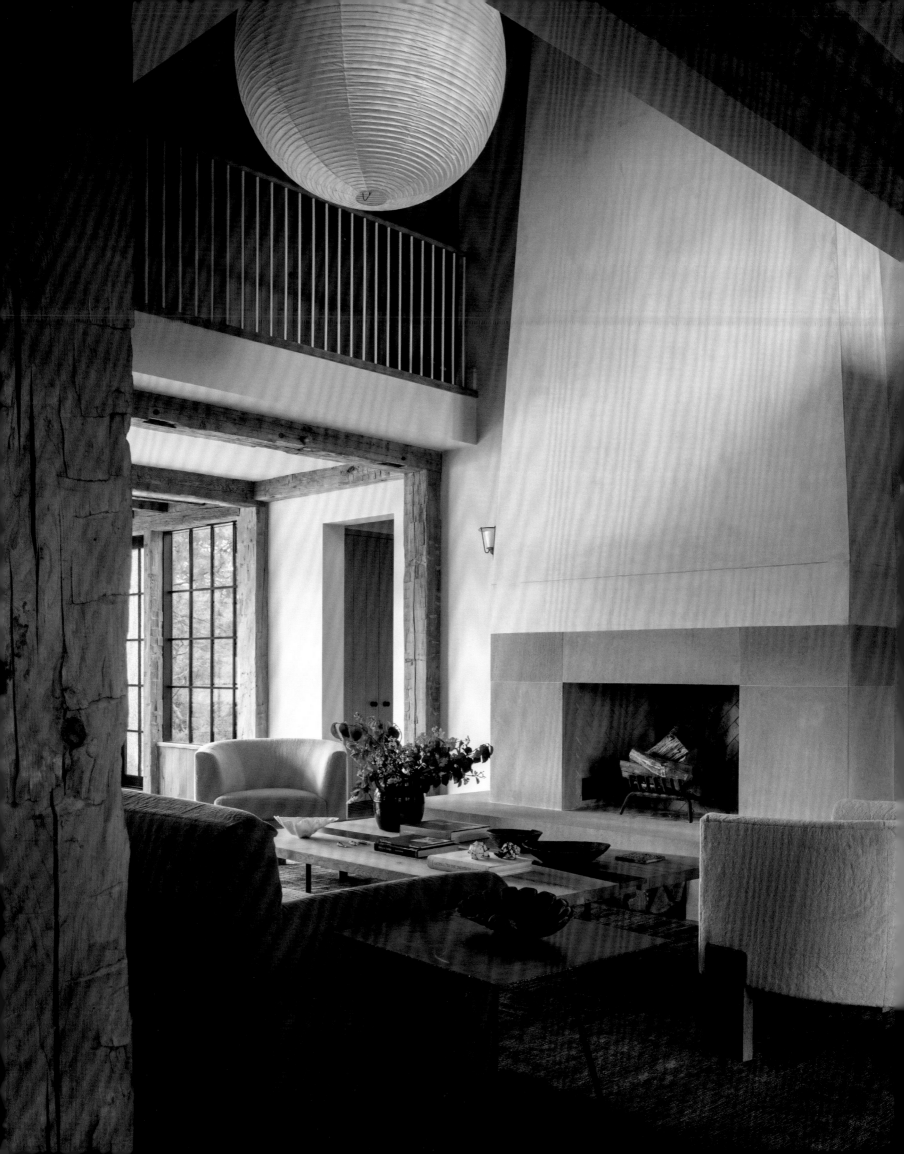

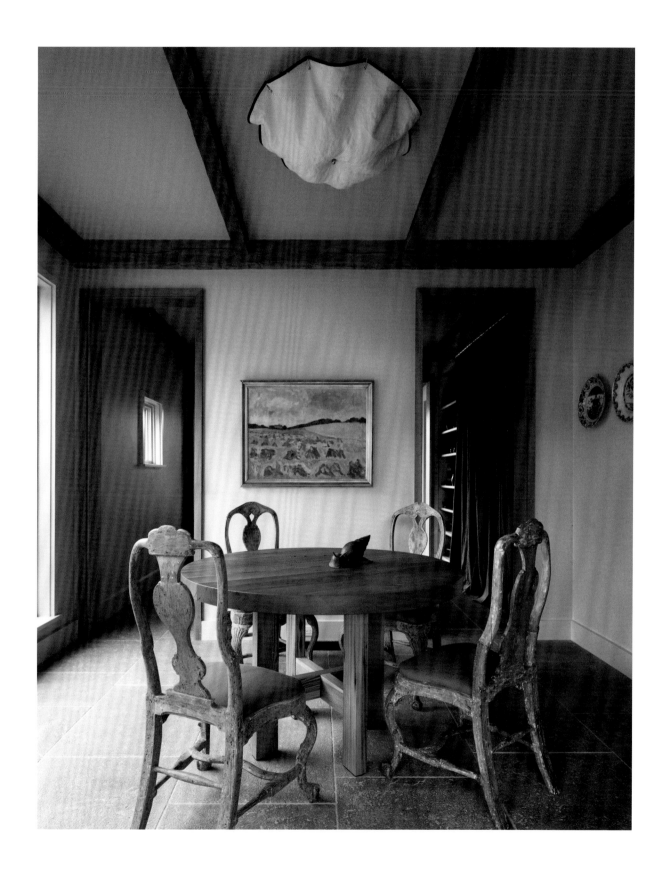

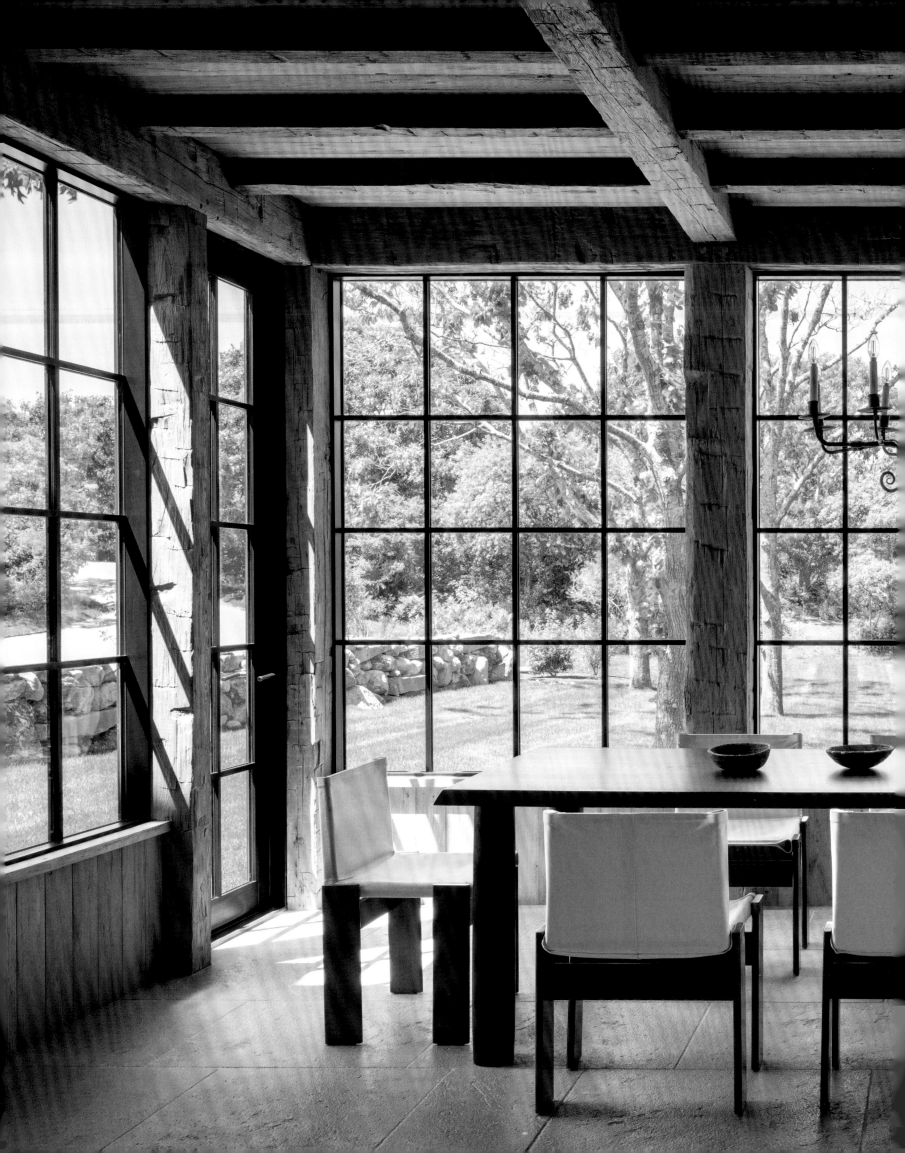

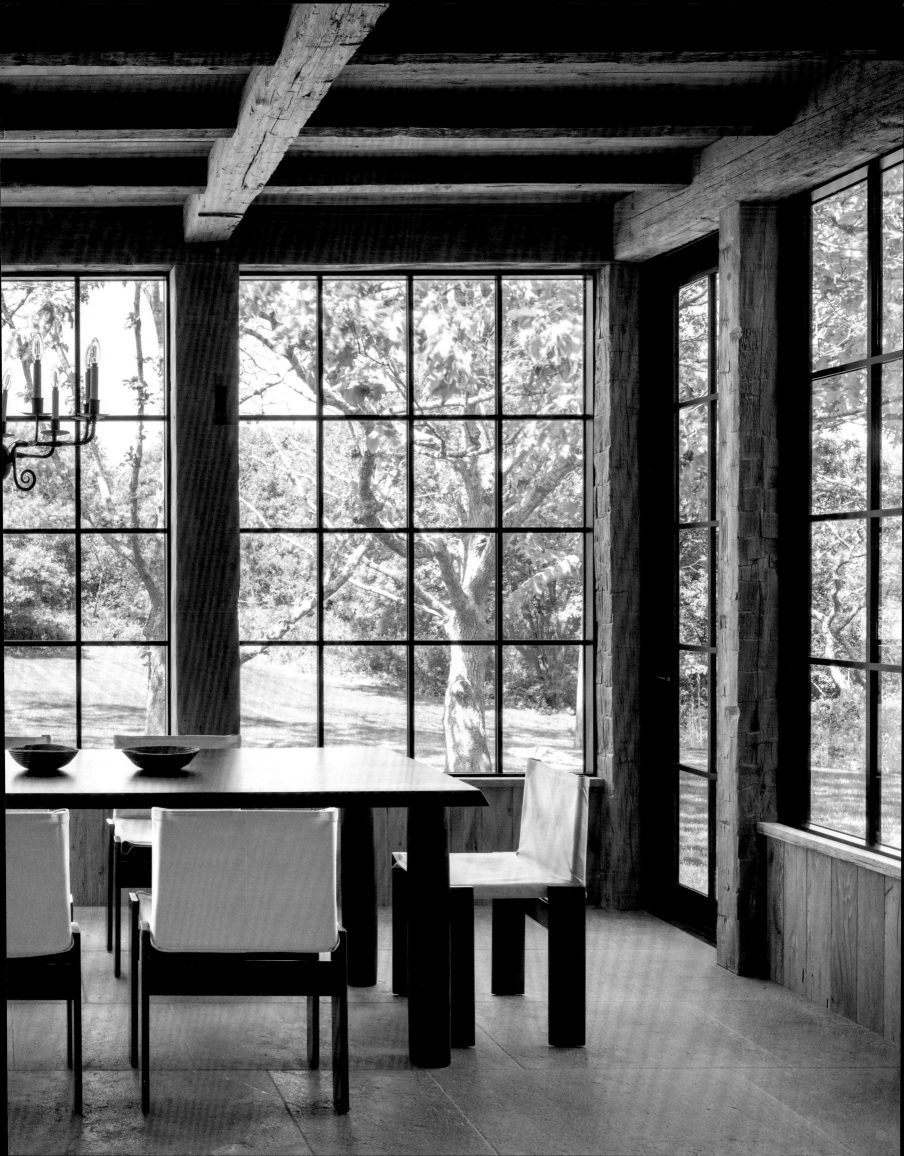

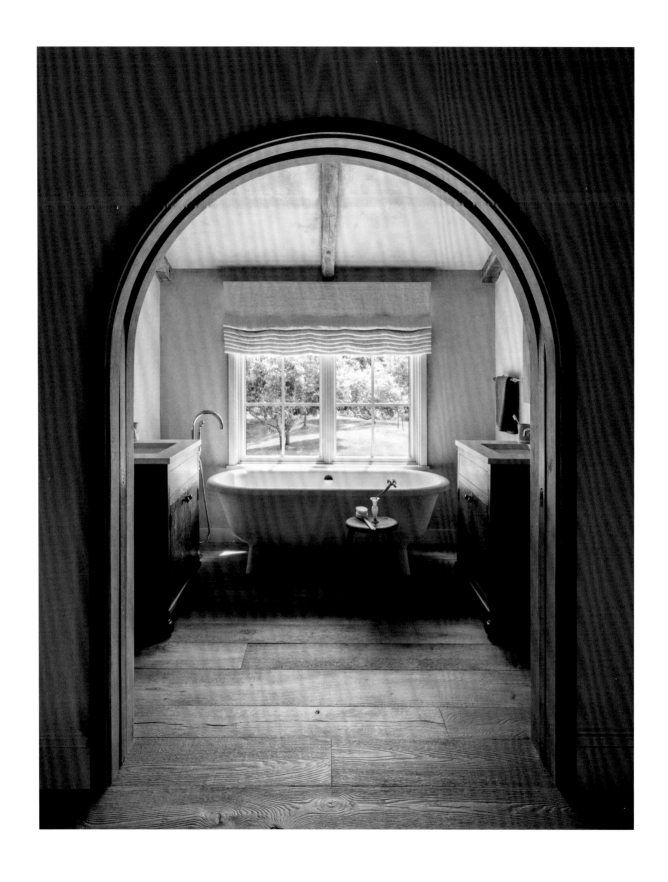

ASHE LEANDRO

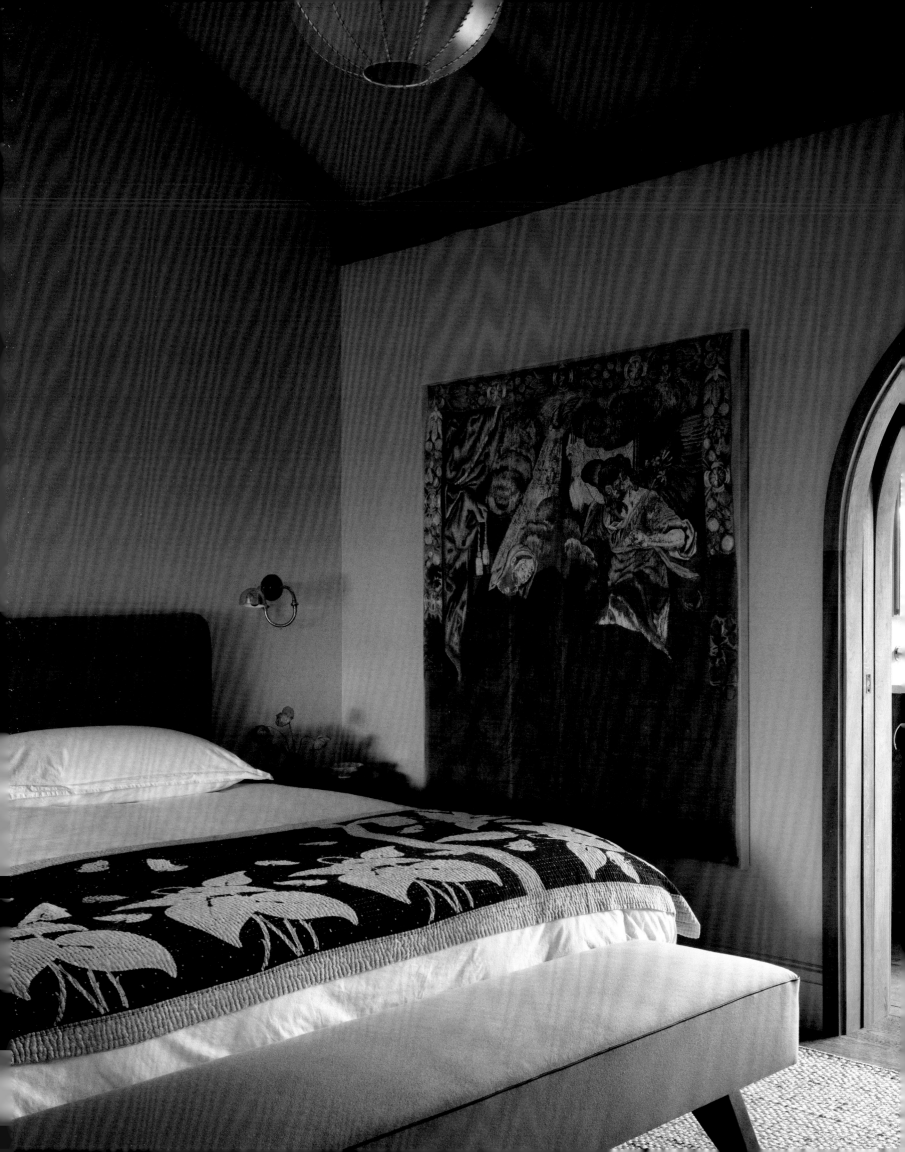

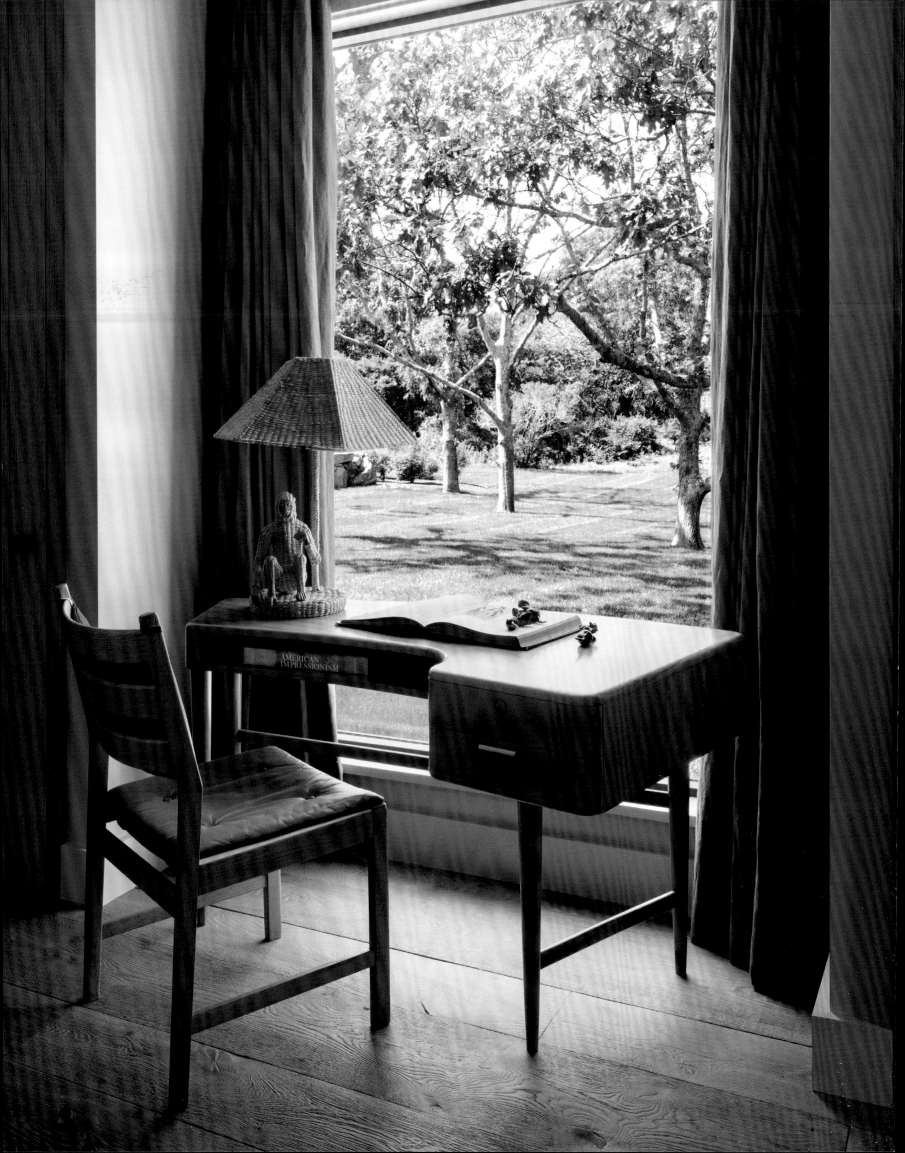

ARCHITECTURAL & INTERIOR DESIGN ASHE LEANDRO
PHOTOGRAPHY SHADE DEGGES

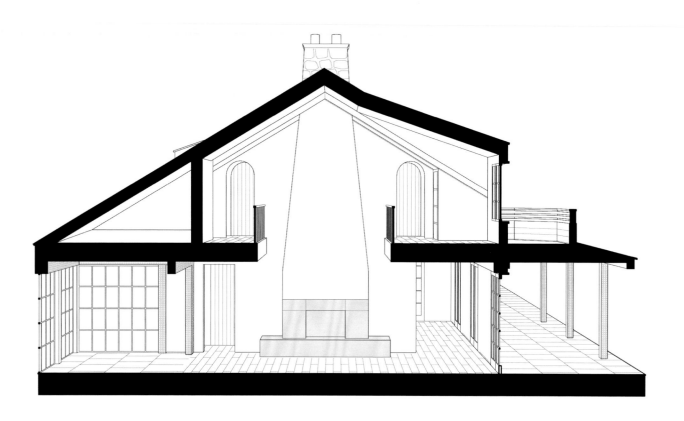

On Martha's Vineyard, you hardly see contemporary buildings. The narrative became that of a modern house within a more traditional, Northeastern architectural style. We strategically made a combination of more classic mullion windows with picture windows framing out specific views. A lot of the architectural decisions were also driven by the interior spaces and how they shaped the house itself. The dining room jets out into the orchard, providing a lantern effect at night.

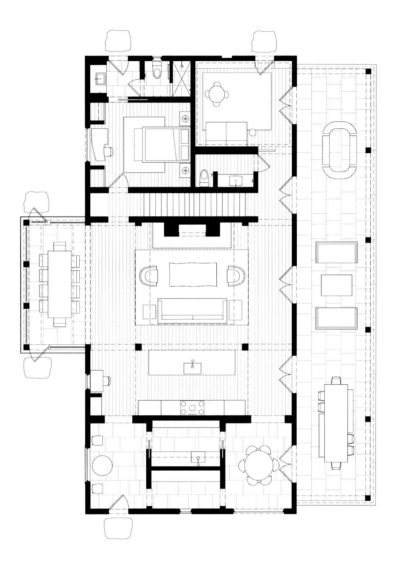

Above: First-floor floor plan.
Opposite: Section through the double-height
living room and dining room.

0 10

B
R
I
X
B
Y

CONNECTICUT

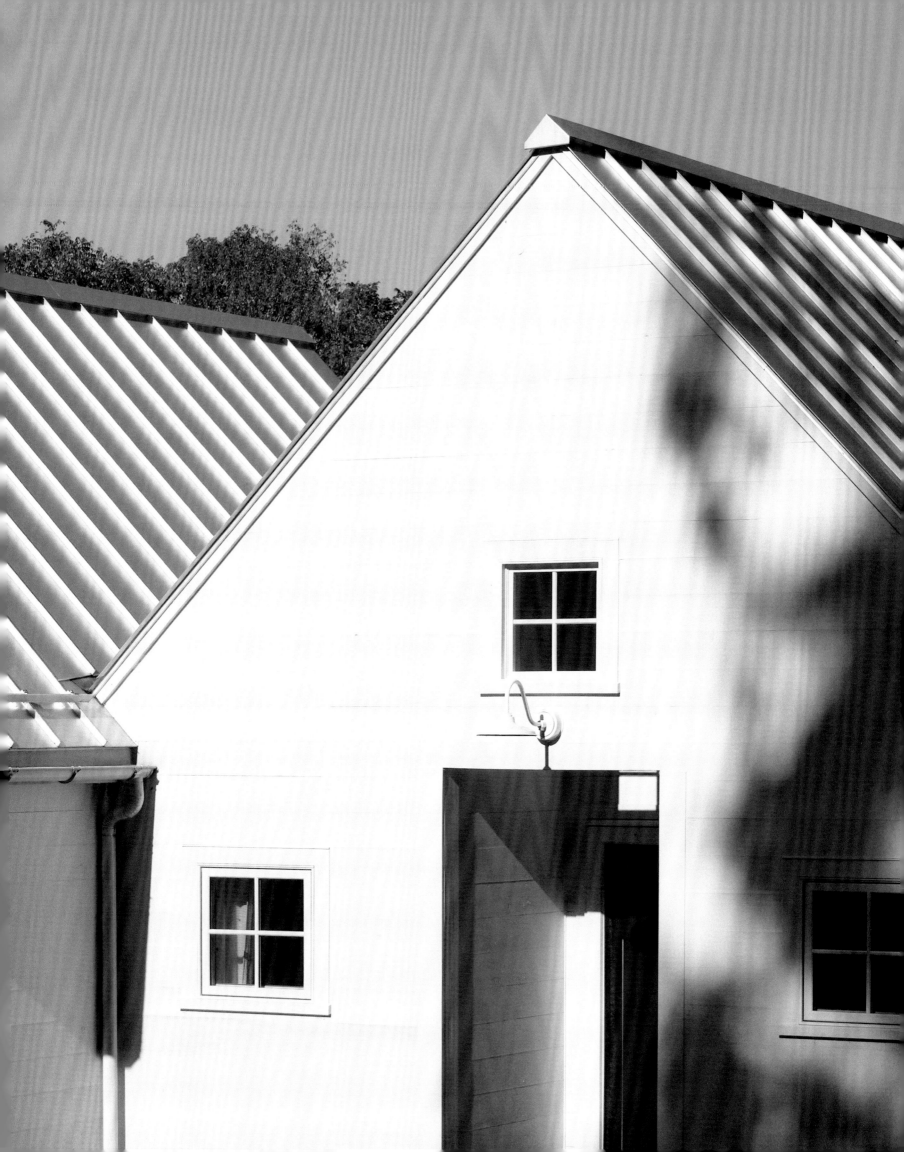

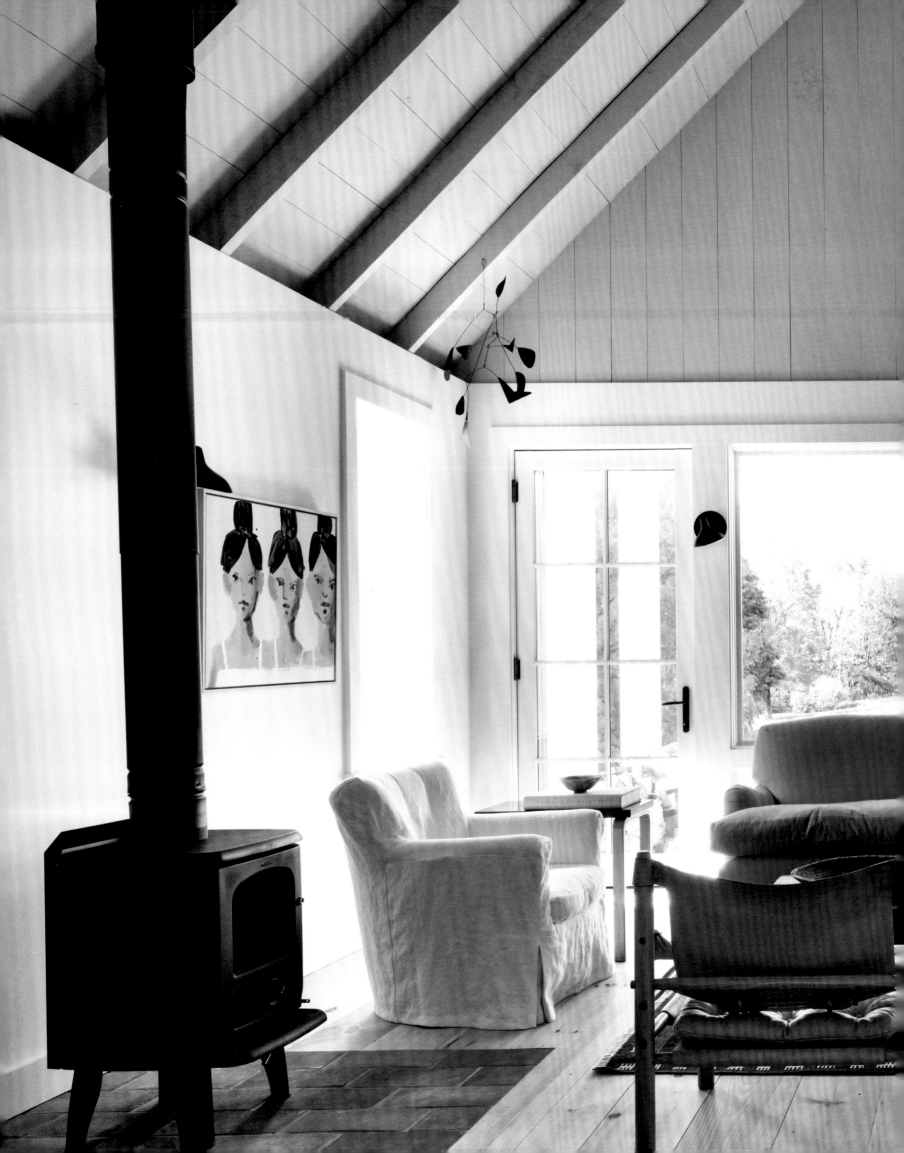

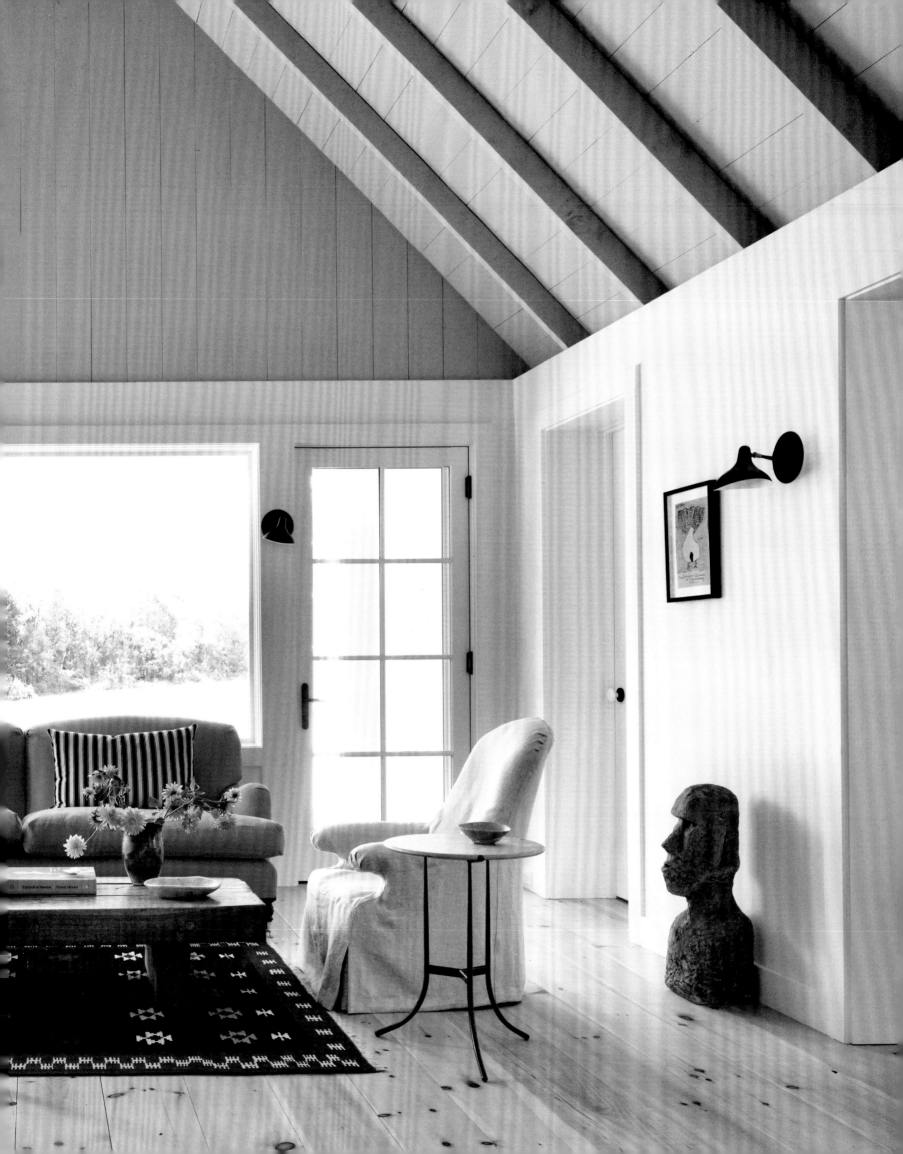

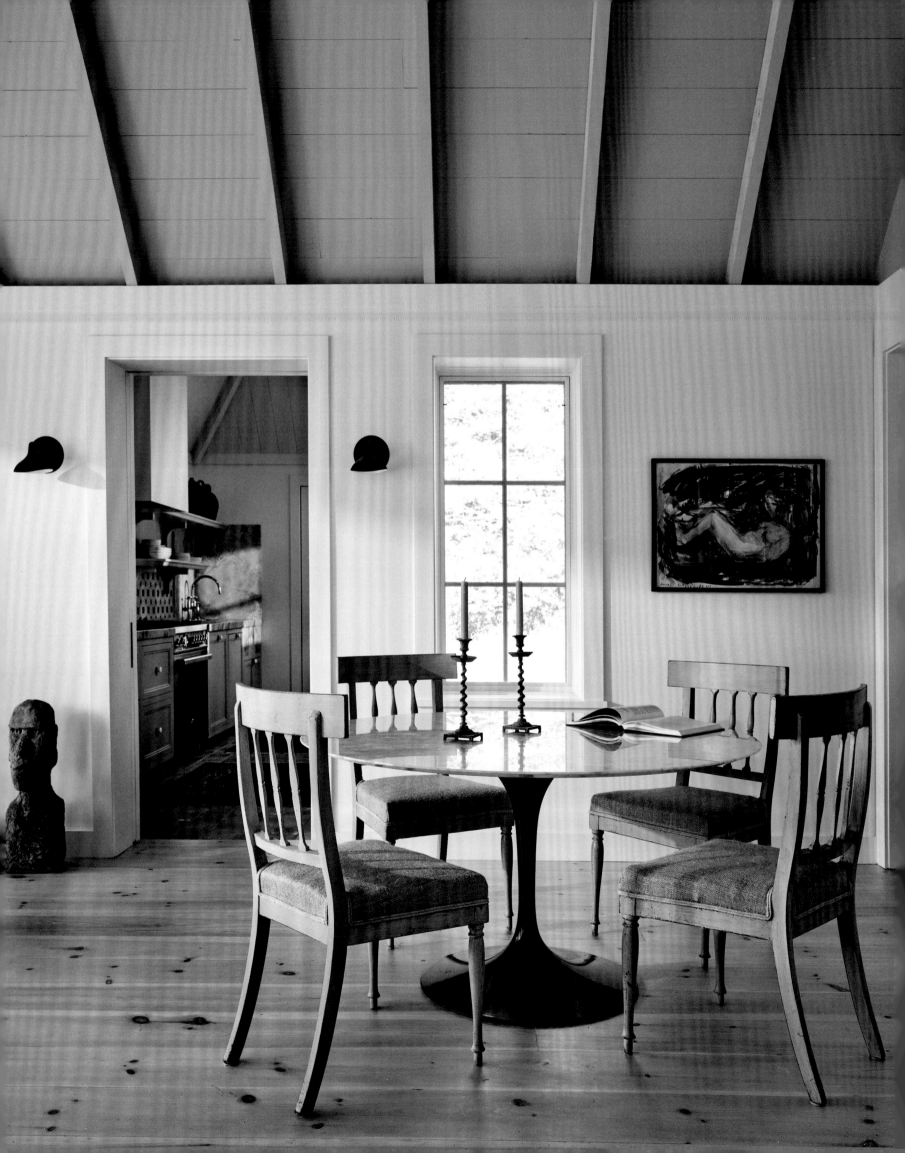

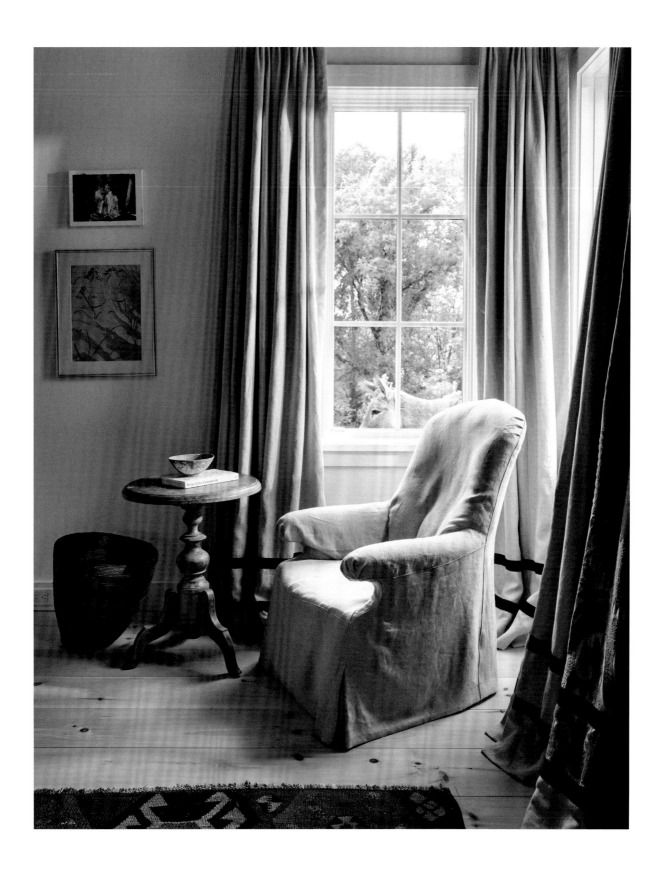

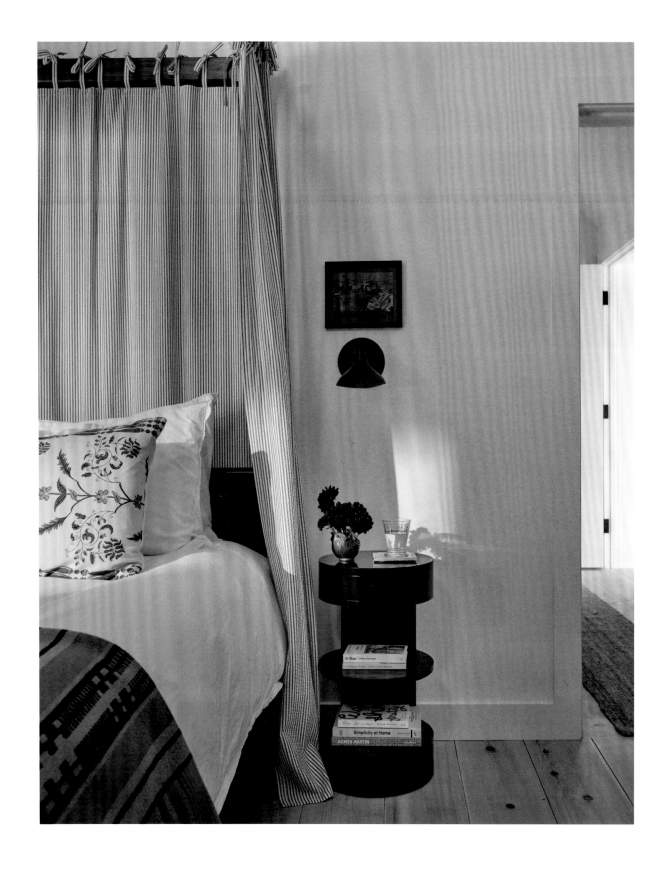

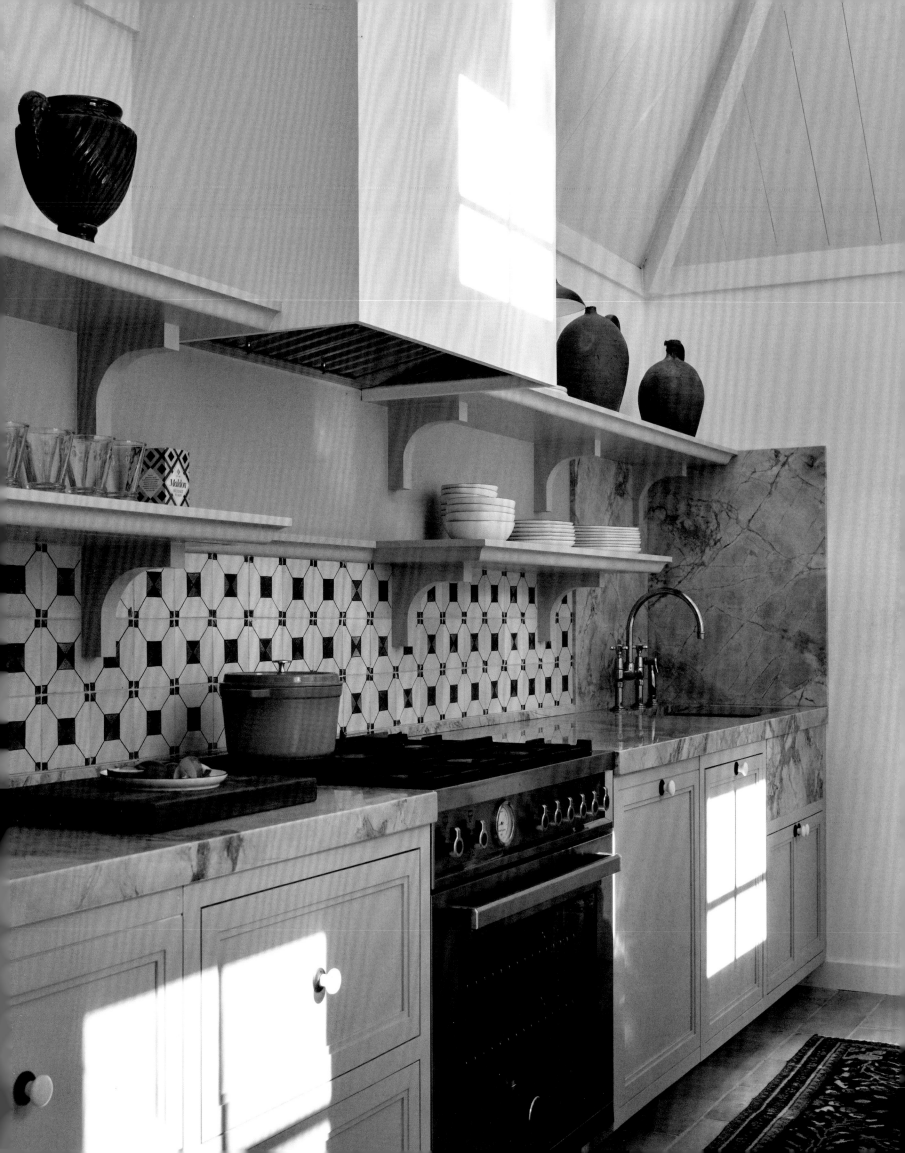

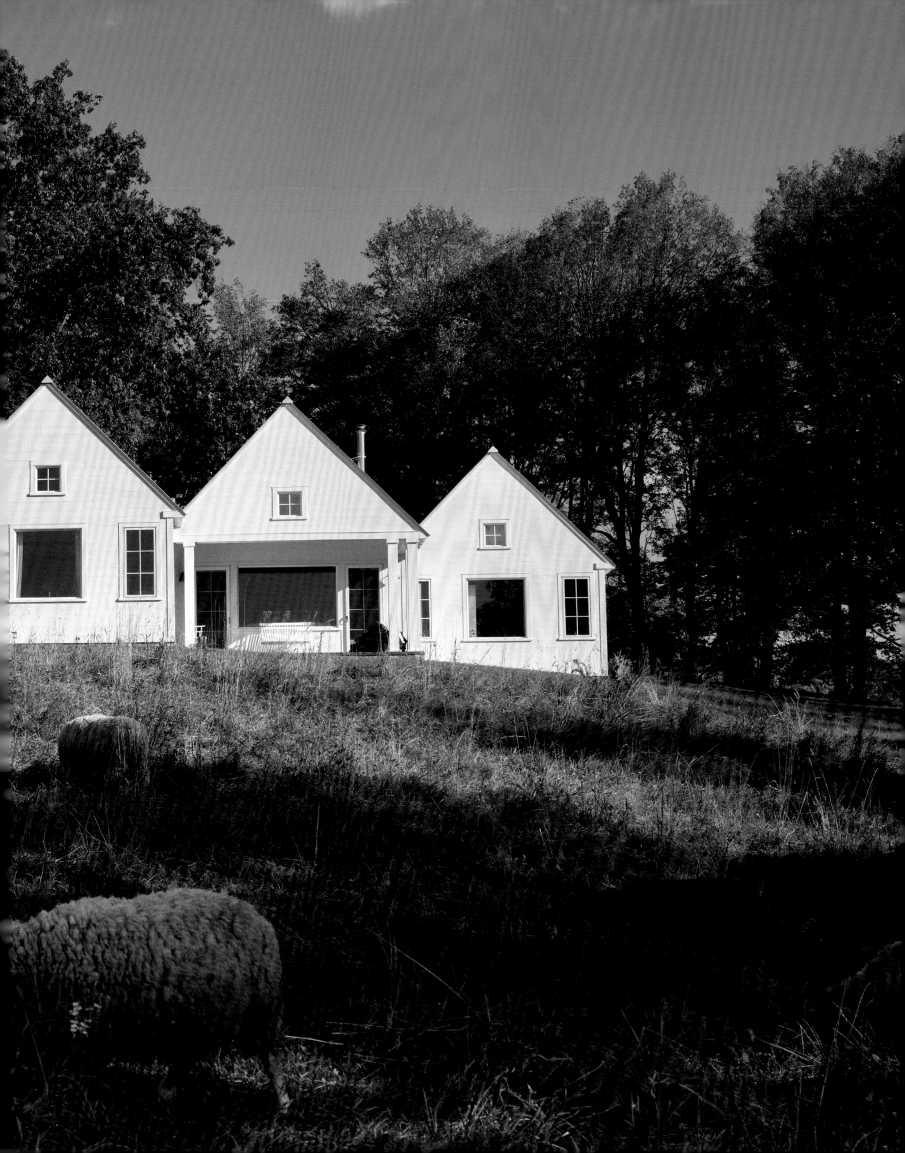

ASHE LEANDRO

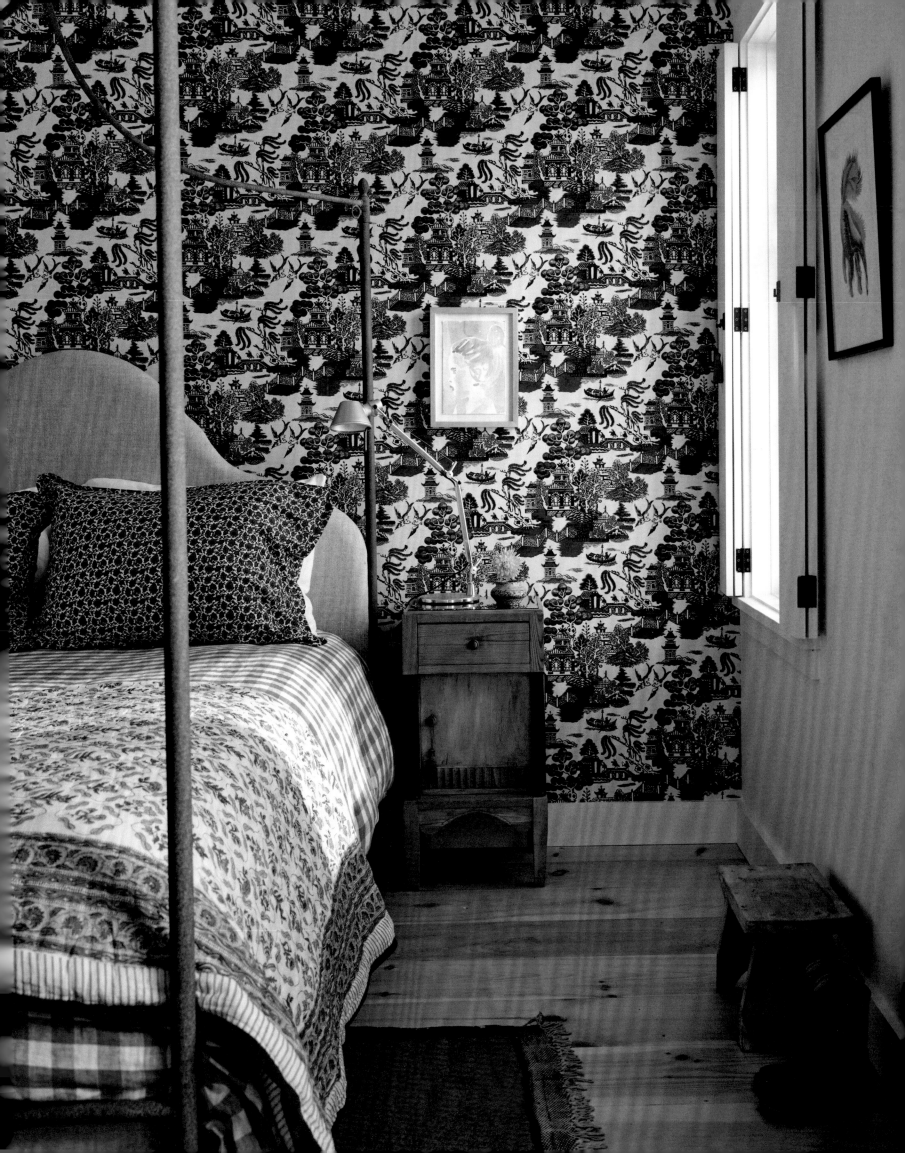

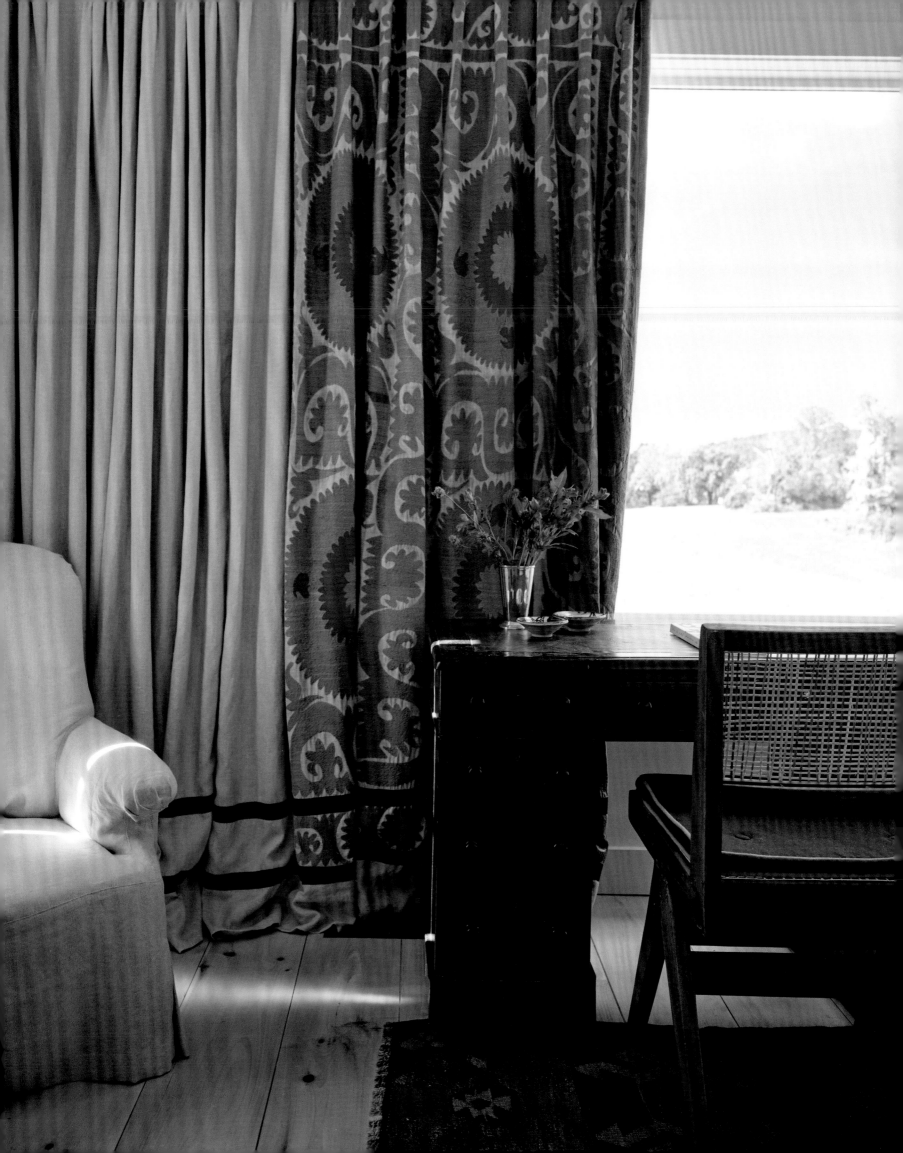

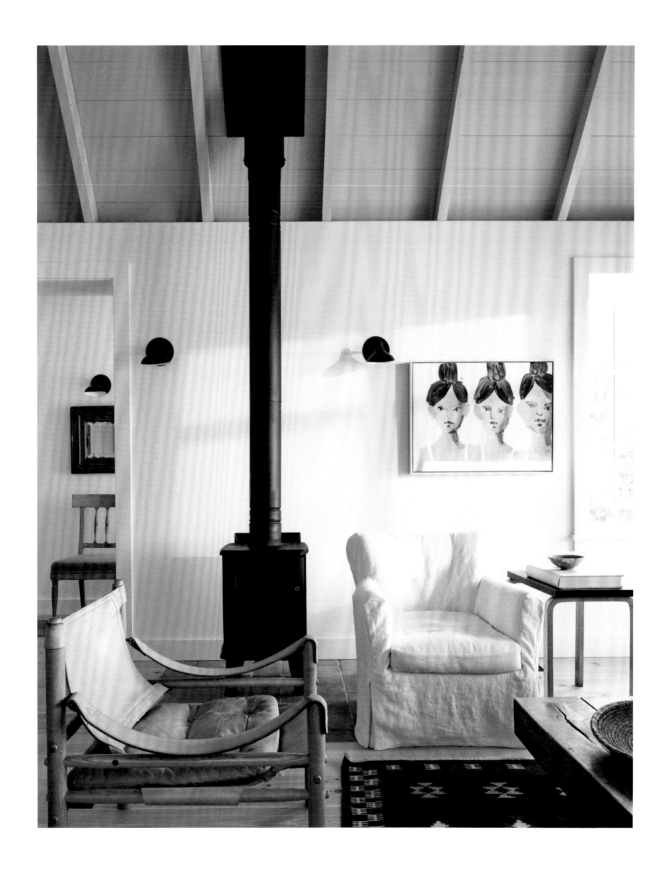

ARCHITECTURAL & INTERIOR DESIGN ASHE LEANDRO
PHOTOGRAPHY ADRIAN GAUT

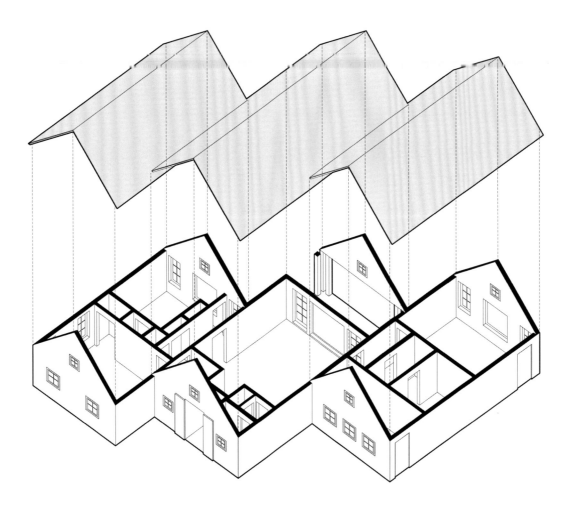

For the program and interior of this guesthouse, our inspiration was a Danish caretaker home with a simple three-bedroom cottage, white painted wood walls, pine floors, and a little woodburning stove. Exterior-wise, it is inspired by the architecture of Hugh Newell Jacobsen (1929–2021). He used a lot of repetition in his work. We liked the idea of creating three very pure white volumes: the guest rooms, the social quarters, and the private quarters (i.e., bedrooms).

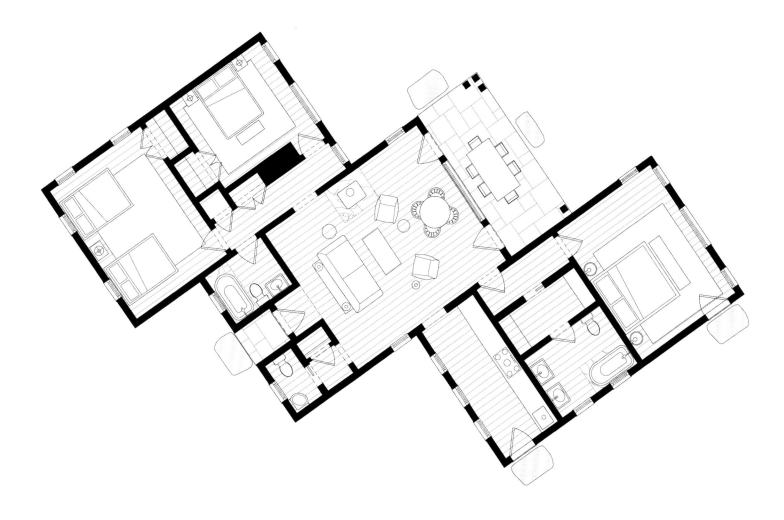

Above: Floor plan of the guesthouse.
Opposite: Architectural diagram
with the three gabled volumes housing
the cottage's program.

 PLANS

0 10

(Ⅷ)

GEORGICA

EAST HAMPTON

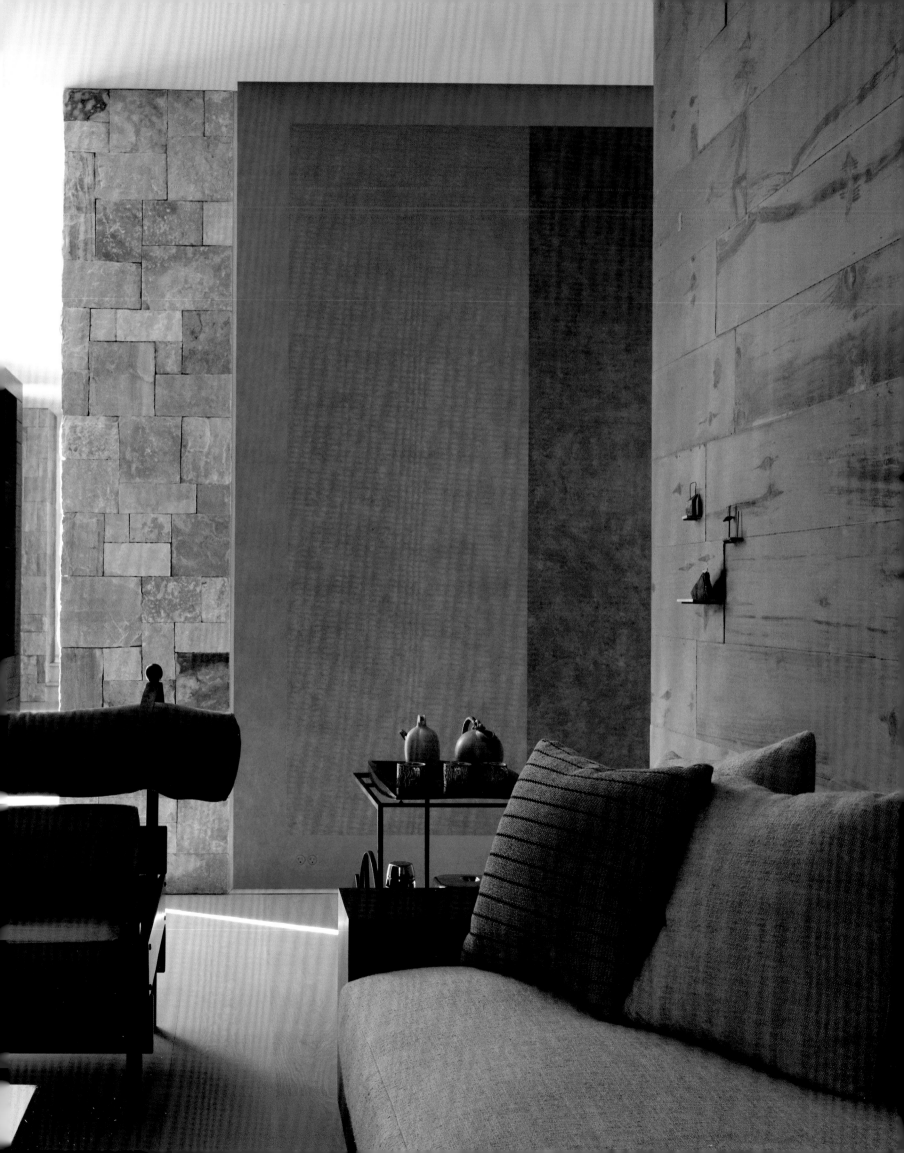

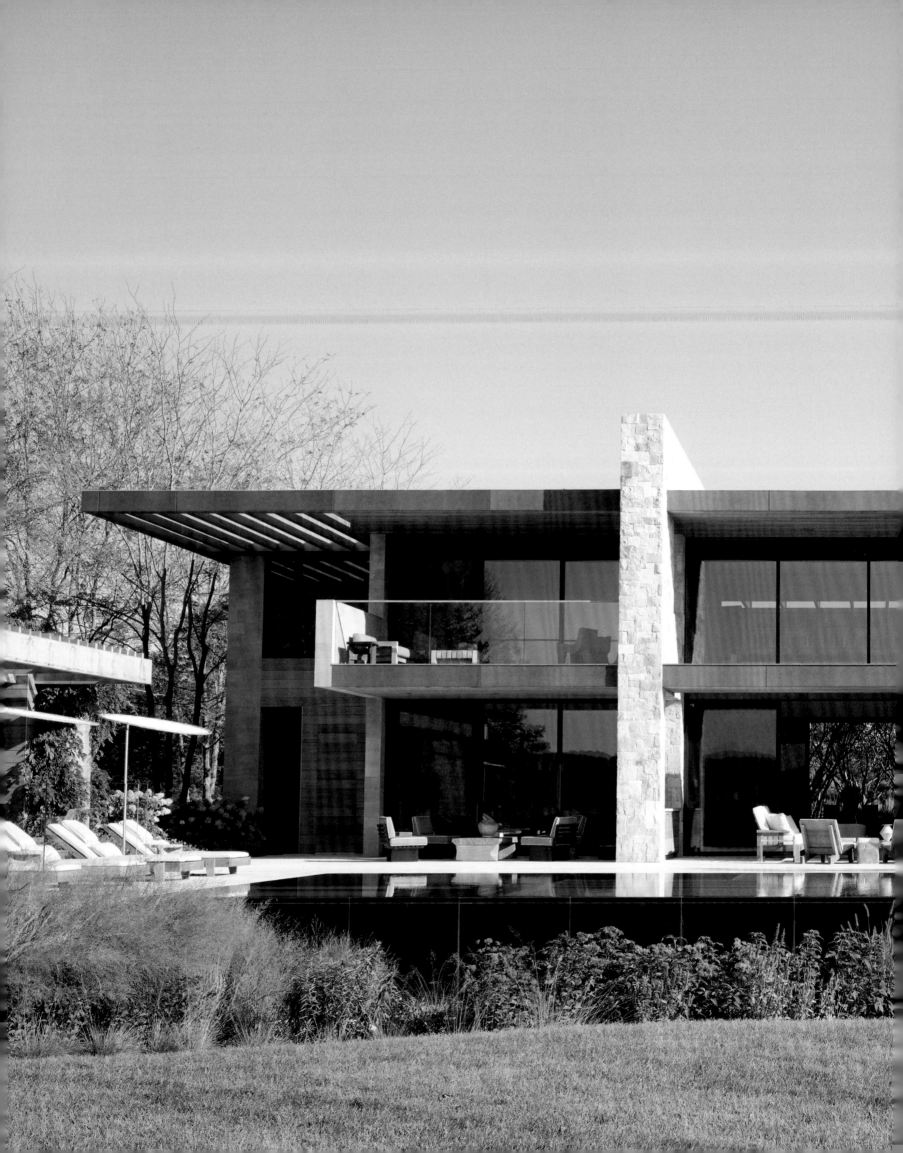

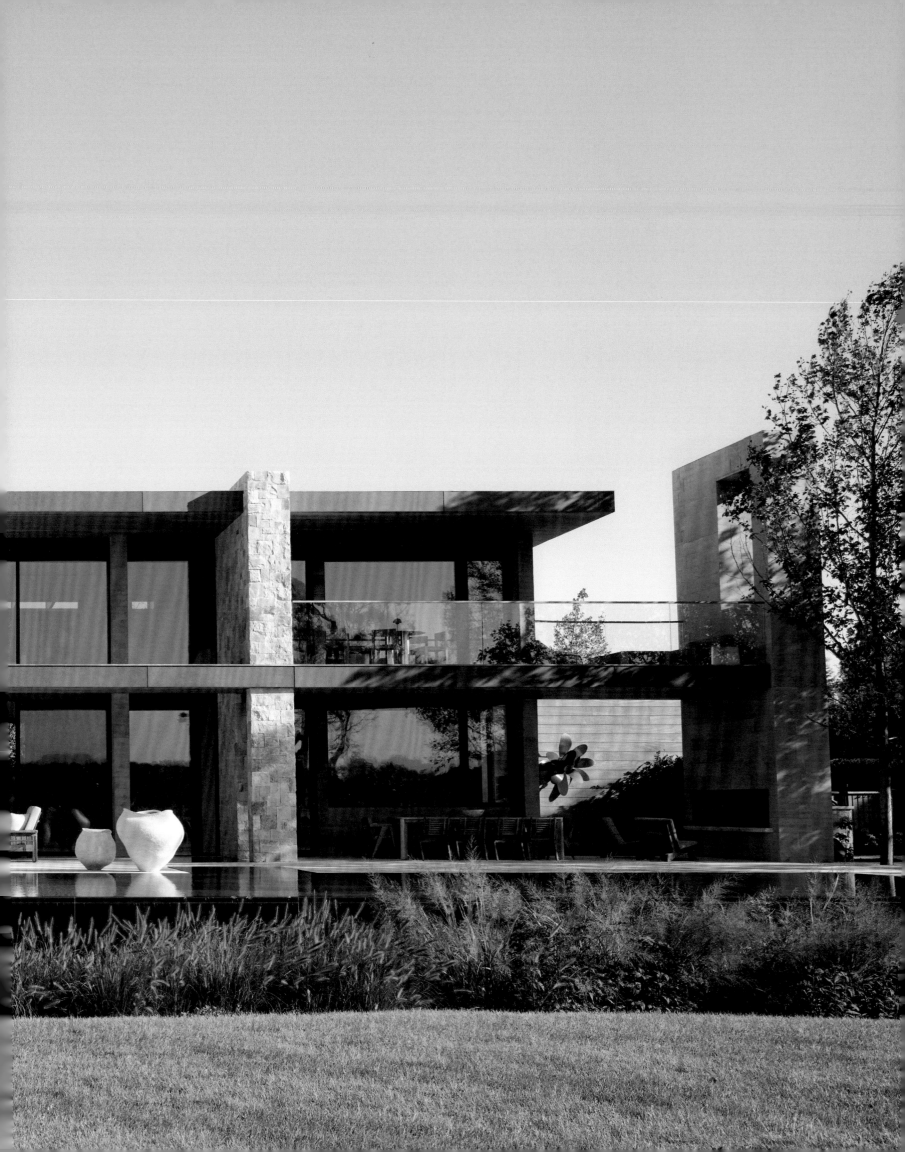

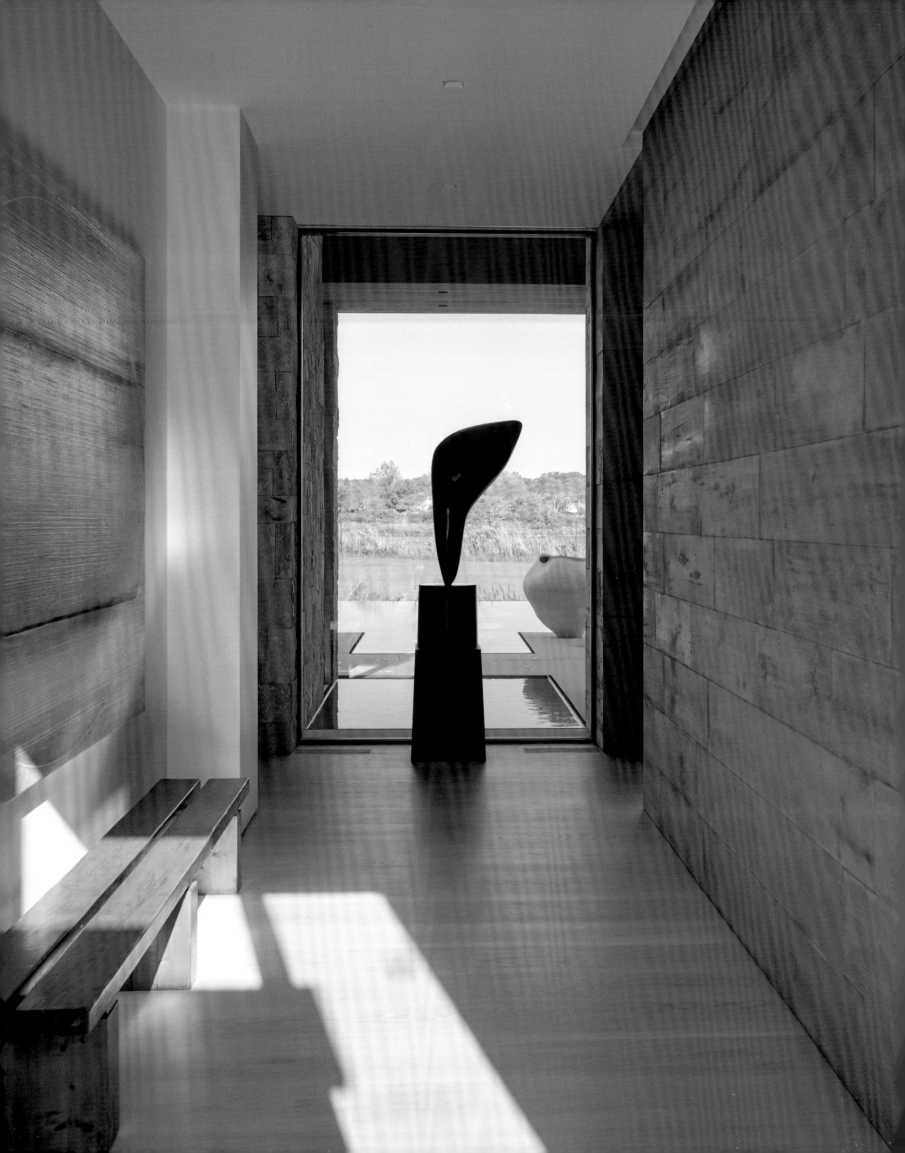

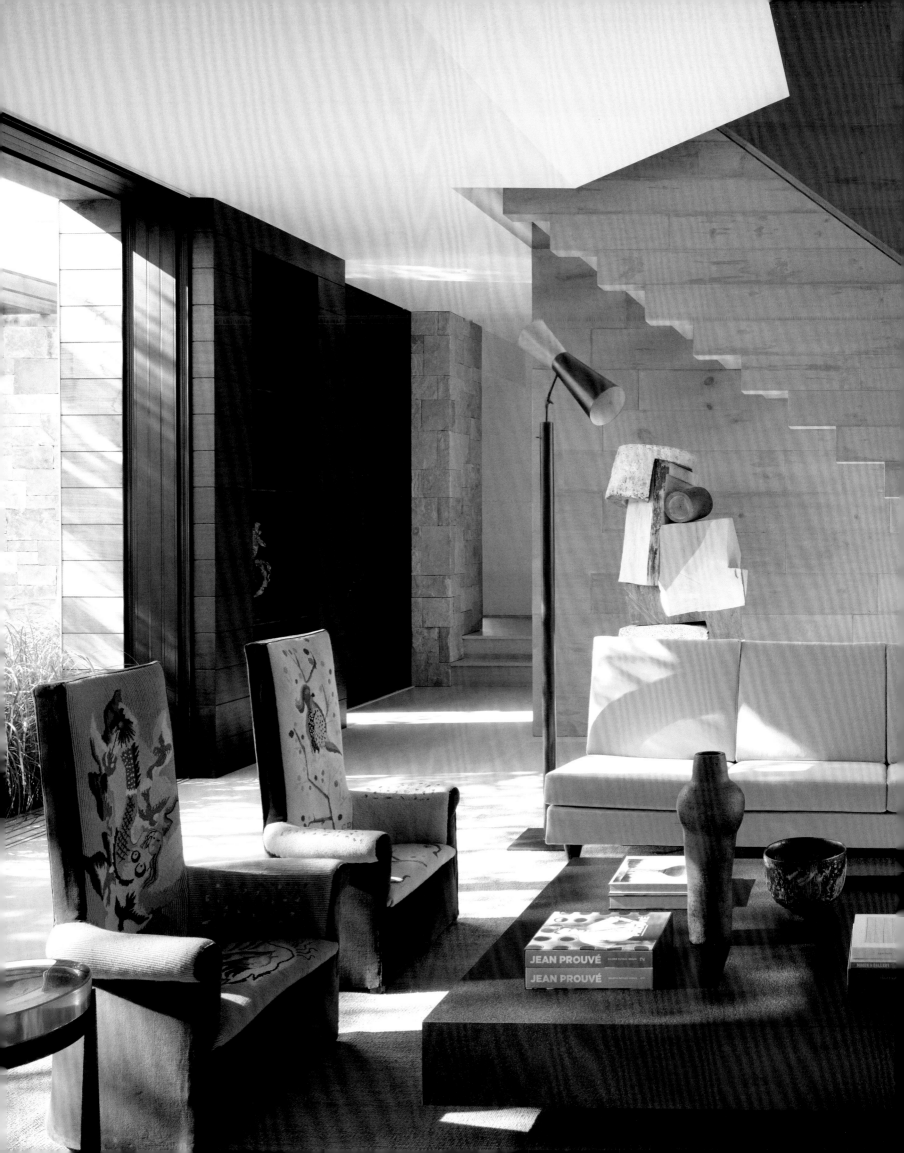

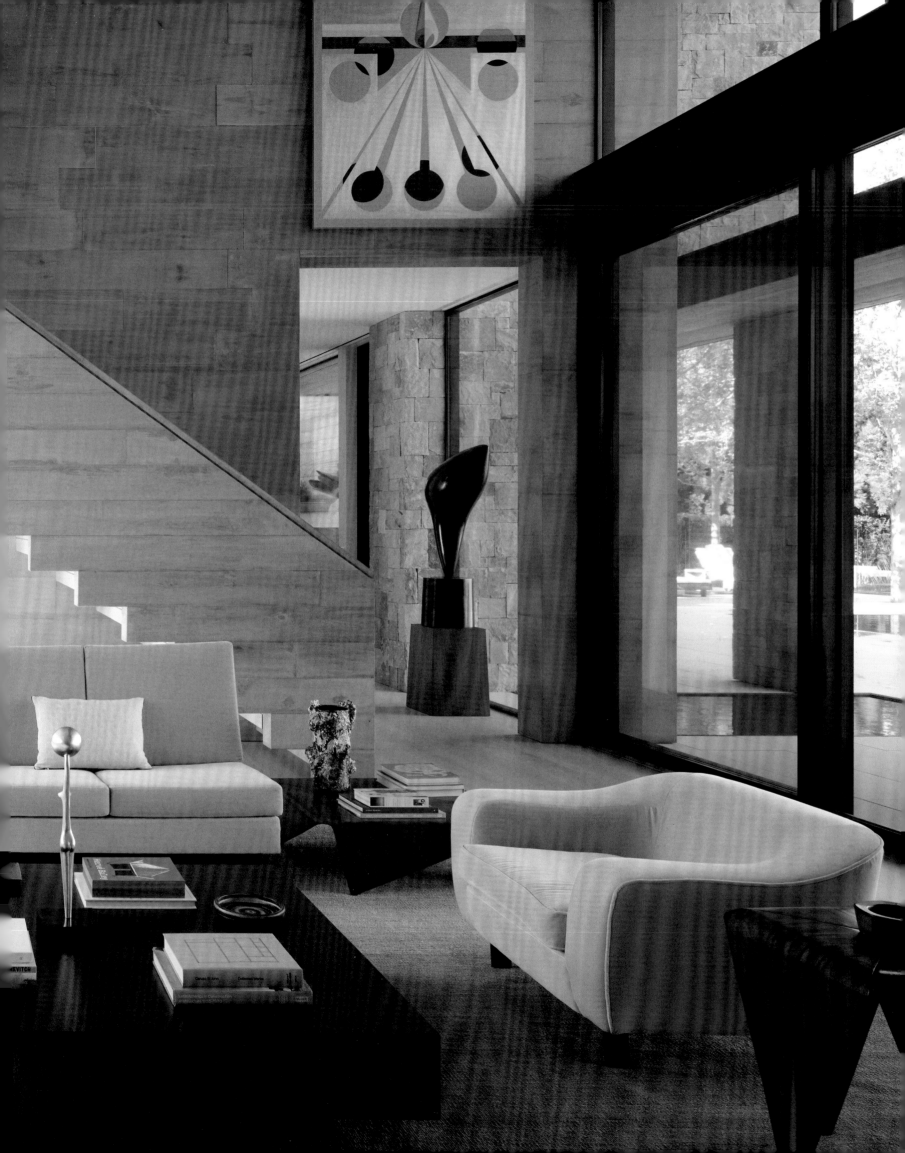

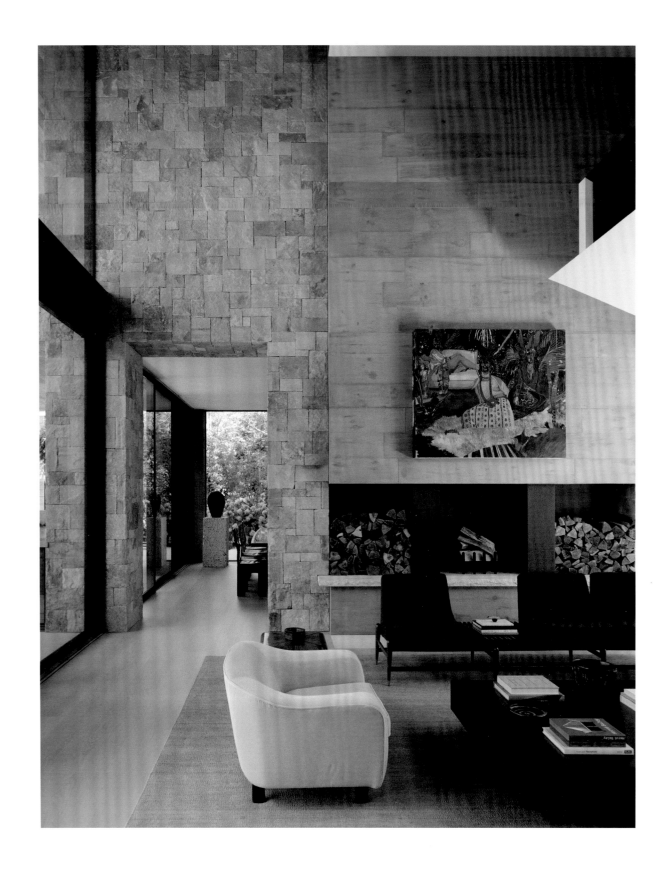

ASHE LEANDRO

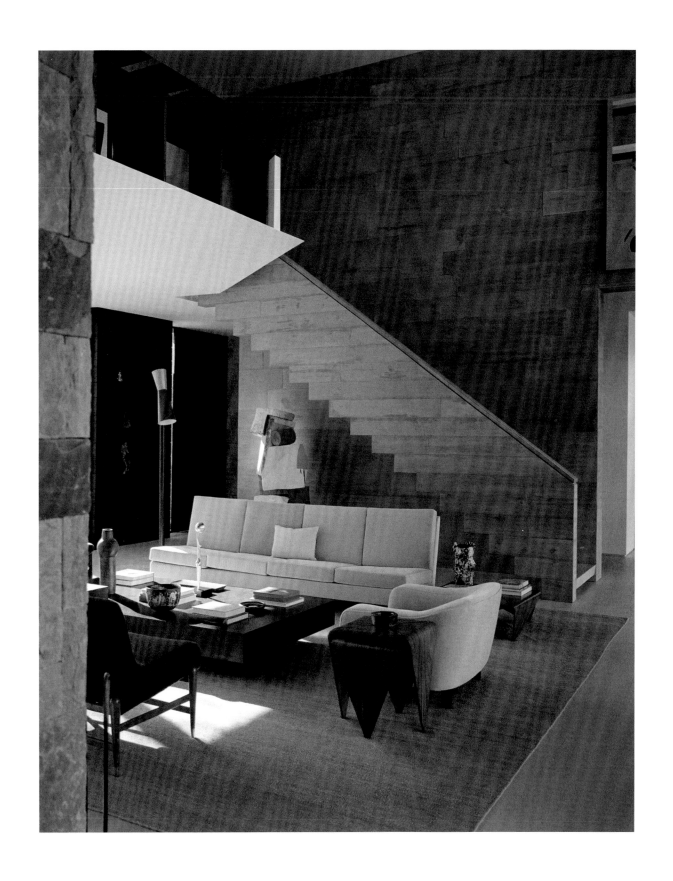

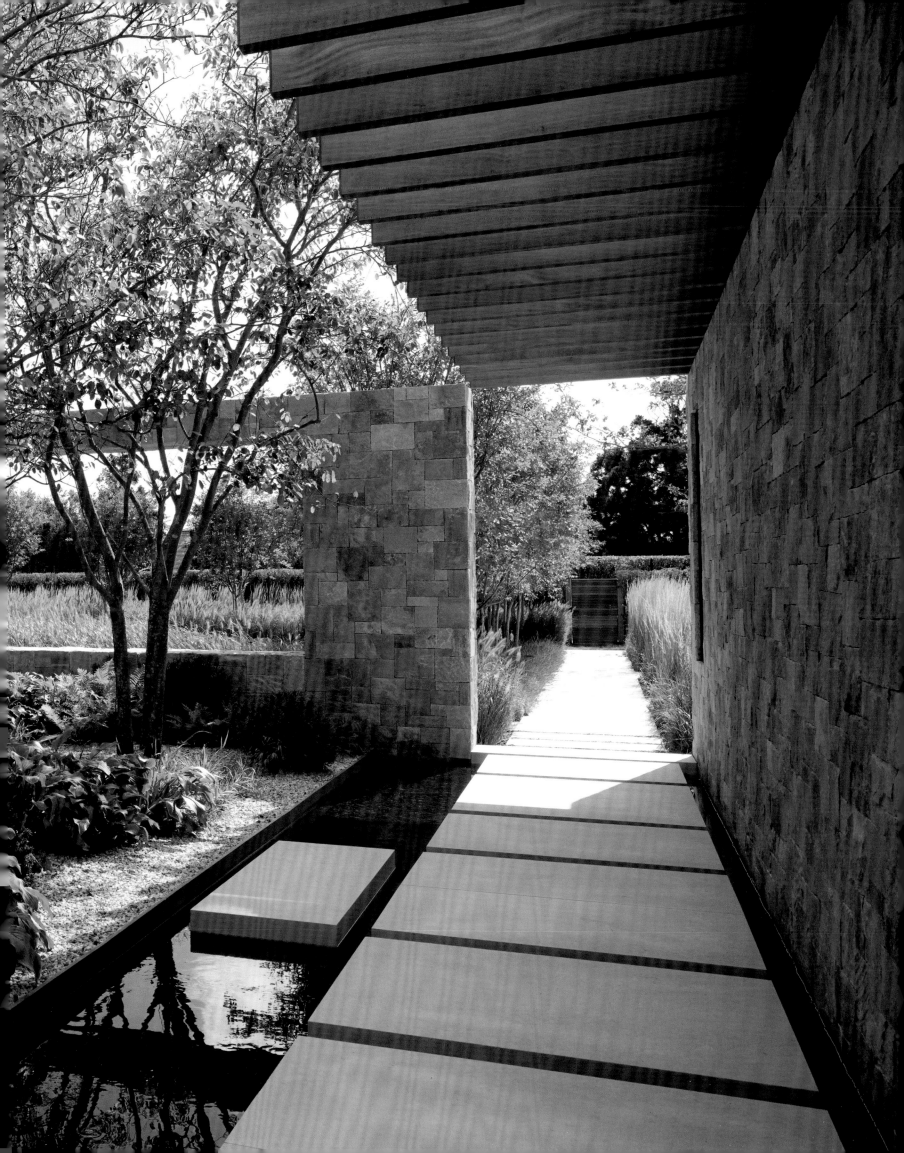

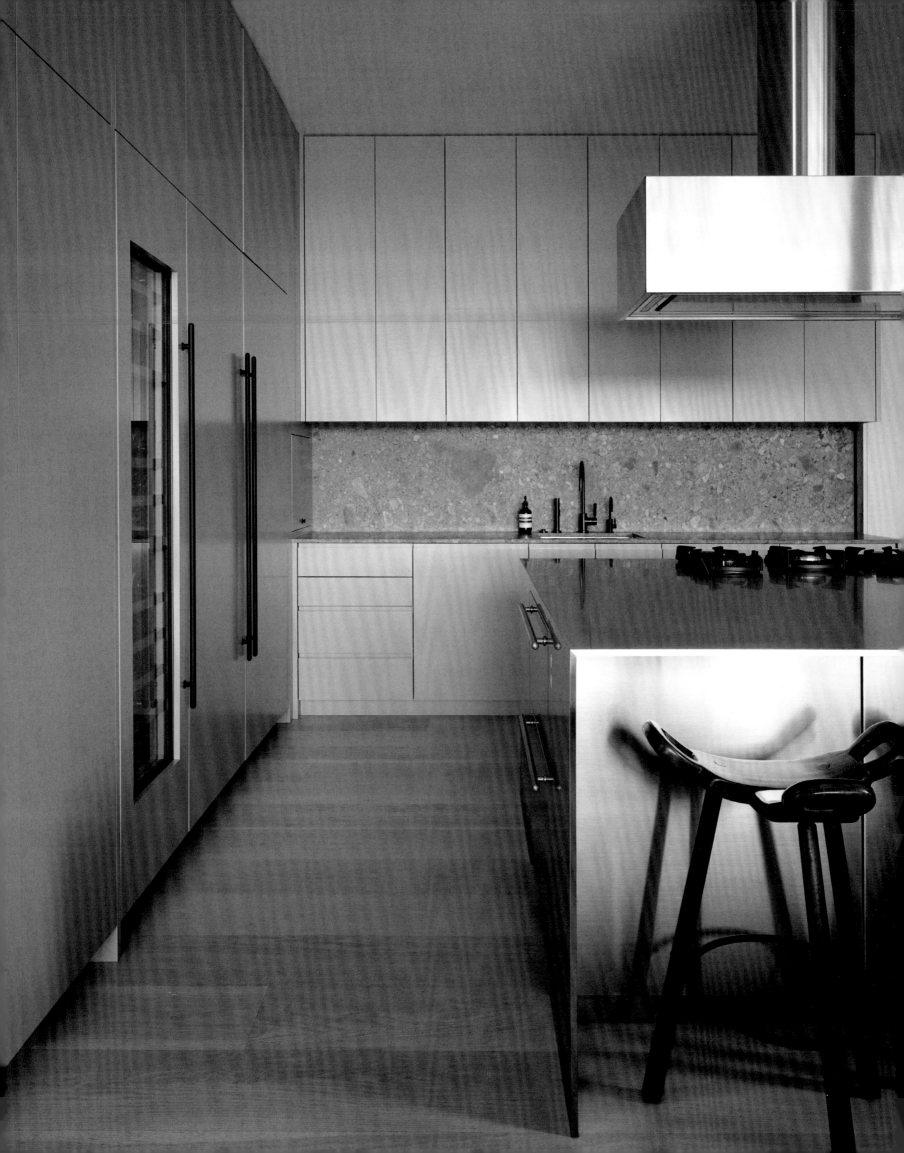

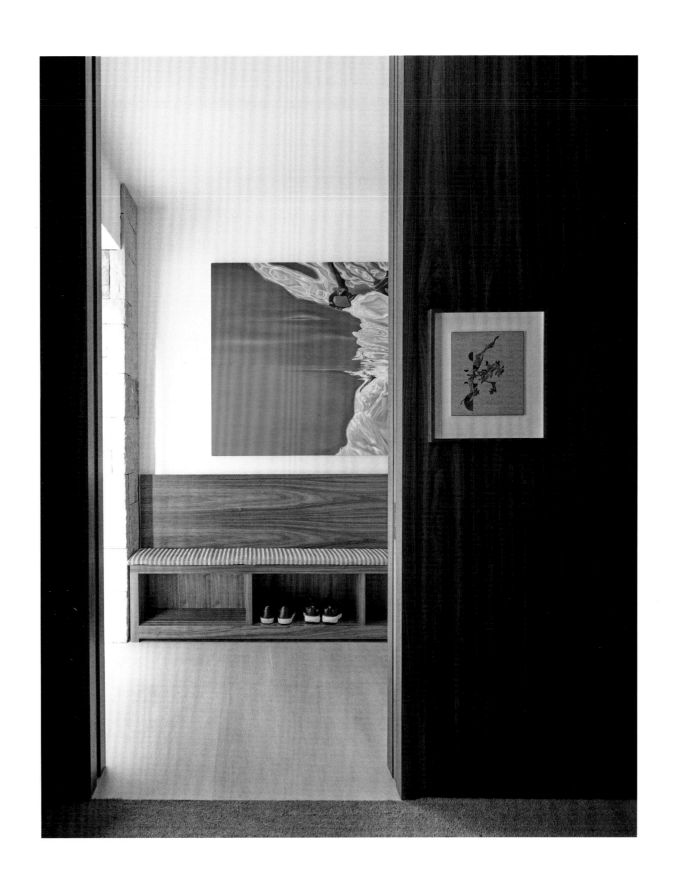

"This was a very easy project for me to relate to. The client wanted a house
that could be in São Paulo or Mexico City, but for the Hamptons.
It was an opportunity to revisit many homes that I grew up with in Caracas."

— REINALDO LEANDRO

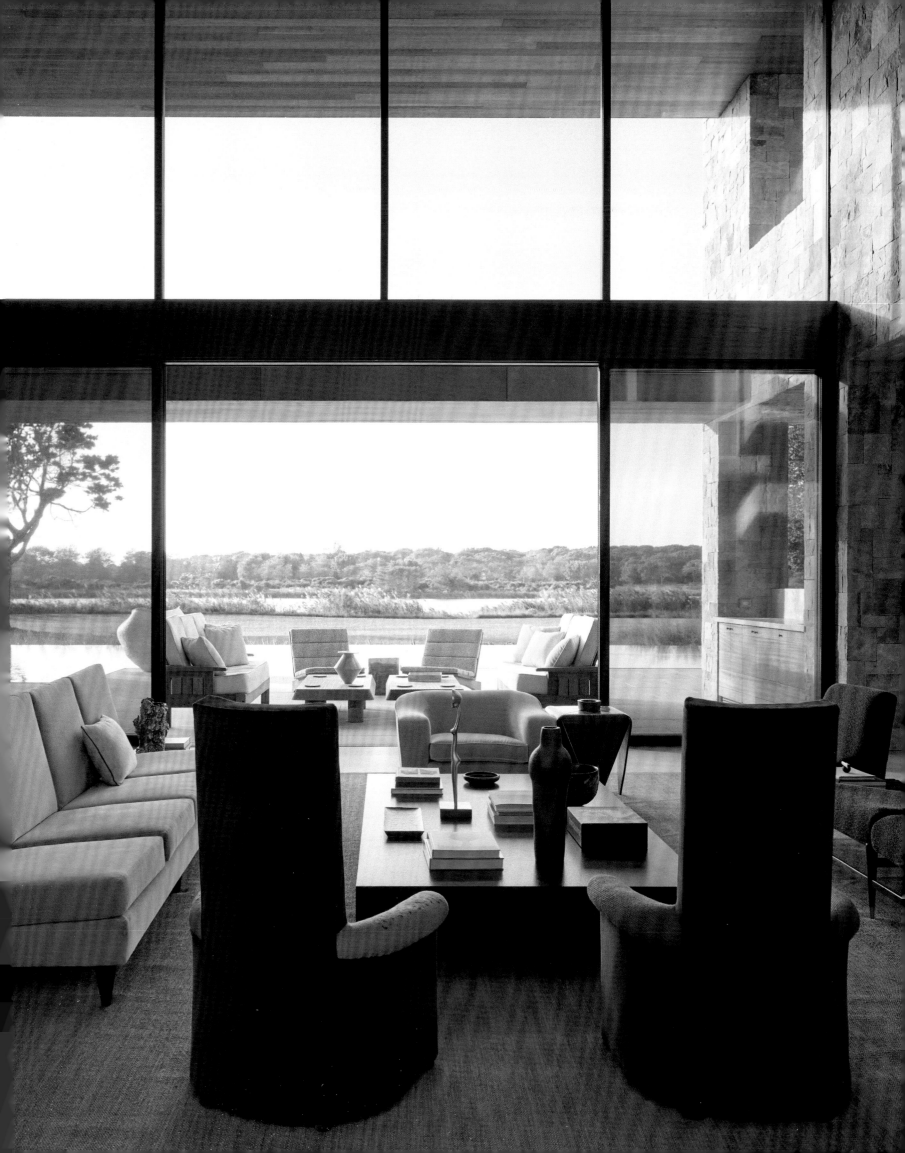

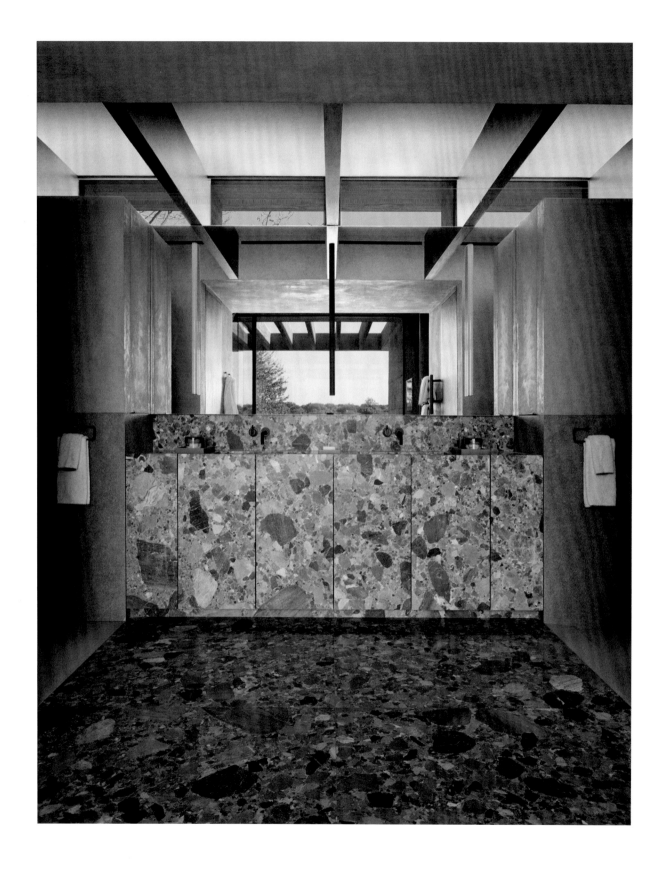

ASHE LEANDRO

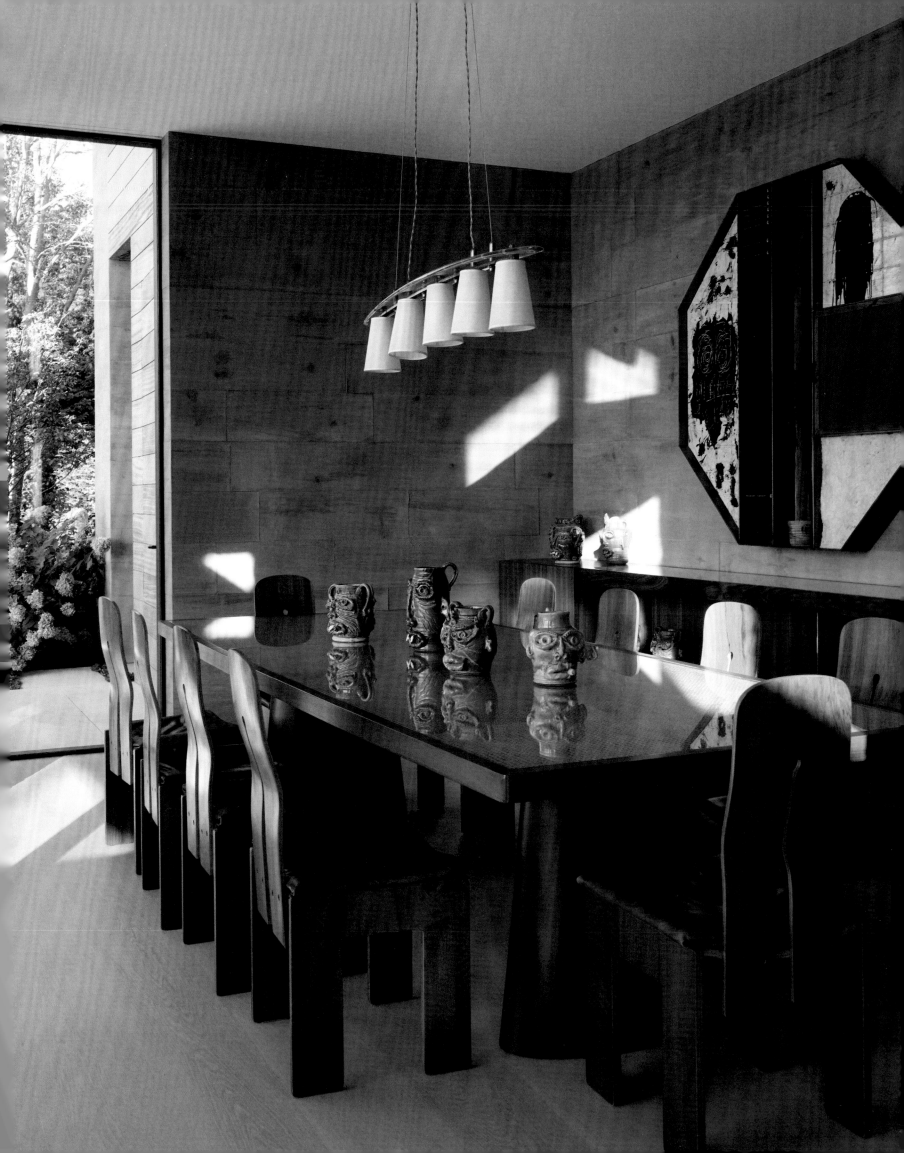

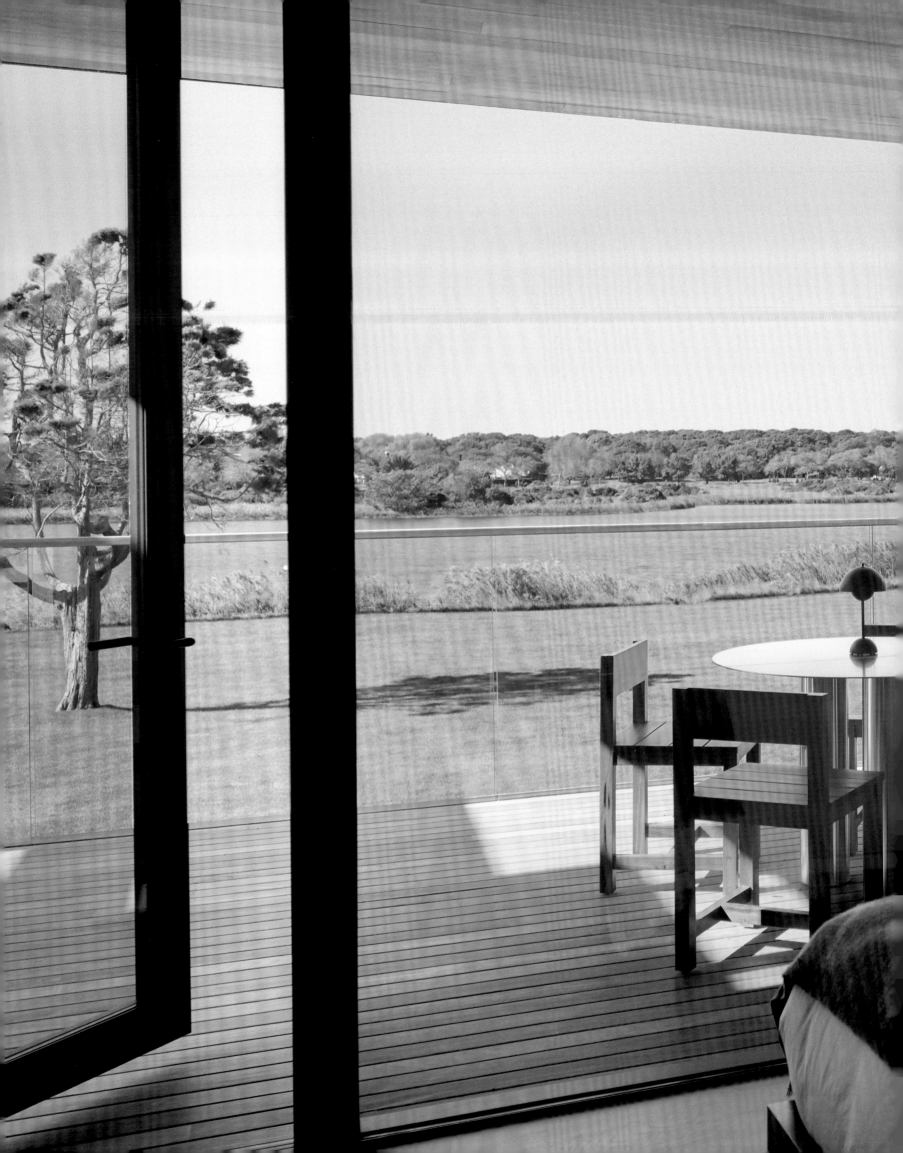

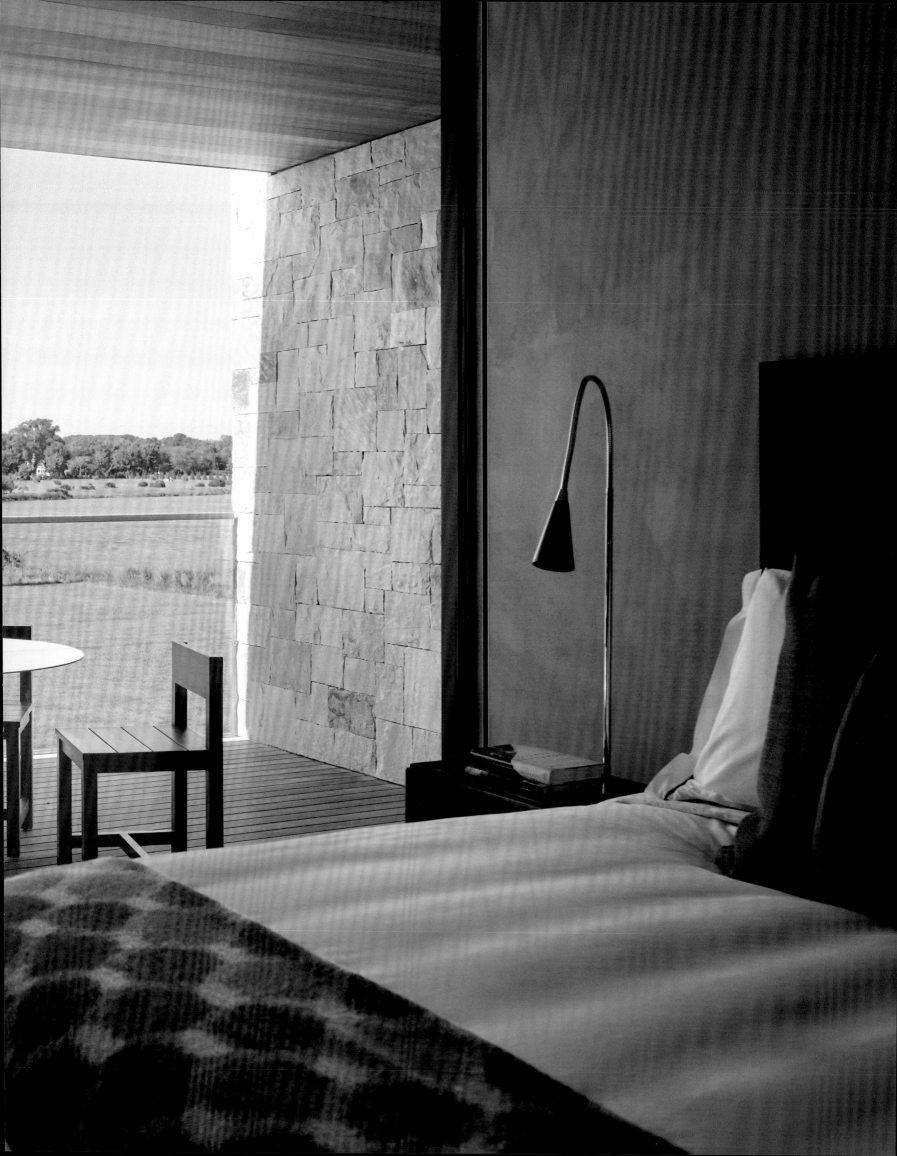

ASHE LEANDRO

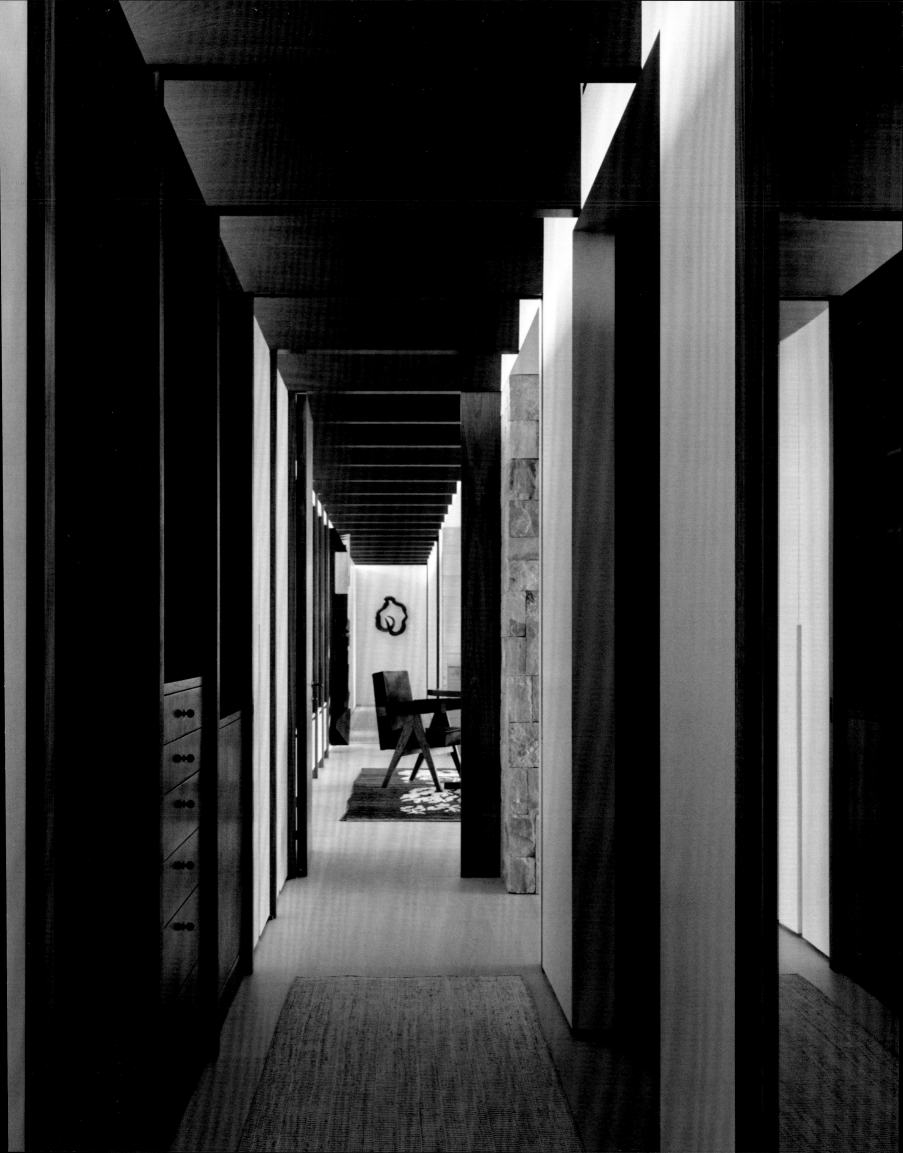

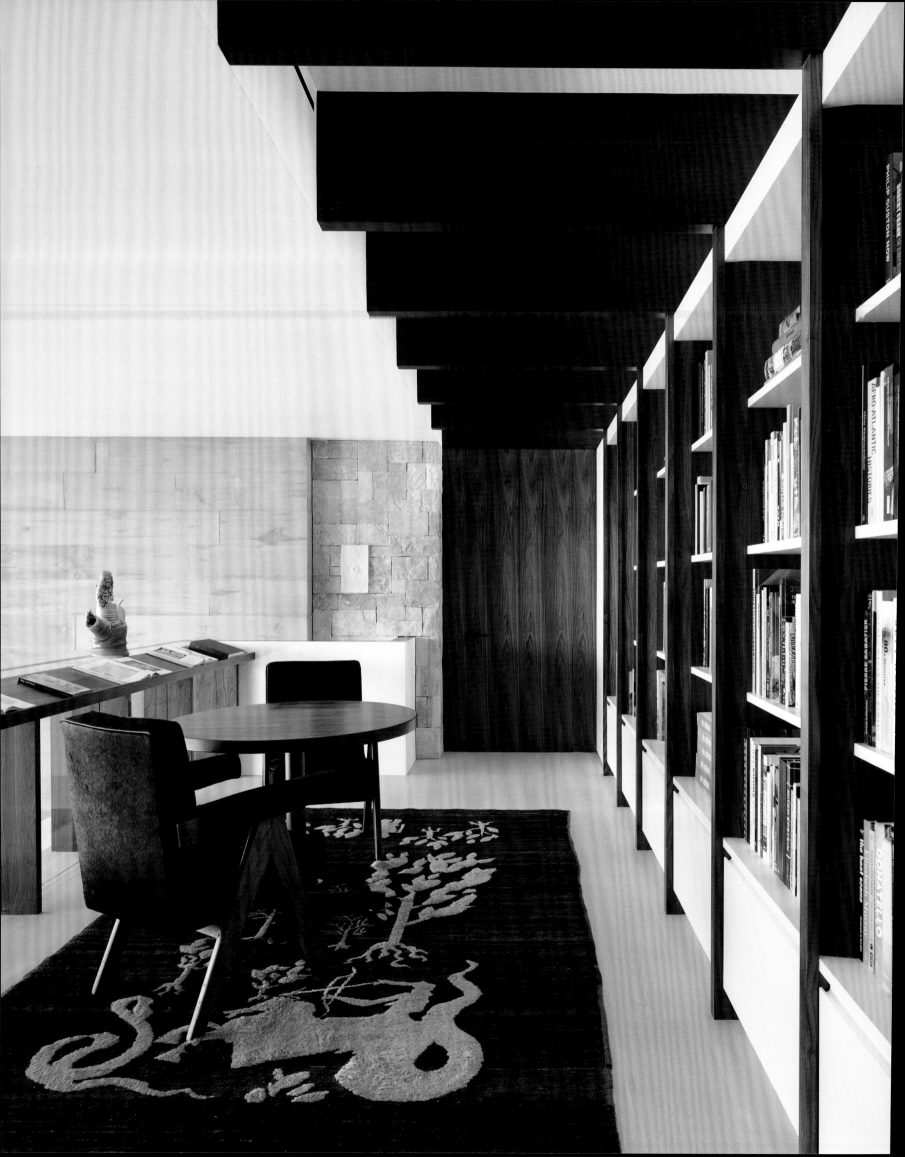

CREDITS

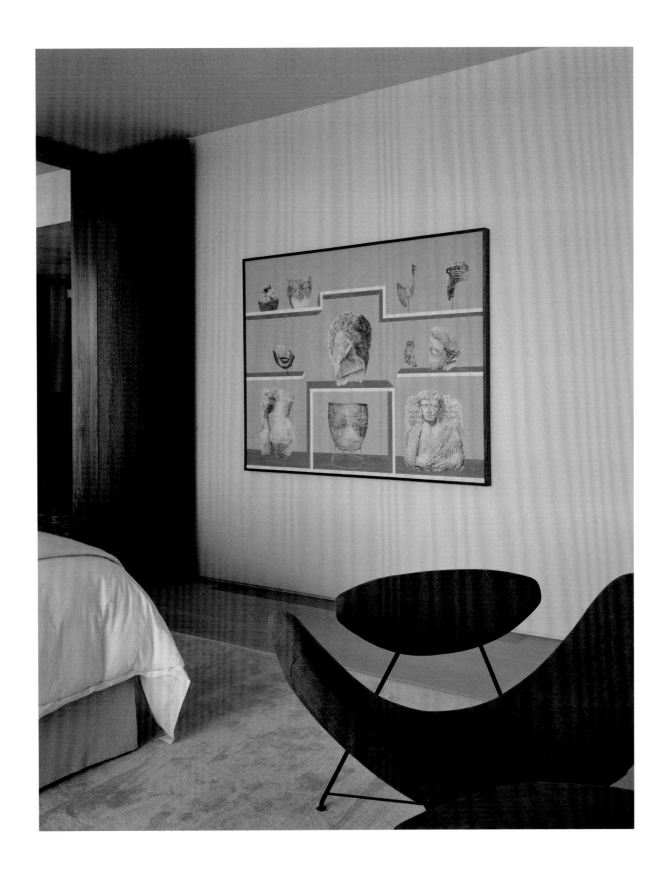

ARCHITECTURAL & INTERIOR DESIGN ASHE LEANDRO
LANDSCAPE DESIGN HOLLANDER DESIGN | LIGHTING DESIGN ORSMAN DESIGN
PHOTOGRAPHY ADRIAN GAUT AND JASON SCHMIDT

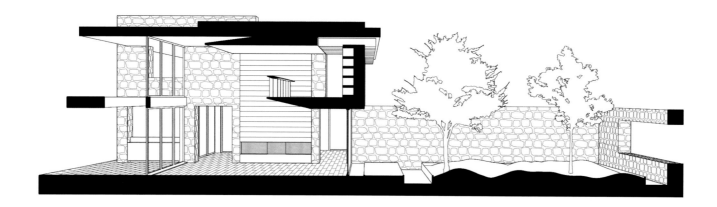

The client wanted a tropical modernist house, but we also looked at a lot of modern
Hamptons homes, particularly Gordon Bunshaft's 1962 house on Georgica Pond. It was also
important that the house disappear from the street and be discovered as you approach it.
So, the architecture slowly reveals itself as you enter the interior courtyard, walk through
the entry, and come into the double-height living room. The house unveils itself onto the
water views.

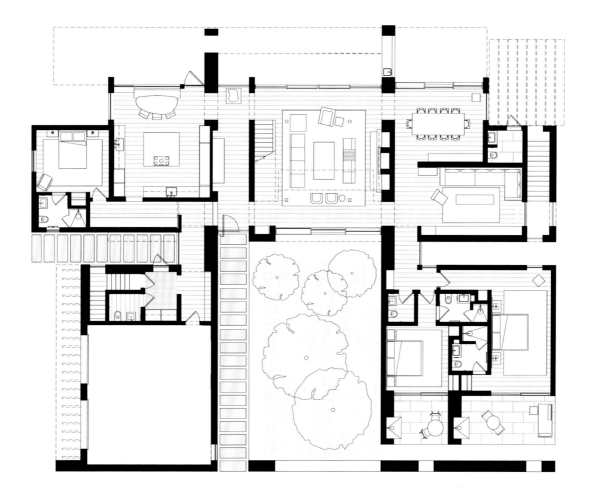

Above: First-floor plan.
Opposite: Section through the
interior courtyard and
the double-height living room.

0 10

(04)

DIALOGUES

FELIX BURRICHTER, REINALDO LEANDRO,
AND ARIEL ASHE

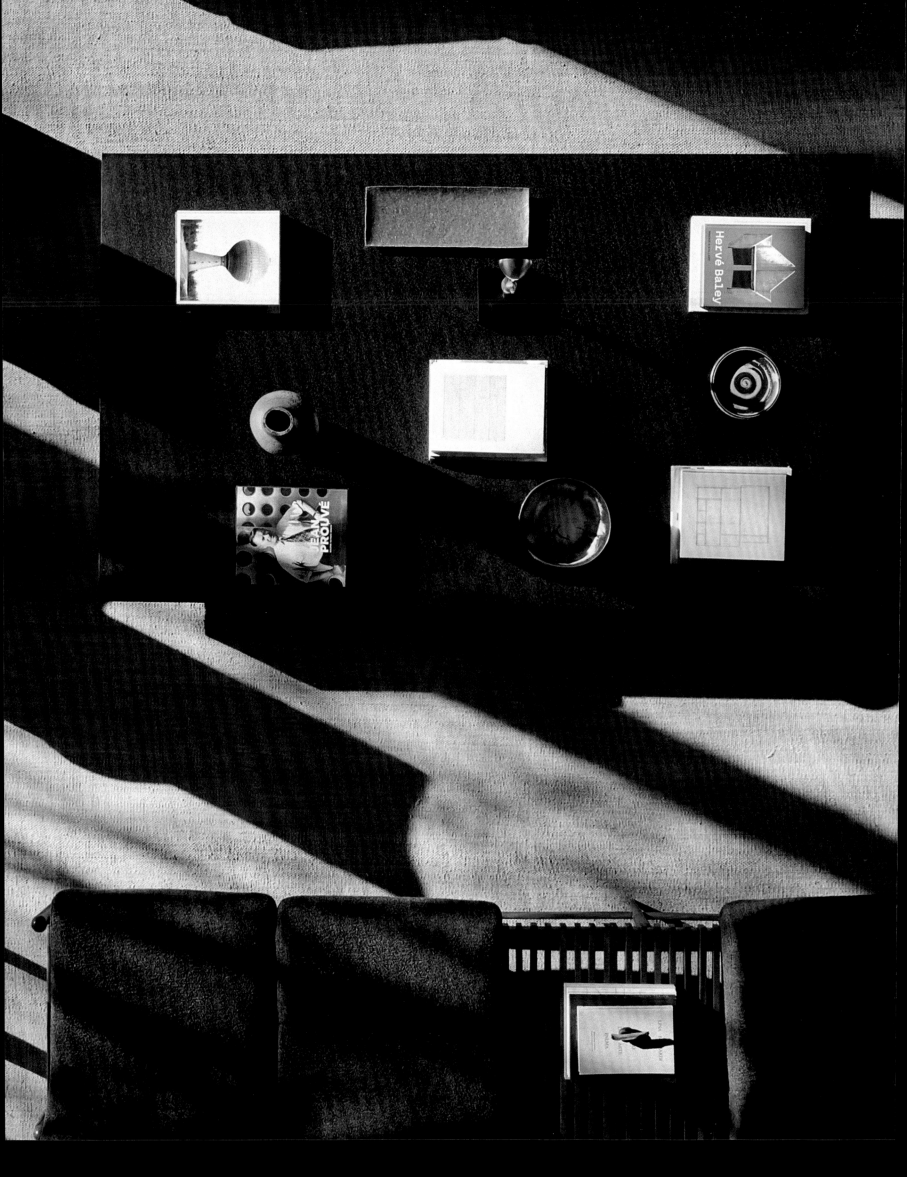

FB I want to start with the very obvious question. Why a book?

RL Since we started Ashe Leandro fifteen years ago, we've always sought to build a body of work that fully represents who we are. To have that documented is really important for both of us. Especially since I think what sets us apart is the fact that we are an architecture and interior design practice, and they really feed into each other a lot. There is no better way than to document that with beautiful photography of some of our favorite recent projects.

FB You have a total of over 150 projects. How did you manage to reduce them to just eight?

RL We photographed twenty projects specifically for the book, but once we started selecting the images, it became clear which ones made the most sense to show: townhouses and ground-ups. That's the area we want to continue growing in.

FB Since it's "only" eight, can you briefly walk me through the projects individually in the order in which they appear in the book?

RL The book starts with a townhouse in Gramercy Park (2022), a project for the artist Rashid Johnson and his wife, artist Sheree Hovsepian. This was an important project for us because it felt very different from the work that we'd done before. The materials and texture of the fabrics we used are much richer than any previous project. It was one of the most important art collections we've worked with.

AA A lot of the flamboyance in the project came from the character of the space and also from the clients, who were very open and always pushed us to do more, to go further. For example, Rashid once called us from a suite in Venice that had all silk fabric on the walls. He loved the room, and so we proposed it for their bedroom.

RL None of the rich details existed. We introduced elements like faux-painted marble baseboards, stone thresholds, wall moldings, a hand-painted seventeenth-century wooden ceiling imported from Sicily, and a sixteenth-century fireplace mantel in the Great Room. The idea was to enrich the space in history.

FB Was that the first project that you felt secure in experimenting with color?

RL No, we played with a lot of color before. But this project just felt more Old World, which isn't something our projects necessarily exude, even if the furniture still feels very contemporary.

FB Let's move on to project number two — the West Village townhouse (2023).

RL That was a lot of fun to work on. I like it especially because it's so colorful. What all our projects have in common is they're all very responsive to the client's wants and needs. This may seem like an obvious statement, but in this case, it was a Federal-style townhouse built in 1899 and the clients fell in love with the quirkiness of it. To bring it up to contemporary standards, we had to demolish a lot of the original interior, so our job was to bring the quirk back. So, we created a lot of little nooks and split-levels that formed distinct areas.

FB One room that stands out is the bedroom with the visible black beams. Are those structural?

RL They're not, but they emulate the existing structure because it's one of the few townhouses that had a fully timber frame structure, which is very rare in New York.

FB What would you say is the defining characteristic of this project? Is it the color treatment? Because it's definitely more colorful than any other project. Was that mostly your input, Reinaldo?

RL Yes. I think so. But honestly, we're never quite sure who did what.

AA Yes, although on this project, you took a little bit of a decorative lead, which is rare. The client has really good taste and a fun collection of furniture that we were able to use, so that made it very easy.

RL We really got to explore our whimsical side, which was fun.

FB The third project is an all-white Park Avenue townhouse (2021).

AA If Rashid and Sheree's house was maximalist, and the West Village one was more whimsical, then the Park Avenue townhouse is very minimalist.

RL Yes. The client didn't like stone, so we included a lot of minimalist, all-white details in plaster and wood. A pivotal reference to me was the original Calvin Klein store by John Pawson on Madison Avenue (1995). We wanted to achieve that kind of

227

Opposite:
Top view of custom stone coffee table and objects in the Georgica Pond house.

pure space with minimal detail. And since the home was very narrow, we introduced a lot of rounded corners. Unlike the West Village project, I was only working on the architecture for this project, not the decoration.

F B Is that division of roles something you decide beforehand?

A A No, it just happens. Usually, Reinaldo hands me an all-white room, and then I start thinking about the interiors.

R L I'm very proud of this project because it was our first gut-renovation townhouse project. I still love that double-height space with the barrel-vaulted ceiling, which is a subtle homage to Ricardo Bofill's La Fábrica.

A A Reinaldo has an encyclopedic knowledge of architecture. He has all these references in his head, and when he sees a building or a space, he can pull something out of his archive, and everything starts there.

R L You do that a lot, too, with furniture.

A A Yeah, but you usually have the first image.

R L Yes. That's kind of how we approach projects. I start with the images first, and then you heavily edit them.

F B Reinaldo is more spatial-driven, and Ariel is more object-driven?

R L Yeah. Although I think Ariel is really good with room layouts, too.

A A And Reinaldo is also very good with objects.

F B Let's move on to house number four: the Museum Mile apartment (2023).

R L Oh, that's a tricky one, actually. A complete gut renovation. It used to be a very stuffy Upper East Side apartment, and nothing you see in these images was there before. Not a single detail.

F B In the previous projects we discussed, there was always a lot of spatial and structural memory for you to work with. Was this one just a blank slate?

R L Spatially, it was actually more defined, so we couldn't move too many walls. We kept none of the original fittings. It's an entirely different apartment than when we first saw it.

F B What are you most proud of in this project?

R L The hallway. It was very wide and didn't really serve any purpose. Instead of making it narrower, we wanted to accentuate the generosity of the space with a special floor of alternating blocks of wood and marble. It was quite difficult to make because the wood expands, and the stone doesn't. But the client was down for it, and we worked with some of the best contractors; now it's the center-piece of the apartment. It functions both as an art gallery and the main hallway to the back of the house and the bedroom areas.

A A The furniture also really works in this apart-ment. It's all mid-century European pieces. The client wanted something very modern, but I was cautious that it wouldn't be too trendy. It feels very modern but timeless—I like to call it our Milanese apartment.

F B The next project is an apartment in Tribeca (2019).

R L This one was easy because it was the first time a client said to make it cool and spend what you need.

A A It was an old Tribeca factory, and we were able to hire the best people in every field: the best plaster artisans, the best stonemasons, the best painters, and the best millworkers, and buy amaz-ing furniture. Because we didn't have to look at the budget, we really started experimenting. On the top floor, for example, we used a ceiling that we reclaimed from a Belgian château, and we did German slurry walls over brick, by applying a kind of sandy plaster. Very New Mexico adobe-style, but not out of place in that space, somehow.

R L It was kind of the catalyst for projects to come.

F B The next project is the Chilmark house, a ground-up building on Martha's Vineyard, completed in 2022.

R L The Chilmark house is interesting because we approached it much more from the interior spaces, unlike Brixby, another ground-up. On Martha's Vineyard, you hardly ever see contem-porary buildings, so the narrative became that of a modern house within a more traditional, Northeastern architectural style. It's not a style I am so familiar with, so I leaned heavily on Ariel because she understood exactly what kind of house

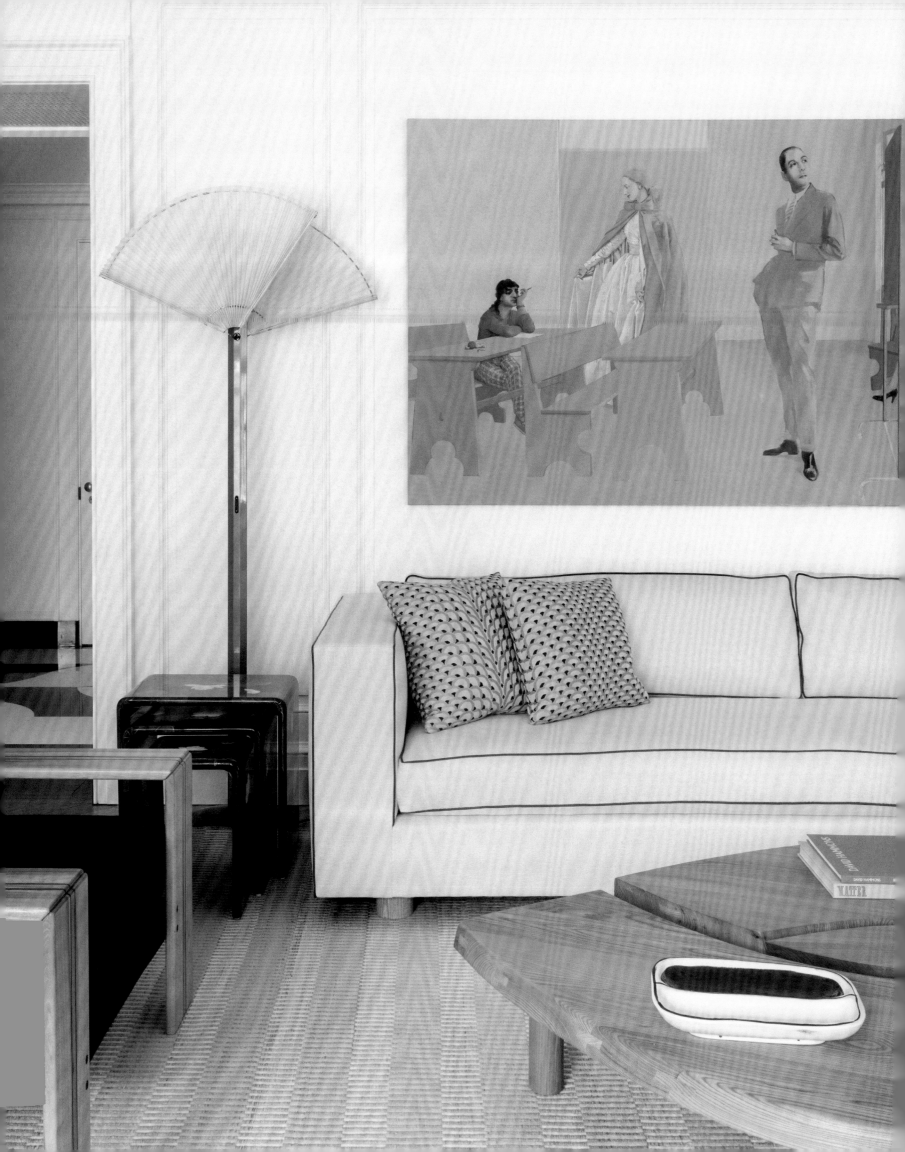

the client wanted. The question was, how can we create a modern barn?

FB And what makes the Chilmark
house modern?
RL We strategically chose a combination of more traditional casement mullion windows with a lot of picture windows framing specific views of the meadow or the orchard — those were contemporary touches. I tried to think about it from the interior living situation too. The client wanted to have an open kitchen, which interacted with the double-high space of the living room. And then there's the way the dining room is positioned. It is open to the living room too, but it juts out from the main barn volume and into the orchard. The house is successful with its open floorplan, while keeping each area defined and unique in its use. Due to the window-style mix, at dusk and into the night the house gives off a "lantern-in-the-tree" effect that is quite beautiful.

FB There is another ground-up house
that you just mentioned in the book:
Brixby, in Connecticut (2023).
AA Brixby is my sister's eighteenth-century brick colonial house, and this is the cottage behind it. We were trying to figure out what might have been there originally — clapboard? We decided on this sort of little Danish caretaker cottage with three bedrooms, all very simple. It has white painted wood walls and pine floors and a little woodburning stove.
RL We were inspired by the architecture of Hugh Newell Jacobsen (1929–2021). He was a postmodern-era architect, and he used a lot of repetition in his work. I liked the idea of creating three very pure white volumes: one to contain the guest rooms, the second for the social quarters, and the third for the private quarters — i.e., the primary bedroom. The structure sits on top of a hill, so upon arrival, you immediately understand the three volumes of the house. For the interior, Ariel was very clear that she wanted it to look like a Danish cottage.

FB Last project: Georgica Pond in East
Hampton, New York (2023).
RL Unlike the Chilmark house, Georgica Pond was a special and exciting project for me as many of the elements were familiar to me. The client collects

South American art, and her favorite furniture is Brazilian modern. She wanted a house that could be in São Paulo or Mexico City, but for the Hamptons. It was an opportunity to revisit many homes that I grew up with in Caracas, so obviously we looked at a lot of Latin American modern architecture, but we also looked at modern Hamptons homes, particularly Gordon Bunshaft's 1962 house in Georgica Pond, which was sadly demolished in 2004.

Design-wise it was important that the client wanted the house to disappear from the street and be discovered as you approach it. The architecture slowly reveals itself as you walk through the interior courtyard, through the entry, and into the double-height living room where the house is fully exposed to the water views. Gio Ponti's Villa Planchart, in Caracas, also inspired some of the interior details for Georgica Pond, like the stairs or the knife-edge of the mezzanine.
AA I had to educate myself on modern Brazilian furniture for the interiors because that's what the client likes to collect. But I also had to find exciting ways to mix it with other pieces, like the two Lurçat chairs from the Maison de Verre, because you can't have all of the same things or it gets boring. The client brought amazing art including pieces by Jean Arp and by Arlene Shechet, whose work is on the book's cover.
RL We encouraged the client to bring the Jean Arp sculpture into the space because it worked so well with the vernacular of the house.

FB What role does art play in the spaces
you conceive, and how involved are you
in procuring art for your clients?
RL We usually have two types of clients — those with important art collections and who come with their art adviser, or clients who have nothing and are looking for us to help build their collections.

FB When you work with a client with an
existing collection, do you design the space
with the art in mind?
RL Spatially, we do think about the placement of art, especially when it comes to larger-scale pieces.
AA I've never decorated around the art, at least not consciously. I look at it as an added layer. In the end, good art can elevate a well-designed space, but it can never make a poorly designed space look good.

Living room of an Ashe
Leandro project on the Upper
East Side, New York, 2022.

AFTERWORD
RASHID JOHNSON

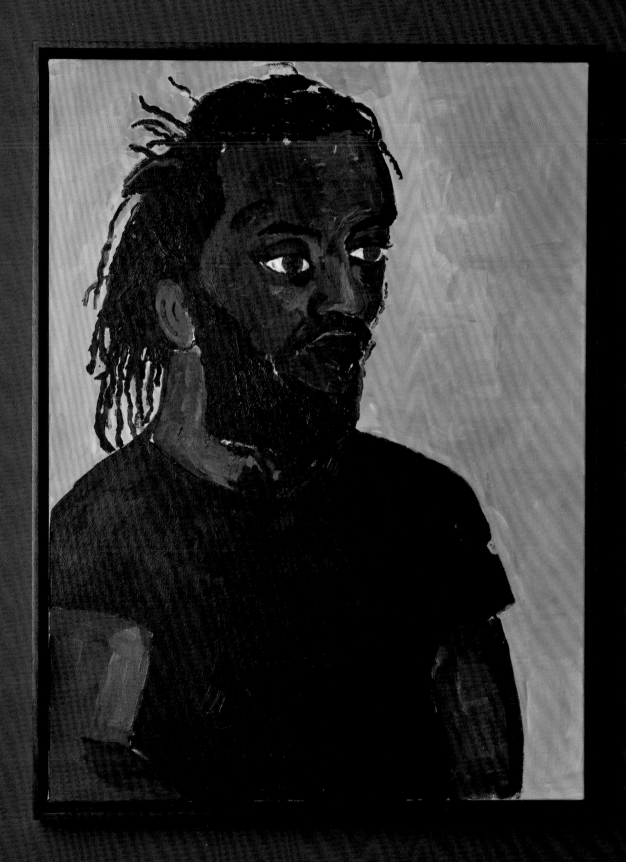

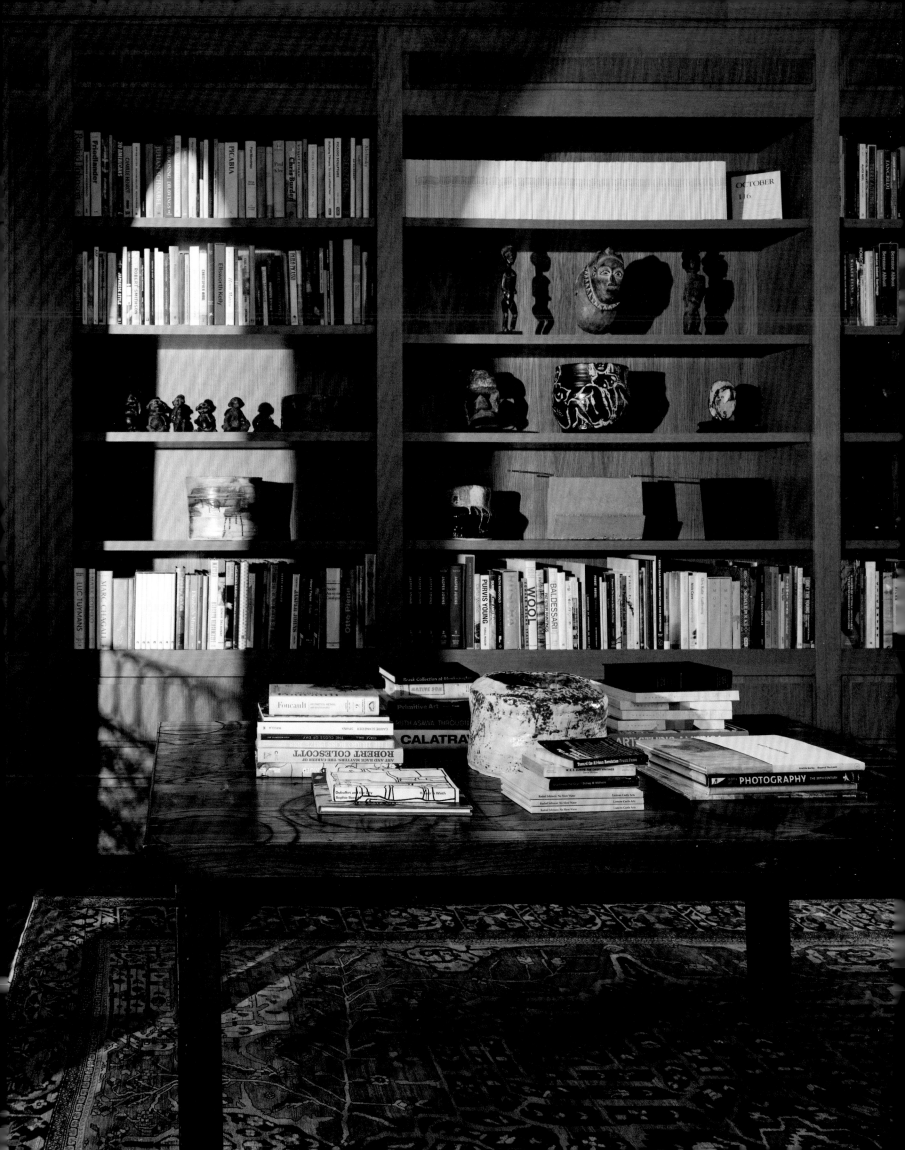

Some collaborations emerge as extraordinary synergies — unique artistic minds intersecting and transcending the expected, evoking something entirely new. In the world of interior design and architecture, Ashe Leandro stands as a testament to this phenomenon. At the heart of Ariel Ashe and Reinaldo Leandro's design philosophy is a commitment to storytelling. Each project unfolds like a carefully conceived narrative, with every element meticulously chosen to contribute to the overall story of the space.

In both art and design, space and identity are layered with history and personal expression. Similarly, materials can tell stories just as art can. Ashe and Leandro have a deep comprehension of this notion; their projects are shaped equally by the history of their clients and by the history of the spaces they choose to transform.

I met Leandro in 2008 at the Armory Show in New York when he bought two of my early soap and wax works (a fact he's reminded me of many times). In February 2013, my wife, Sheree, and I closed on our first townhouse. It was a big moment for us. Another collector of mine had used Ashe Leandro for his home and I had visited and loved it. We called Ariel and Rei for help. I had a passion for Brazilian modern furniture and had already begun to collect it. I had also made a few trades for some key design pieces — a Nakashima desk and coffee table and some Campana Brothers furniture. Ashe Leandro worked with us and our collection, never overly inserting themselves but calmly directing the process of engaging us within our new home. We were immersed but not lost — and never forgotten.

Through their intuitive grasp of form, function, and the emotional resonance of spaces, Ariel and Reinaldo have cultivated a distinctive language that speaks to the intersection of culture and identity with a seemingly inexhaustible wellspring of creativity. From the inception of an idea to its manifestation in the tangible, each project documents their commitment to constructing environments that transcend the ordinary. They somehow manage to marry the timeless with the avant-garde.

But most importantly, Ashe Leandro projects deeply resonate with the personalities and personal histories of the individuals who inhabit them; you can feel in an Ashe Leandro space the past, present, and desired future of those who live there. Art in its various forms is the vehicle through which we share pieces of ourselves. There is no place where this expression is fuller, more unfettered, and rawer than in one's home. Sheree and I are grateful to know Ariel and Reinaldo and are thankful for their contributions to our homes.

235

Library in Rashid Johnson and
Sheree Hovsepian's townhouse by
Ashe Leandro, New York, 2022.

ACKNOWLEDGMENTS

TO AGNES
&
THE M & M'S

First and foremost, we would like to thank all of our clients for working with us, believing in our vision, and letting us design for you.

Thank you to everyone who let us put their homes in this book. Thank you to Seth Meyers for opening the volume with such a kind foreword and to Rashid Johnson for closing it with such a thoughtful afterword. Thank you to the ever-elegant Naomi Watts for trusting us with your home in what would become a turning point in our careers.

The second most important component for the accomplishment of all of these projects is the Ashe Leandro team. Thank you. You are the best. Mia Todd, Brian Jones, Peter Martin, and Jonathan Brown were all instrumental in the making of this book.

There are many people involved in the creation, execution, and installation of each project, from the architects and designers at Ashe Leandro to the contractors, specialty trades, artisans, movers, and so forth. There are a few that particularly stand out: Eric Sheffield of Eric Sheffield Architect, the best partner to have to make our architectural projects move smoothly. Joe Regele and Pat Patterson and the team of Regele Builders; we started working together at A L's inception and we are still building the best projects together. To Robert Pluhowski, our go-to skater and custom furniture maker.

To our Ruemmler partners, Mia and Max.

To our peers Billy Cotton, Robert Stilin, Thomas A. Kligerman, Michael Bargo, Rafael de Cardenas, Ryan Korban, Jessica Schuster, Giancarlo Valle, Edmund Hollander, Andre Mellone, and Nathan Orsman for always being generous in sharing support, sources, and advice.

To all the editors, writers, and publications that have encouraged and supported us: Amy Astley, Sam Cochran, and Alison Levasseur of the *Architectural Digest* team. Asad Syrkett and Bebe Howorth of *Elle Decor*. Felix Burrichter of *Pin-Up* magazine, for your years of friendship and collaboration on this book. To Jacqueline Terrebonne of *Galerie* magazine. The team at 1stDibs. To Tom Delavan, Sarah Medford, William Li, Whitney Robinson, Wendy Goodman, and Marie Kalt. And to Margaret Russell and Michael Boodro for opening the door to us at *Architectural Digest* and *Elle Decor*, respectively. To the photographers who shot the images for this book: Adrian Gaut, Shade Degges, Jason Schmidt, Stephen Kent Johnson, and Malcolm Brown.

To Javas Lehn, the designer of this book, and Sandra Gilbert Freidus of Rizzoli for being such great listeners and wanting to make something beautiful.

REINALDO LEANDRO: To my friend and partner Ariel for always challenging me and being so effortlessly stylish. To Patrick McGrath, for your wit, patience, and impeccable taste; you are truly my better half. To my architecture school in Venezuela, the UCV-FAU—it was truly the best education and one of the best times of my life. Two architects and teachers that will always be in my mind are Joel Sanz and Pablo Lasala. To Vanessa, Dani, and Ale, for being my confidants. To my Venezuelan crew Gabriel, Alberto (Sapo), Alberto R., Diego, Mafe, Anita, Sonia, and Clemen, I am not the best at keeping up, but I still hold the memories. To Luke, Sky, Alex, and Jessie, the best travel partners. To the roster of architects and architectural designers that have been part of my team: Peter, Jonathan, Daniel, Dylan, and Easton (from the ESA team!), and of course the interior designers who complete us.

To my sisters, who are so geographically far but always so present.

And finally, to my parents, for showing me how and what love is.

ARIEL ASHE: To Reinaldo for being the perfect partner. To my husband, Zach Heinzerling, and daughter, Agnes, for putting up with my design addiction in its many forms. To DD Allen for giving me my graduate school education. To Ann Tenenbaum for introducing me to DD. To Ethan Silverman for getting me to New York. To Akira Yoshimura for the dream job at *Saturday Night Live*. To Peter Miles for being Peter Miles. Thank you to my sister for teaching me how to be a mother and to Seth for allowing me to design your amazing homes. And thank you to my brother, Tolya, for keeping me sane. Finally, thank you to the original artists Tom and Joanne Ashe for this magical life.

Very special thank you to my steadfast interiors team: Brian, Charlotte, Cayla, Ian, Ash, Claire, and John!

CREDITS

IV. MUSEUM MILE

pp. 16, 132–33 Alexander de Vol, *Pikestones II*, ca. 2022 (left)

p. 131 Pierre Paulin, F675 Butterfly Lounge Chair for Artifort, Netherlands, ca. 1960s, Paulin, Paulin, Paulin ®

pp. 132–33 Amy Bessone, *Atlas*, 2018 (middle), © 2024 Artists Rights Society (ARS), New York/ADAGP, Paris; Roger Herman, *Untitled 9* (ceramics and glaze), 2021 (far right); Vince Palacios, *Black and multi-color*, from the "Potato Tree" series, 2022 (bottom right)

pp. 132–33, 140 Antonia Ferrer, *Untitled*, 2021 (above bench)

p. 134 Roger Herman, *Untitled 16* (ceramics and glaze), 2021 (left of fireplace)

pp. 134, 135 Marria Pratts, *I'm Building My Own Face* (acrylic, oilstick graphite, and wax), 2021

p. 135 Danny Kaplan, Lamp 4A, 2021; Christophe Delcourt, Rem Vase, ca. 2022 (center); Josef Hoffmann, "Ring" Vase, 2003 (right)

pp. 136–37 Jean Prouvé, Vitra Standard SP Chair, 2022 (new production), © 2024 Artists Rights Society (ARS), New York/ADAGP, Paris; Claudia Alvarez, *Untitled, Girl with Braids* (detail), 2021 (left of dining table); Horst P. Horst, *Cy Twombly in Rome 1966* (*Untitled #13*) (detail), 1966 (right)

pp. 136–37, 145 John Roman Brown, *Bee Sting*, 2021

p. 142 Darren Almond, *Chime* (aluminum), 2021

V. TRIBECA

p. 149 Rosemarie Trockel, *Untitled*, 1983, © 2024 Artists Rights Society (ARS), New York/VG Bild-Kunst, Bonn

pp. 150–51 Élisabeth Garouste and Mattia Bonetti, *Lampe Masque*, ca. 1991 (far right), © 2024 Élisabeth Garouste/Artists Rights Society (ARS), New York/ADAGP, Paris, © 2024 Mattia Bonetti/Artists Rights Society (ARS), New York/ADAGP, Paris; Ruemmler Nº 556 Pendant Fixture with Silk-Covered Shade (far center)

p. 152 Nicholas Alan Cope, *Beverly Hills*, 2009

p. 153 Dean Levin, *Untitled*, 2017

pp. 154–55 Ancil Chasteen, *Untitled*; Eighteenth-century Swedish iron rush and candleholder

p. 156 Jay Heikes, *Zs*, 2016

p. 157 Albert Cheuret, Pair of "Cigognes" Sconces, 1925

p. 160 Ruemmler Nº 548 Floor Lamp; Evan Robarts, *Untitled*, 2016 (detail)

VI. CHILMARK

pp. 165, 168 Isamu Noguchi, Akari 120A, 2022 (Noguchi Museum, new production), © 2024 The Isamu Noguchi Foundation and Garden Museum, New York/Artists Rights Society (ARS), New York

p. 169 Axel P. Jensen, *Harvest Scenery*, 1944, © 2024 Artists Rights Society (ARS), New York/VISDA

p. 175 Seventeenth-century Portuguese silk tapestry

p. 176 Antonello Radi, Ceramic Radishes, ca. 2022

VII. BRIXBY

pp. 182–83, 193 Mie Olise Kjærgaard, *Three Girls in White Tops*, 2021; Milton Avery (lithograph), 1953 (right), © 2024 The Milton Avery Trust/Artists Rights Society (ARS), New York

pp. 182–83, 193 Alvar Aalto Side Table, © 2024 Artists Rights Society (ARS), New York/KUVASTO, Helsinki

p. 184 Jens Søndergaard, *Reclining Woman*, 1947, © 2024 Artists Rights Society (ARS), New York/VISDA

p. 185 John Roman Brown, *Untitled*, 2023

p. 190 Jordan McDonald, Oval Mirror, ca. 2022

p. 191 Leanne Shapton, *Portrait of Agnes*, 2023; Jean Lurçat, *Anteater* (lithograph), 1948, © 2024 Fondation Lurçat/Artists Rights Society (ARS), New York/ADAGP, Paris

p. 192 Pierre Jeanneret, PJ-SI-25-A Desk Chair, 1956. © 2024 Artists Rights Society (ARS), New York/ADAGP, Paris

VIII. GEORGICA

Front Cover, pp. 31, 202–3, 206, 213 Jean Lurçat, Pierre Chareau, d'Après Jean Lurçat Chairs, 1924–27 © 2024 Fondation Lurçat/Artists Rights Society (ARS), New York/ADAGP, Paris

p. 197 Sol LeWitt, *Wall Drawing* (color ink washes), 1988 (first installation), © 2024 The LeWitt Estate/Artists Rights Society (ARS), New York; Cecilia Vicuña, *Piedra y mica vieja* (*Precarios*), ca. 1990, © 2024 Cecilia Vicuña/Artists Rights Society (ARS), New York, courtesy the artist and Lehmann Maupin, New York, Hong Kong, Seoul, and London; Cecilia Vicuña, *Azul tiempo* (*Precarios*), ca. 2017 © 2024 Cecilia Vicuña/Artists Rights Society (ARS), New York, courtesy the artist and Lehmann Maupin, New York, Hong Kong, Seoul, and London; Cecilia Vicuña, *Balanza chueca* (*Precarios*), ca. 2017 (right), © 2024 Cecilia Vicuña/Artists Rights Society (ARS), New York, courtesy the artist and Lehmann Maupin, New York, Hong Kong, Seoul, and London

pp. 198–99 Gloria Kisch, *Flower 7*, 2007 (right)

pp. 198–99, 200, 213 Kazunori Hamana, *Untitled*, 2020

p. 200 Charlotte Perriand, 'Les Arcs' Bench, ca. 1973, © 2024 Artists Rights Society (ARS), New York/ADAGP, Paris; Ed Clark, *Untitled*, 1975

pp. 200 (middle), 202–3 (right) Hans (Jean) Arp, *Knospe/Bourgeon* (*Bud*), 1957 (cast 2012), © 2024 Artists Rights Society (ARS), New York/VG Bild-Kunst, Bonn

pp. 201, 219 Talunda Regio Billiat, *Chiwepu Chenhamo* (*Whip of Poverty, Part 1*), 2017

Front Cover, pp. 202–3, 207 Arlene Shechet, *Touching Summer*, 2020 (behind couch)

pp. 31 (right), 202–3, 207, 213, 226 Leza McVey, *Untitled*, 1960 (on coffee table, left)

Front Cover, pp. 202–3, 207 Simone Fattal, *Pliny the Elder*, 2021, © 2024 Artists Rights Society (ARS), New York/ADAGP, Paris (left, in niche); Le Corbusier "Diablo" Lamp in Metal, Green and Yellow Shade, ca. 1960 © F.L.C./ADAGP, Paris/Artists Rights Society (ARS), New York 2024

pp. 31, 202–3, 207, 213 Tony Marsh, *Ice Cauldron*, 2020 (right of couch)

Front Cover, pp. 31, 202–3, 207, 213, 226 Simone Leigh, *Sentinel* (*Gold*) (on coffee table, right)

pp. 202–3, 207 Eamon Ore-Giron, *Infinite Regress LXIX* (flashe on linen), 2019 (upper right)

pp. 31, 204 Gisela McDaniel, *On A Good Day* (oil on canvas with sound), 2019

p. 204 Theaster Gates, *Preservation Exercise #6* (*Wrap*), 2022 (far left)

p. 205 Lauren Halsey, *Untitled* (hand-carved gypsum on wood), 2020

pp. 208–9 Nicole Eisenman, *Head with a Demon*, 2018 (left); Nairy Baghramian, *Knee and Elbow*, 2020 (right)

p. 211 Calida Rawles, *Infinite From Root to Tip*, 2020 (left); Gabriel Orozco, *Suisai XVII*, 2016 (right)

pp. 215 Rashid Johnson, *Untitled, Microphone Sculpture*, 2018 (right); Jim McDowell, *Face Jugs*, 2018, 2020 (on dining table and console)

p. 218 Blue Green Works, Palm Table Lamp

pp. 219, 221 Pierre Jeanneret, Committee Chair, ca. 1959, © 2024 Artists Rights Society (ARS), New York/ADAGP, Paris

p. 220 Ruby Neri, *Sculpture #4*, 2014 (left); Myrbor rug designed by Jean Lurçat, ca. 1925–1930, © 2024 Fondation Lurçat/Artists Rights Society (ARS), New York/ADAGP, Paris

p. 221 Gala Porras-Kim, *11 Broken and Some Restored Artifacts* (graphite, colored pencil, watercolor, acrylic on paper mounted on canvas), 2019

DIALOGUES/AFTERWORD/ BACK COVER CREDITS/CAPTIONS

pp. 55, 225 A Roman marble head of Bacchus, ca. second century AD

p. 229 Ruemmler Nº 172 Button (detail)

p. 230 Lukas Duwenhögger, *Rezalet* (*Impertinence*), 1998

p. 233 Henry Taylor, *Portrait of Rashid Johnson*, 2019

p. 236 Packing blankets

Back Cover Cheyney Thompson, *After Rubens* (*2F*), 2019

PHOTOGRAPHY CREDITS

Adrian Gaut Front Cover, pp. 5, 7–8, 10, 16, 17, 23, 31, 37, 55, 63–71, 73–85, 89–111, 131–40, 142–45, 181–93, 197, 205, 207, 220–21, 225–26, 233–34, Back Cover

Shade Degges pp. 2–4, 6, 12–15, 18–19, 22, 24 25, 28, 33–34, 38, 52, 59, 116, 123, 149–57, 159–61, 165–77, 229–30

Malcolm Brown pp. 9, 11, 26

Jonny Ribeiro p. 45

JULIOTAVOLO p. 46

Tom Ashe p. 49 (top left)

Diego Vallenilla p. 49 (bottom left)

Stephen Kent Johnson pp. 115, 117–22, 124–27

Jason Schmidt pp. 198–204, 206, 208–11, 213–19

Reinaldo Leandro p. 236

First published in the United States
of America in 2024 by
Rizzoli International Publications, Inc.
300 Park Avenue South
New York, NY 10010
www.rizzoliusa.com

Publisher: Charles Miers
Project Editor: Sandra Gilbert Freidus
Design: Javas Lehn Studio
Production Manager: Kaija Markoe
Managing Editor: Lynn Scrabis
Editorial Assistance: Hilary Ney, Kelli Rae
Patton, Sara Pozefsky

Printed in Italy

2024 2025 2026 2027 / 10 9 8 7 6 5 4 3 2 1

ISBN: 978-0-8478-3719-9
Library of Congress Control Number:
2024934580

Visit us online:
facebook.com/RizzoliNewYork
instagram.com/rizzolibooks

twitter.com/Rizzoli_Books
pinterest.com/rizzolibooks
youtube.com/user/RizzoliNY
issuu.com/Rizzoli

FSC
www.fsc.org
MIX
Paper | Supporting
responsible forestry
FSC® C084761